FLEETWOOD MAC
EVERYWHERE

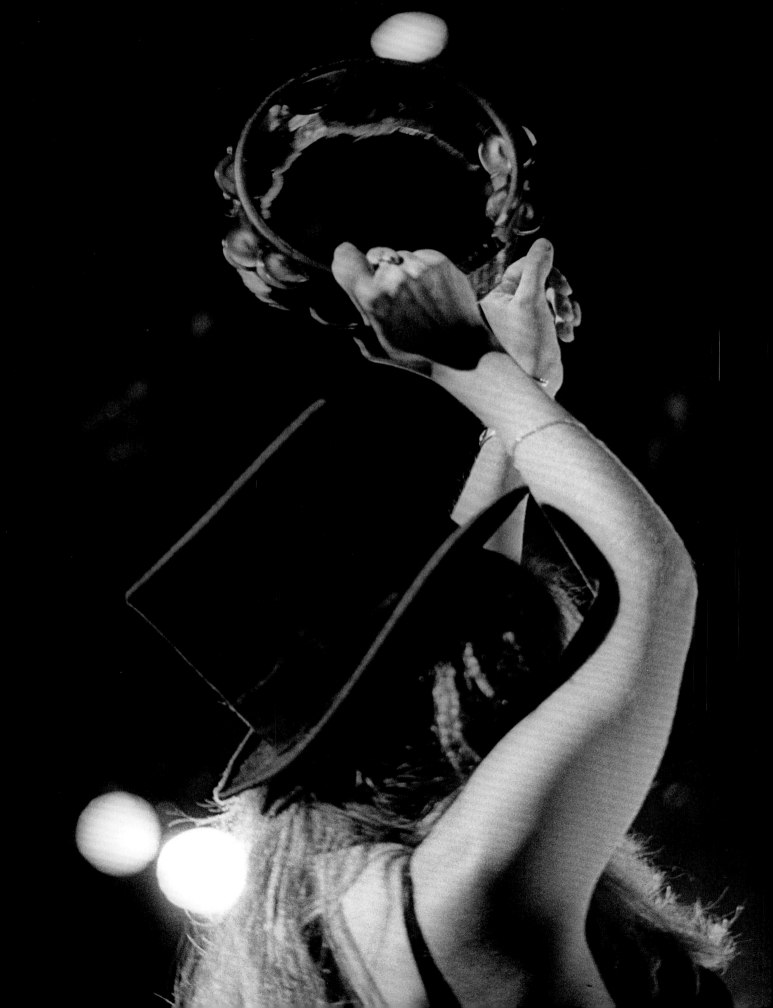

FLEETWOOD MAC
EVERYWHERE

Mike Evans

weldon**owen**

weldonowen
An imprint of Insight Editions
P.O. Box 3088
San Rafael, CA 94912
www.weldonowen.com

CEO Raoul Goff
VP Publisher RogerShaw
Editorial Director Katie Killebrew
Executive Editor Edward Ash-Milby
VP Creative Chrissy Kwasnik
Art Director Allister Fein
VP Manufacturing Alix Nicholaeff
Production Manager Joshua Smith
Sr Production Manager, Subsiduary Rights
 Lina s Palma-Temena

This edition first published in 2023 by
Palazzo Editions Ltd
15 Church Road
London, SW13 9HE
www.palazzoeditions.com

Text © 2023 Mike Evans
Design and layout © 2023 Palazzo Editions Ltd

Mike Evans has asserted his moral right to
be identified as the author of this work in accordance
with the Copyright, Designs and Patents Act of 1988.

Every effort has been made to trace and acknowledge the
copyright holders. If any unintentional omission has occurred,
we would be pleased to add an appropriate acknowledgment
in any future edition of the book.

Editor: Jo Rippon
Designed by Adelle Mahoney for Palazzo Editions

All rights reserved. No part of this book may be reproduced
in any form without written permission from the publisher.

ISBN 979-8-88674-115-5
Manufactured in China
10 9 8 7 6 5 4 3 2 1

PREVIOUS: *Stevie Nicks, 1977, Berkeley, California*

CONTENTS

Introduction	6
Chapter 1 Fleetwood Mac (1968)	10
Chapter 2 Mr. Wonderful	22
Chapter 3 Then Play On	32
Chapter 4 Blues Jam at Chess	42
Chapter 5 Kiln House	48
Chapter 6 Future Games	58
Chapter 7 Bare Trees	68
Chapter 8 Penguin	76
Chapter 9 Mystery to Me	88
Chapter 10 Heroes Are Hard to Find	96
Chapter 11 Fleetwood Mac (1975)	108
Chapter 12 Rumours	122
Chapter 13 Tusk	136
Chapter 14 Mirage	154
Chapter 15 Tango in the Night	170
Chapter 16 Behind the Mask	186
Chapter 17 Time	198
Chapter 18 Say You Will	210
Chapter 19 Extended Play	222

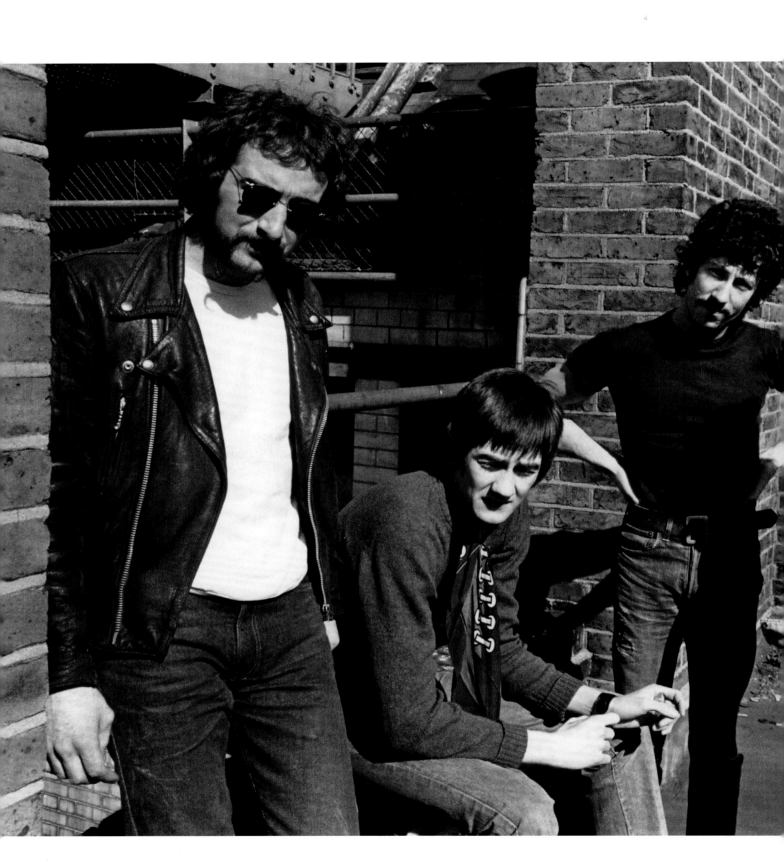

INTRODUCTION

The tragic death of Christine McVie in late November 2022 brought to a close the half-century story of one the most enduring acts in rock and pop music.

Fleetwood Mac first rose to prominence as a key name in the British "blues boom" in the late sixties, but by the end of the seventies they were one of the most successful bands in the history of rock music, playing a major part in developing the "soft rock" genre in mainstream pop.

The band emerged from the seminal blues band led by John Mayall, the Bluesbreakers, in which guitarist Peter Green, drummer Mick Fleetwood, and bass player John McVie, all participated before forming their own outfit in 1967. With the addition of slide guitar virtuoso Jeremy Spencer, Fleetwood Mac took the UK scene by storm, a debut album climbing to UK No. 4, and the instrumental single "Albatross" hitting the No. 1 spot.

The line-up subsequently went through a number of changes, including the departure of Jeremy Spencer to join a religious sect, and the key recruitment of Christine McVie (formerly known as Christine Perfect) on piano and vocals. Christine had been playing with their friendly rivals Chicken Shack, before marrying John McVie in 1968 and subsequently joining his band.

LEFT: *Fleetwood Mac, 1968. L–R: John McVie, Mick Fleetwood, Peter Green, Jeremy Spencer.*

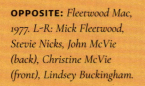

OPPOSITE: *Fleetwood Mac, 1977. L-R: Mick Fleetwood, Stevie Nicks, John McVie (back), Christine McVie (front), Lindsey Buckingham.*

Through the early seventies the key trio of McVie, Fleetwood, and McVie, cut five albums with a variety of personnel, and while they were evolving away from their original blues style, saw no immediate great success. A litany of personal frictions and managerial disasters saw the band more than once on the point of collapse, but having relocated to America, salvation came their way in the form of guitarist-vocalist Lindsey Buckingham, and his partner, vocalist Stevie Nicks.

With Buckingham and Nicks in the line-up, the final piece of the jigsaw was in place, and would lead to the band's breakthrough as one of the biggest musical names on the planet. First, came the bestselling album *Fleetwood Mac* in 1975, which was followed in 1977 by the release of their supreme triumph *Rumours*, one of the most successful albums of all time. By 2021 the album had sold over twenty million copies in the US alone.

Rumours controversially focused on the traumatic personal relationships within the band, and alongside a drug-fueled lifestyle it guaranteed sensational press coverage throughout the rest of the decade. With their on the road excesses constantly under the spotlight, Fleetwood Mac were considered the personification of rock star decadence.

Following the success of *Rumours* was almost impossible, but later albums, like the multi-platinum *Tango in the Night* in 1987, kept the band in the upper echelons of rock aristocracy. Lindsey Buckingham left the group more than once, while Stevie Nicks gradually kept the group at a distance in favor of her various solo projects.

Christine McVie had all but retired in recent years, although various reunions, tours, and occasional forays into the recording studio meant that Fleetwood Mac continued to operate in one form or another, albeit increasingly sporadically. Now, with Christine's death, any possible reunions of the remaining key members will be inevitably regarded as a memorial tribute to the band's key vocalist, instrumentalist, and songwriter.

In telling the long story of Fleetwood Mac, I have used their studio albums—with each album detailed as originally released in the UK—as markers in their remarkable journey from club-based blues band to global superstars. It's a journey like no other in the annals of popular music.

Mike Evans, May 2023

"We made quite an auspicious debut at the Windsor Jazz and Blues Festival, but Bob Brunning knew he was only in the group until John McVie made his mind up."

MICK FLEETWOOD

FLEETWOOD MAC (1968)

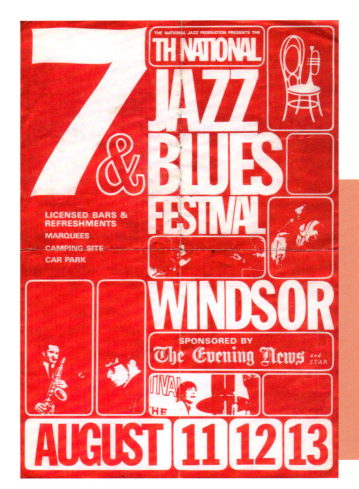

LEFT: *A promotional flier for the 7th National Jazz & Blues Festival, held in August 1967, in Windsor Great Park, UK; the debut gig for Peter Green's Fleetwood Mac featuring Jeremy Spencer.*

From their earliest days, the key founding members of Fleetwood Mac were already warding off accusations of "selling out," while being in the frontline of the British blues boom of the late 1960s. It was a charge that would be regularly made by dedicated fans, whose numbers nevertheless increased a millionfold over the decades that followed.

If we draw a family tree of the various line-ups of the band through that remarkable history, the earliest roots go back to 1963, a time of imminent change on the British music scene. The Beatles had taken the country by storm by early 1963, with their first chart-topping single, "Please Please Me," paving the way for a wave of "Merseybeat" bands hailing from Liverpool. And simultaneously "down south" in London, an emergent blues boom was centered on the Marquee Jazz Club, where Alexis Korner's Blues Incorporated and the Cyril Davies R&B All-Stars held sway on the weekly Rhythm and Blues sessions. It was this latter scene that was the catalyst for the emergence of The Rolling Stones and other British R&B groups, not just in London but up and down the country. And it was in Manchester that a blues enthusiast by the name of John Mayall began playing the local clubs with his band the Powerhouse Four, before moving to London, where he created one of the seminal names in British blues, the Bluesbreakers.

JOHN MCVIE

John Graham McVie, was born in Ealing, west London, in November 1945. While at Walpole grammar school, in his early teens he started playing guitar in a rudimentary

fashion. But it was obvious to young John that there were plenty of budding guitarists among his school mates, so instead he decided to try the bass guitar, after the fashion of Jet Harris in the top British instrumental group The Shadows.

John's first band, while he was still in school, was a local outfit called the Krewsaders, who played a few gigs at parties and weddings. When he left school in 1962, not long before his seventeeth birthday, an unexpected chance came via his friend and neighbor, Cliff Barton. Bass player Barton was already an up and coming name on the London blues scene after he'd started playing with the Cyril Davies R&B All-Stars. When he was approached by (still relatively unknown) John Mayall to join the embryo Bluesbreakers, Barton declined the offer but suggested to Mayall that he contact his friend McVie.

As often with a newly formed band, when McVie joined in January 1963 there was a period of flux within the ranks, but things settled down from July 1963 to April 1964, when the line-up consisted of Mayall—multi-tasking on vocals, guitar, keyboards and harmonica—McVie on bass guitar, Bernie Watson on guitar and Peter Ward—soon replaced by Martin Hart—on drums. That was the personnel, with Hart on drums, that appeared on the band's debut single, "Crawling Up A Hill" backed with "Mr. James," which represented John McVie's first experience of the recording studio. Released in April 1964 on the Decca label, the single was soon followed by a second release, "Crocodile Walk" and "Blues City Shakedown," plus a live debut album, *John Mayall Plays John Mayall*, by which time Hughie Flint had replaced drummer Martin Hart, and guitarist Roger Dean had taken over from Bernie Watson.

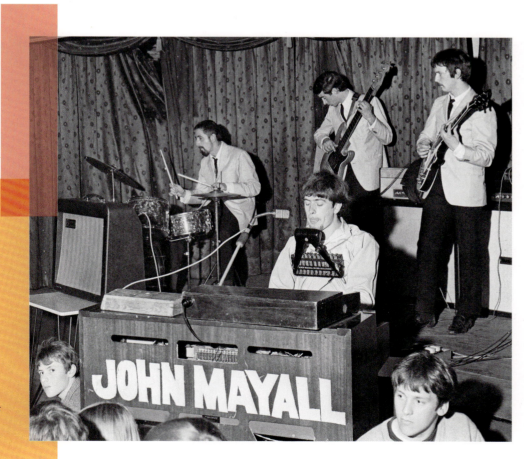

RIGHT: *John Mayall & the Bluesbreakers onstage at the Ricky-Tick club, Plaza Ballroom, Guildford, UK, June 4, 1965. L-R: Hughie Flint, John McVie, John Mayall (front), Eric Clapton.*

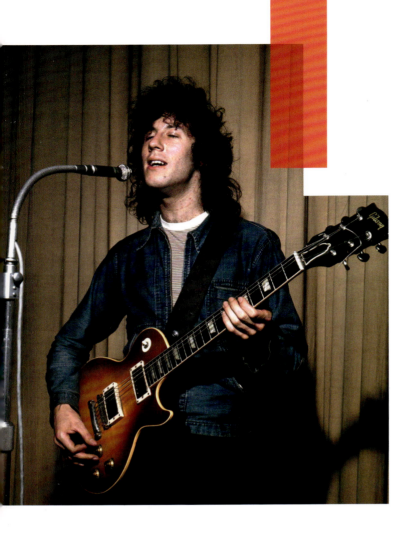

ABOVE: *Peter Green, circa 1969*

A blues purist, Mayall wasn't entirely happy with Roger Dean's guitar playing, which tended to a country music style. So Dean was replaced by Eric Clapton—like Mayall, another blues traditionalist—who had just left the leading R&B group the Yardbirds, on account of them getting "too commercial." During his tenure with The Yardbirds, Clapton was already being regarded as a guitar hero by R&B fans, and on joining the Mayall group his reputation as a blues maestro was confirmed. Thus the classic Bluesbreakers line-up—Mayall, Clapton, Flint, and McVie—released what many still regard as a milestone album of the era, *Blues Breakers With Eric Clapton*, in July 1966.

But despite the album making the UK No. 6 spot, Clapton had itchy feet again. Just prior to the album's release, he left the Bluesbreakers to form Cream, the much-heralded "supergroup" with bassist Jack Bruce and drummer Ginger Baker. So with a hit record in the charts, Mayall was suddenly without his star instrumentalist, but he didn't let that phase him. Clapton's place was soon filled by another (albeit then unknown) blues guitar virtuoso, by the name of Peter Green.

PETER GREEN

Peter Greenbaum was born in October 1946, in East London, and by the time he was a teenager was a huge fan of US blues artists such as John Lee Hooker, Muddy Waters, and B.B. King. Having acquired an acoustic guitar at the age of ten, by the time of his fifteenth birthday he was playing with a rock 'n' roll group, Bobby Denim and the Dominoes. After going on to play with a couple of R&B outfits, in early 1966 he joined keyboard player Peter Bardens in Peter B's Looners, a blues and soul band who cut a single, "If You Wanna Stay Happy" and "Jodrell Blues." And crucially, it was at this point that Green was to work with drummer Mick Fleetwood (who had been playing off and on with Bardens since 1963) for the first time.

In May 1966, Peter Bardens disbanded the Looners to reform as Shotgun Express, a dedicated soul line-up which featured two exceptional vocalists—Beryl Marsden from Liverpool, and an up-and-coming name on the London scene, Rod Stewart. But Peter Green's tenure with the new ensemble didn't last long; in July he was invited by John Mayall to occupy the guitar spot just vacated by Clapton. "Peter made himself known to me out of the audience several times, criticizing the people I'd got up on stage,

saying he was much better than they were..." was how Mayall would describe his first encounters with Green "...So eventually I gave him a chance...because he was becoming a nuisance!"

The Bluesbreakers, while their new guitarist was astounding fans with a technical prowess on a par with the recently departed Clapton, once again found themselves in a state of flux when drummer Hughie Flint quit in the September, to be replaced by Aynsley Dunbar. That was the line-up—Mayall, Green, McVie, and Dunbar, plus some additional horn contributions—that recorded the third Bluesbreakers album, *A Hard Road*, released in February 1967. Mayall, however, and not for the first time, was still dissatisfied with aspects of the sound of the band, deciding just a couple of months after the album release to fire Dunbar. Mayall and John McVie both felt that they needed a less complicated, straight-ahead blues approach from the rhythm section, and Peter Green suggested his old colleague from the Peter Bardens days—Mick Fleetwood.

> "Peter made himself known to me out of the audience several times, criticizing the people I'd got up on stage, saying he was much better than they were... So eventually I gave him a chance... because he was becoming a nuisance!"
>
> JOHN MAYALL

MICK FLEETWOOD

The son of a Royal Air Force officer, Michael John Kells Fleetwood was born on June 24, 1947, in Redruth, Cornwall. From his early teens his only ambition in life was to play the drums, and as soon as he got the chance early in 1963, he headed for where the action was, London. Staying at his married sister's house in the Notting Hill area, he would practice in the garage between sussing out what was happening on the music scene; it was, after all, the beginning of "swinging London," with the Beatles, Stones et al spearheading a musical revolution.

In a classic case of pure serendipity, Mick's sister lived just three doors down from Peter Bardens; upon hearing Fleetwood practicing, Bardens invited the drummer to join a band he was putting together. They were The Cheynes, who debuted in July 1963, promoting themselves as "Britain's Most Exciting Rhythm & Blues Sound." One of the hundreds of never-quite-made-it groups on the UK scene, they recorded three singles and played support to such names as The Yardbirds, The Animals, and The Rolling Stones, before disbanding in April 1965 when Bardens opted to join Van Morrison's group Them.

Fleetwood's next move was with the Bo Street Runners, another group of hopefuls that eluded success. He played with them from April 1965 until February 1966, when Peter Bardens invited him to join his new outfit, Peter B's Looners—who included, of course, Peter Green on guitar. Fleetwood and Green remained with Bardens when he disbanded

the Looners to form the short-lived Shotgun Express, who in turn called it a day in February 1967. Meanwhile Green had joined John Mayall's Bluesbreakers, so Mick was at a loose end musically, when in April 1967 Peter Green offered him a place behind the drumkit with the Bluesbreakers.

Neither Green nor Fleetwood lasted long with the punctilious Mayall, however. The Bluesbreakers' boss man was something of a stickler for band discipline and, when Fleetwood proved to be a heavy drinker, his time with the band was up within six weeks of his recruitment. Likewise, Peter Green's career with Mayall was similarly short-lived; the guitarist was resistant to the "guitar hero" tag he was acquiring among the Bluesbreakers' fans, and in June 1967 he too left their ranks, planning a new group with Mick Fleetwood.

Green envisioned a line-up that would also include John McVie, and although the bass player hung on in with Mayall until later in the year, Green was convinced he would eventually make the move. And to make the point, Green included McVie when he contrived a band name referencing the two rhythm section stalwarts—Fleetwood Mac. In the meantime, he placed an ad in *Melody Maker* in July 1967, that simply stated "Bass player wanted for Chicago-type blues band," a position he rightly assumed would be temporary until such time McVie joined the fold. Bob Brunning, an amateur bass player whose only experience was with a college band called Five's Company, answered the call to find himself auditioning with Peter Green himself. Brunning was offered the job there and then, and was even more amazed to be told that their first gig would be the prestigious Windsor Jazz and Blues Festival (officially titled the Seventh National Jazz, Pop, Ballads, and Blues Festival) taking place the following month.

As soon as he had left John Mayall, Peter Green had been discussing his plans for a new band with Mike Vernon, a producer at Decca who'd been involved in a number of Bluesbreaker recordings. Vernon was a dedicated blues enthusiast and, with his brother Richard, had set up an independent label, Blue Horizon, which up to then had concentrated on releases of obscure American blues artists. Vernon encouraged Peter Green in forming his new band, with a guaranteed record release once they were up and running.

Green insisted that they find a second guitar player to finalize the line-up at Windsor, clearly resisting the spotlight of "star" guitar man falling solely on himself. To that end, Mike Vernon suggested a young guitarist he'd heard on a talent-spotting trip, Jeremy Spencer.

JEREMY SPENCER

Born in July 1948 in Hartlepool, in the north-east of England, Jeremy Spencer grew up in the Midlands town of Lichfield. His initial music of choice was 1950s rock 'n' roll, his heroes Elvis, Buddy Holly, and so on. Straight ahead blues meant little to him until he

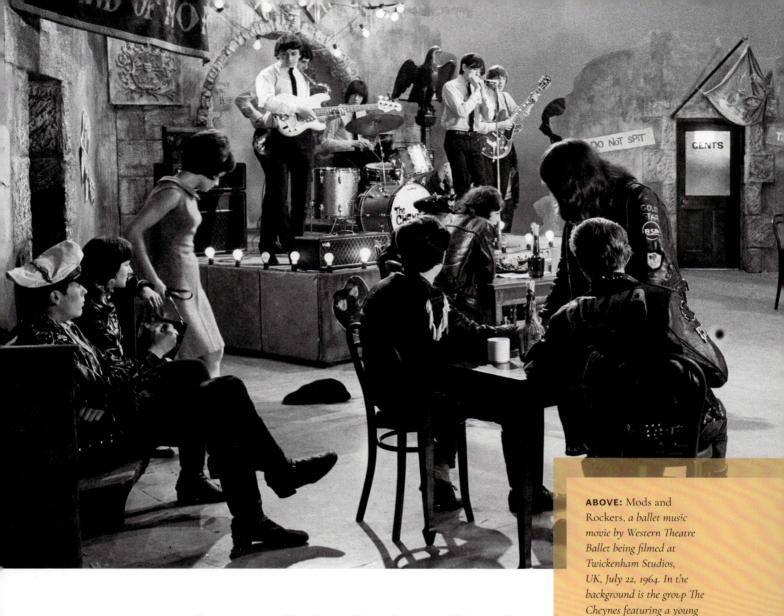

ABOVE: Mods and Rockers, *a ballet music movie by Western Theatre Ballet being filmed at Twickenham Studios, UK, July 22, 1964. In the background is the group The Cheynes featuring a young Mick Fleetwood on drums.*

came across a track by Elmore James—"The Sun Is Shining"—on an R&B compilation album, *The Blues: Volume 3*. He was stunned by what he heard, and vowed to teach himself the guitar in James' style. With that in mind, while a student at Staffordshire College of Art, he formed an R&B band, The Levi Set. It was 1967 when the ambitious guitarist contacted Mike Vernon, inviting him to hear the group.

Vernon was interested enough to invite The Levi Set to London to cut some audition tapes, but the results were simply not up to par. He was, however, sufficiently impressed by the guitarist to recommend him to Peter Green for his new outfit. Green was bowled over; he'd never heard anyone play slide guitar in true Elmore James fashion. Rushing up to Spencer's home he offered the guitarist the job, to start immediately.

The now-complete line-up went into frantic rehearsals in a pub on Chelsea's Fulham Road, the Black Bull, readying themselves for the Windsor festival, one of the major events in the UK music calendar. It ran from Friday to Sunday, August 11 to 13, with major rock names including The Small Faces, Pink Floyd, and Ten Years After. The Sunday concert was headed by Cream, the Jeff Beck group, and John Mayall's Bluesbreakers, all major names heading a bill that also included Peter Green's Fleetwood Mac featuring Jeremy Spencer.

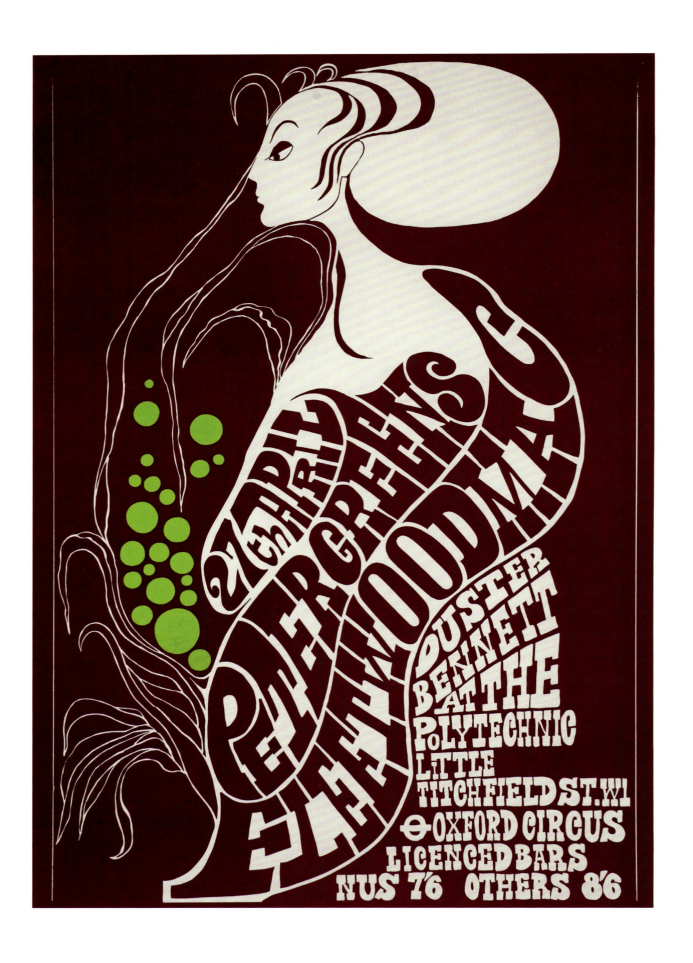

With Peter Green already recognized as a guitar hero to challenge Eric Clapton, the new group's debut was much anticipated by blues fans. And as the *Melody Maker* reported, the band (opening their set with a spectacular Spencer-led rendition of Elmore James' "Dust My Broom") rose to the occasion, despite some heavyweight competition and an inadequate sound system: "A host of guitarists like Peter Green, Eric Clapton, Jeff Beck and David O'List, had their sound reduced to a near pathetic level. Peter Green's Fleetwood Mac made an impressive debut, while John Mayall was received with fervent enthusiasm."

"We made quite an auspicious debut at the Windsor Jazz and Blues Festival . . . " Mick Fleetwood would recall, "but Bob Brunning knew he was only in the group until John McVie made his mind up."

The new band would take full advantage of their "auspicious debut" at Windsor, over the next three months or so playing the UK blues circuit up and down the country. And at the same time plans were being laid for the group to start recording with Mike Vernon.

Some initial tracks included Bob Brunning on bass, though most were never released following the arrival of John McVie from the Mayall ranks. The impetus for McVie to make his departure from the Bluesbreakers was Mayall adding two saxes to the line-up, creating a "jazzy" texture which was a step too far away from the blues for McVie. In December 1967 the bass player finally accepted Peter Green's long-standing offer, and the blueprint personnel for the first Fleetwood Mac album was complete.

Vernon's initial plan was for his Blue Horizon label to release Fleetwood Mac material through Decca, but when that didn't happen he struck a deal with rival company CBS. Before John McVie finally took his place in the line-up, a single had been released with Bob Brunning on bass in November 1967.

The A-side was a Jeremy Spencer rendition of an Elmore James song, "I Believe My Time Ain't Long," with the B-side featuring a Peter Green original, "Rambling Pony." Despite the band now attracting a burgeoning following in blues clubs up and down the country, the record failed to make headway in terms of sales. But that wouldn't be the case, when the band—now truly living up to their eponymous name with John McVie on bass—released their first album on February 24, 1968.

Credited to "Peter Green's Fleetwood Mac," the album featured four vintage blues numbers—favorites from their stage set at the time—three originals by Jeremy Spencer, and five by Peter Green. The release proved to be an overnight success, reaching the UK No. 4 spot and staying in the Top Twenty for the best part of a year. Their status as one of the front runners on the British blues circuit was secured, with fans filling venues wherever they played. *Melody Maker* called it "the best English blues LP ever released here." And although it only scraped into the Top 200 in the United States, writer Barry Gifford praised it in *Rolling Stone* magazine as "potent enough to make the South Side of Chicago take notice."

OPPOSITE: *A psychedelic style poster advertises a gig by Peter Green's Fleetwood Mac at the London Polytechnic in 1967*

FLEETWOOD MAC (1968)

Original vinyl edition

FLEETWOOD MAC

Side one
My Heart Beat Like A Hammer [Jeremy Spencer]
Merry Go Round [Peter Green]
Long Grey Mare [Peter Green] *
Hellhound On My Trail [Robert Johnson]
Shake Your Moneymaker [Elmore James]
Looking For Somebody [Peter Green]

Side two
No Place To Go [Howlin' Wolf]
My Baby's Good To Me [Jeremy Spencer]
I Loved Another Woman [Peter Green]
Cold Black Night [Jeremy Spencer]
The World Keep On Turning [Peter Green]
Got To Move [Elmore James, Marshall Sehorn]

Recorded: November–December 1967, CBS Studios, London
Released: February 24, 1968 (UK), June 1968 (US)
Label: Blue Horizon (UK), Epic (US)
Producer: Mike Vernon
Personnel: Peter Green (vocals, guitar, harmonica), Jeremy Spencer (vocals, slide guitar, piano), John McVie (bass guitar), Mick Fleetwood (drums), *Bob Brunning (bass guitar)
Chart position: UK No. 4

TRACK-BY-TRACK

MY HEART BEAT LIKE A HAMMER
With a classic Elmore James-style riff from Jeremy Spencer, who also takes the lead vocal, this original was the introduction to the Mac for most fans— in retrospect an atmospheric evocation of the late sixties' blues boom.

MERRY GO ROUND
Peter Green takes the front vocal on his own composition, and some incisively simple guitar licks in the solo.

LONG GREY MARE
Another Green original, with the guitarist doubling on harmonica, and bass guitar by John McVie's brief predecessor Bob Brunning.

HELLHOUND ON MY TRAIL
A vintage song by Robert Johnson, the blues legend who died in 1938 aged twenty-seven, after recording just twenty-nine numbers. Vocals are by Jeremy Spencer, who also supplies some effective piano.

SHAKE YOUR MONEYMAKER
Another nod towards his hero Elmore James from Jeremy Spencer. The up-tempo rocker, which was written by James, became an essential in the band's live act.

LOOKING FOR SOMEBODY
Peter Green leads on his third original, which closed side one on the original vinyl edition, the guitarist again providing the lead vocals and harmonica.

NO PLACE TO GO
The great Chicago bluesman Howlin' Wolf (Chester Burnett) penned this minimalistic but strident number, Green once more leading on vocals and harmonica.

MY BABY'S GOOD TO ME
Spencer takes the lead again on his own song, his slide guitar proving testimony to Peter Green's enthusiasm when he first heard Spencer play.

I LOVED ANOTHER WOMAN
A more languid approach from Peter Green's lead guitar, an echo-tinged sound which would be reflected on the band's 1970 hit single "Green Manalishi."

COLD BLACK NIGHT
In the classic blues format, an archetypal "my baby left me" lyric from Jeremy Spencer, his precise vocals and economic guitar fills doing perfect justice to a time-honored theme.

THE WORLD KEEP ON TURNING
Green in laidback mood on a solo effort accompanied with some sparse acoustic guitar. He's clearly listened intently to the great country blues singers, with mature-sounding vocals that belie his youthful years.

GOT TO MOVE
Another Elmore James original, again Jeremy Spencer takes the reins on a spirited ride into Chicago blues territory. The song was credited as being co-written by James and record producer Marshall Sehorn.

> "Potent enough to make the South Side of Chicago take notice."
> ROLLING STONE

BELOW: *On the rooftop of a building in Oxford Street, London, March 1968. L-R: Jeremy Spencer, Peter Green, John McVie, Mick Fleetwood.*

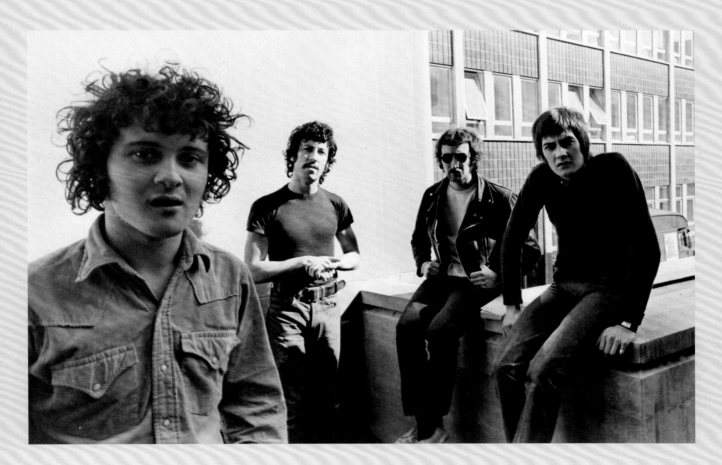

"We realised there was a mounting demand not only for American-made blues but for British groups playing good blues in their own way."

MIKE VERNON

MR. WONDERFUL

As well as being a launch pad for the embryonic line-up of Fleetwood Mac, the Windsor Jazz and Blues Festival held in August 1967 heralded the start of what would be a second UK blues boom. The R&B explosion pioneered by Alexis Korner had catapulted groups such as The Rolling Stones, The Yardbirds and The Animals into the national pop chart limelight, and by the middle of the decade commercial success for these and other bands had blurred the line between pop and blues. As a consequence, a new wave of dedicated blues outfits were enjoying a growing cult following in blues clubs and festivals across the UK.

Key to this development was the Blue Horizon label which, as well as recording Fleetwood Mac for their debut single and subsequent album, had also signed another band who had made an impressive UK debut at the Windsor event, Chicken Shack. Prior to Windsor, Chicken Shack—formed by guitarist Stan Webb and bass player Andy Silvester—had played just a month's season at the legendary Star-Club in Hamburg, Germany, so as it had been for Fleetwood Mac, the Jazz and Blues Festival was something of a baptism of fire. And for many observers, the stand-out feature of Chicken Shack's performance was the presence of their sensational pianist and vocalist, Christine Perfect.

CHRISTINE MCVIE

Christine Perfect was born in the Lake District of northern England, but grew up in Smethwick, near Birmingham. She grew up in a strongly musical family, her father Percy being a concert violinist and music teacher, and her grandfather the organist in Westminster Abbey. She began taking formal piano lessons seriously when she was about eleven years old, but was

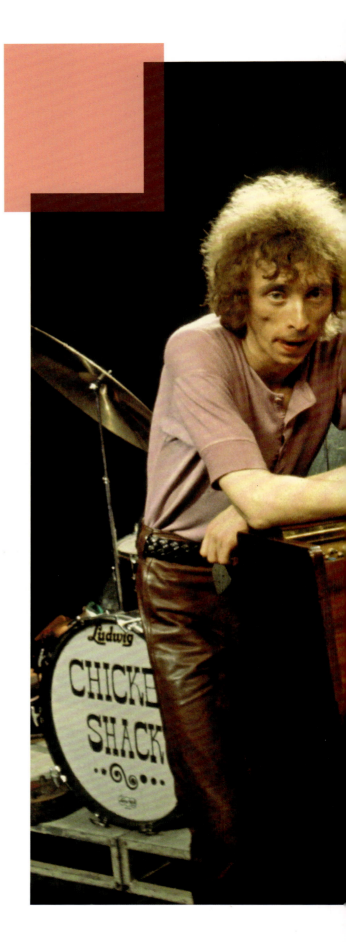

RIGHT: *UK Blues group Chicken Shack with Christine Perfect (seated) in 1968*

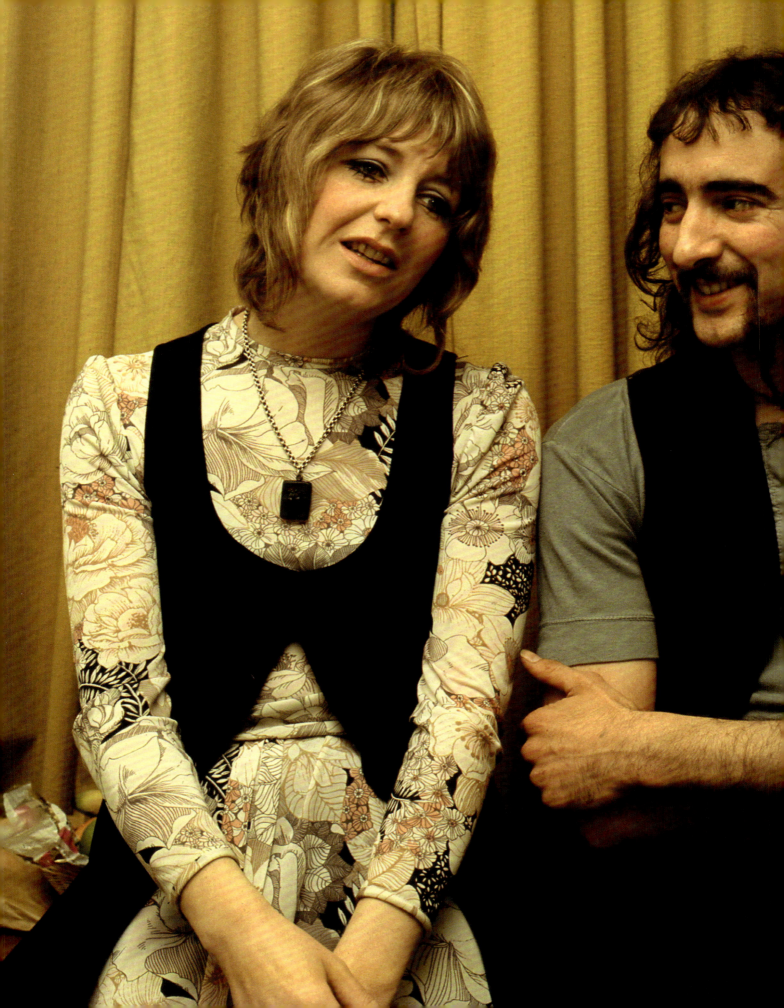

> "It was a terrible band. We used to play at the local Liberal club and come away with three pounds each."
>
> CHRISTINE MCVIE

soon converted to rock 'n' roll after her elder brother John brought home a songbook featuring material recorded by the great New Orleans R&B pianist-vocalist Fats Domino.

Like many musicians of the UK blues and rock scene in the 1960s, Christine spent her formative years at art school. At the Moseley School of Art, Birmingham, she studied sculpture and became involved with various musicians on the burgeoning British blues scene, including Webb and Silvester, then in a band called Sounds of Blue. They persuaded Christine to join them.

"It was a terrible band," she said. "We used to play at the local Liberal club and come away with three pounds each."

The band broke up before Perfect had finished college. After graduation she moved to London and became a window dresser in a West End store. Still hankering for a role in music, she heard that Webb and Silvester were looking for a pianist. They took her on immediately and Christine Perfect alternated with Stan Webb on vocals for Chicken Shack.

With both bands signed to Blue Horizon, making their debut virtually simultaneously, through late 1967 and early 1968, they would frequently find themselves on the same bill, along with other stars of this new blues revival such as Savoy Brown, Ten Years After, and Jethro Tull. Vernon and the blues bands were even named-checked in a satirical song by the poetry-rock band Liverpool Scene, "I've Got Those Fleetwood Mac, Chicken Shack, John Mayall, Can't Fail Blues." Soon John McVie and Christine Perfect began dating, and were a regular item by the time the future Mrs McVie was invited to guest on the second Fleetwood Mac album in April 1968.

LEFT: *Christine Perfect and John McVie, circa 1970*

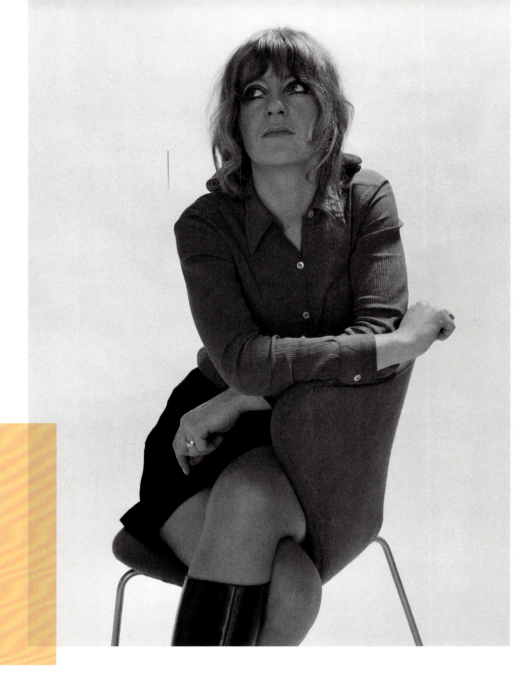

RIGHT: *Christine McVie (née Perfect), October 1968*

OPPOSITE: *On the set of a TV studio, Denmark, 1968*

Buoyed by the success of their eponymous album, and their growing reputation on the blues scene nationwide, Fleetwood Mac needed major media exposure. They had already appeared on the influential BBC Radio One show *Top Gear*, co-presented by Tommy Vance and John Peel in November 1967, but they knew that the key to a higher profile would be a hit single. To that end, in March 1968 Blue Horizon released a new Peter Green song, "Black Magic Woman" as a single, with "The Sun is Shining" (again, Jeremy Spencer referencing Elmore James) on the flip side.

Although the single was far from a chart-buster, just making UK No. 37, it was enough for the group to win more radio airplay. Plus, a growing fan base was developing in continental Europe, to the extent that Fleetwood Mac made their first TV appearance in the spring of 1968, during a short tour of Norway, Sweden and Denmark.

April 1968 saw Fleetwood Mac back in the recording studio, preparing for the release of a second album. Blues purists to a man, the band insisted that producer

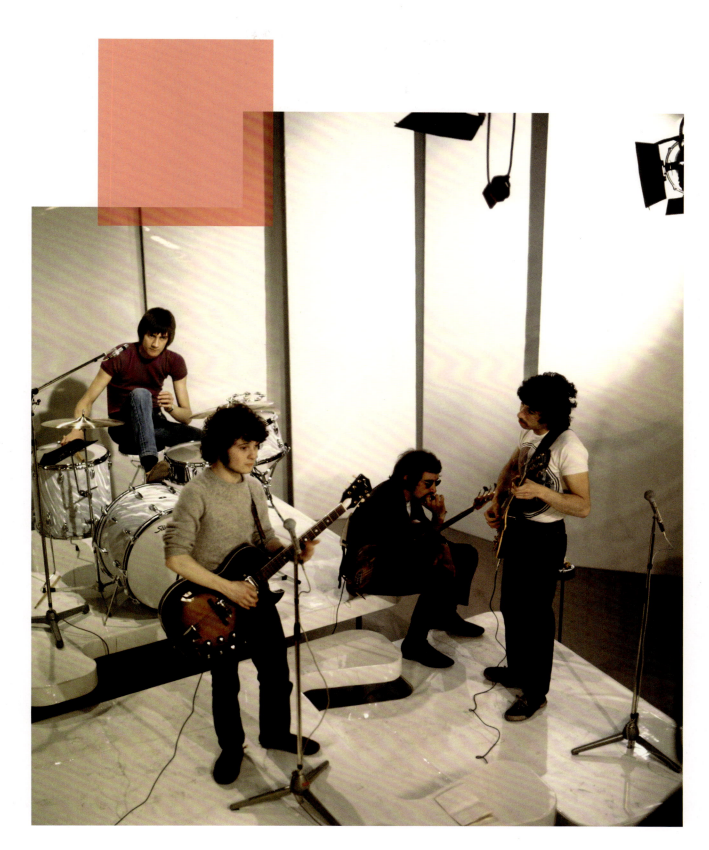

Mike Vernon and the recording engineer Mike Ross should attempt to replicate an "authentic" sound reminiscent of the days before stereo. Their intention was to achieve a primitive feel to the recordings that would complement their own approach to playing the blues, although the majority of the tracks were originals—with six written by Peter Green and the band's new manager Clifford Adams. The album widened the scope of the group's performance with the addition of a four-piece saxophone section, plus fellow Blue Horizon harmonica star Duster Bennett, and Christine Perfect from Chicken Shack.

To be called *Mr. Wonderful*, the album was due to be released in August 1968. Prior to that, on July 5 Blue Horizon released the band's third single, "Need Your Love So Bad." A gentle blues by Little Willie John, it featured vocals by Peter Green and Christine Perfect on piano, plus a string section for good measure. Failing to set the charts alight, it nevertheless kept the band in their fans' minds prior to their next album release, while the group themselves were completing a debut US tour through the June and July.

The American trip was far from a success, probably costing the band money they could ill afford, to play support to various better-known UK acts, but it did introduce them to a territory that would become central in the group's history further down the line. And ten days after the band's return to England, John McVie and Christine Perfect got married.

As Christine would comment on the friendly rivalry between the Shack and the Mac: "To be honest, there's no jealousy between us and Fleetwood. In fact, their success has helped us a lot. All the people in the blues world know I'm married to John, and in a way it's good publicity for us . . . "

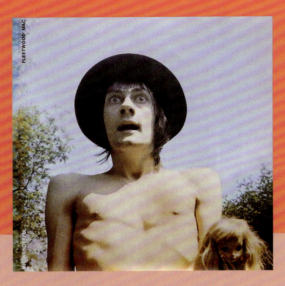

MR. WONDERFUL

Side one
Stop Messin' Round [Clifford Adams, Peter Green]
I've Lost My Baby [Jeremy Spencer]
Rollin' Man [Clifford Adams, Peter Green]
Dust My Broom [Elmore James, Robert Johnson]
Love That Burns [Clifford Adams, Peter Green]
Doctor Brown [J. T. Brown, Waymon Glasco]

Side two
Need Your Love Tonight [Jeremy Spencer]
If You Be My Baby [Clifford Adams, Peter Green]
Evenin' Boogie [Jeremy Spencer]
Lazy Poker Blues [Clifford Adams, Peter Green]
Coming Home [Elmore James]
Trying So Hard To Forget [Clifford Adams, Peter Green]

Recorded: April 1968, CBS Studios, London
Released: August 23, 1968 (UK)
Label: Blue Horizon (UK)
Producer: Mike Vernon
Personnel: Peter Green (vocals, guitar, harmonica), Jeremy Spencer (vocals, slide guitar), John McVie (bass guitar), Mick Fleetwood (drums)
Additional personnel: Christine Perfect (keyboards, piano, vocals), Duster Bennett (harmonica), Steve Gregory (alto saxophone), Dave Howard (alto saxophone), Johnny Almond (tenor saxophone), Roland Vaughan (tenor saxophone)
Chart position: UK No. 10

TRACK-BY-TRACK

STOP MESSIN' ROUND
A rip-roaring opener, which had been used as the flipside of the band's most recent single, the saxes giving the up-tempo song a 1940s jump band feel.

I'VE LOST MY BABY
A more languid twelve bar song from Jeremy Spencer. The classic blues format strips the sound bare—this is where delivery is paramount, distancing amateur from professional and the men from the boys.

ROLLIN' MAN
Peter Green fronts his song, again the saxes evoking Fleetwood Mac as an old-school R&B combo.

DUST MY BROOM
The Elmore James/Robert Johnson classic, with a guitar riff that became standard (and indeed, often a cliché) among the UK blues bands.

LOVE THAT BURNS
Written by Peter Green and Clifford Adams, with an evocative piano solo fade-out from Miss Perfect—who, of course, by the time the album was released, was actually Mrs McVie.

DOCTOR BROWN
In the same guitar mode as "Dust My Broom," a relaxed, strutting blues originally written and recorded by R&B man Buster Brown in 1960.

NEED YOUR LOVE TONIGHT
That riff again, this time on a Jeremy Spencer original. Classic crowd-pleasing Mac, play it loud.

IF YOU BE MY BABY
Again, the saxes lift the riffing to another level, while Green excels on vocals and guitar.

EVENIN' BOOGIE
A raucous instrumental penned by Jeremy Spencer, featuring (albeit briefly) the only full-throttle sax breaks on the album.

LAZY POKER BLUES
Green at his best, with a stomping rhythm and insistent horns, and Christine shining through on piano.

COMING HOME
Another piece of archetypal Elmore James, with Spencer in his element. The Brit blues boom personified.

TRYING SO HARD TO FORGET
Peter Green leading the intro on harmonica, a laid-back piece of lo-fi blues that features his blues harp throughout.

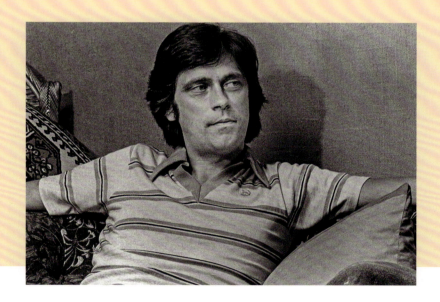

BELOW: *Producer Mike Vernon pictured in 1979*

At the band's insistence, Mike Vernon and recording engineer Mike Ross attempted to replicate an "authentic" sound with *Mr. Wonderful*, reminiscent of the days before stereo.

"I've always liked rock, and it's a pity in a way that everyone is going on about the rock thing because it seems as though we're just being 'in.' Actually, I've always wanted to do this kind of thing on stage—but it doesn't mean we'll be neglecting the blues."

PETER GREEN

THEN PLAY ON

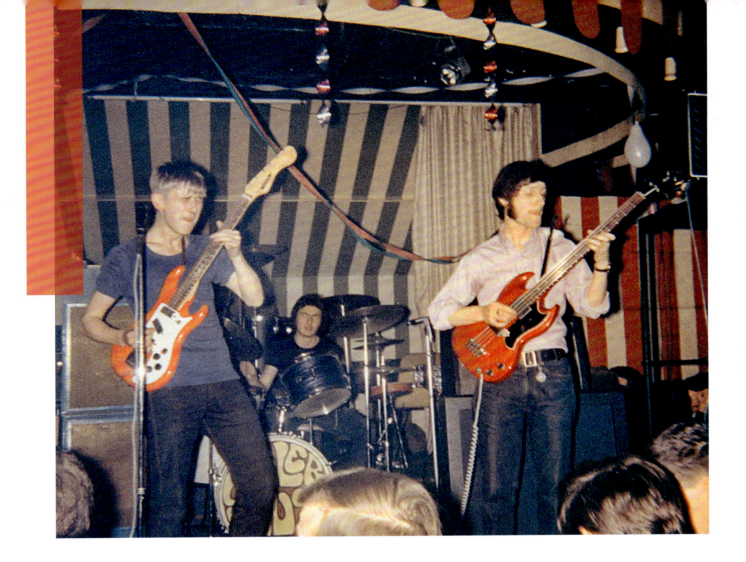

Although *Mr. Wonderful* was another good seller for the band, like its predecessor making the UK Top Ten, Peter Green began to feel that they needed to stretch themselves musically.

The band's own concert performances, geared to promoting the album, were basically a balance of Peter Green playing his style of blues alongside Jeremy Spencer playing his. And although Spencer would add some novelty to the on-stage repertoire with hilarious impersonations of Elvis and other rock 'n' roll stars, he was otherwise satisfied to concentrate on his basic love—Elmore James-inspired blues. Despite being a trenchant bluesman at heart, in keeping with the fervid atmosphere of the period, Green decided that the band should be exploring new directions, outside the confines of what was in danger of becoming a stereotypical blues band.

It was a time of revolutionary changes on the rock music scene, tied in with the general countercultural upheaval of the late 1960s. Fleetwood Mac had experienced the cutting-edge developments of psychedelic music when they had been in the States, particularly in San Francisco—the epicenter of the hippie scene—where they got to know groups like the Grateful Dead, who were at the center of the action. With a conscious shift of emphasis very much on his mind, Peter Green decided that part of the answer might lie in adding another guitar to the line-up.

DANNY KIRWAN

Born in Brixton, South London, in May 1950, Danny Kirwan was discovered by Peter Green when the latter was on a talent hunting trip with Mike Vernon. Initially, the Blues Horizon boss had hoped to sign Kirwan's band Boilerhouse, but when he concluded that only the guitarist was right for the label, and they failed to find a new bass player and drummer, Green realized this could be the key to an added guitar voice in Fleetwood Mac.

Kirwan joined the band just a few weeks before the release of *Mr. Wonderful* in August 1968. He played his first gig with the band on August 14, at the Nag's Head Blue Horizon club in Brixton, and just ten days later was appearing on stage at a mammoth free concert in London's Hyde Park. And although a fan of both Green and Jeremy Spencer's blues playing, his broader approach contributed to the expansion of the band's sound that Green wanted. Years later, Mick Fleetwood would maintain that, as soon as he joined the line-up, Kirwan's presence set in train a liberation of their music into wider pastures than that of a blues band: "Looking back on it, Danny [was] really contributing yet another level of musical openness that was to become a major part of Fleetwood Mac." And Kirwan himself laid his position on the line soon after joining the band, telling *Melody Maker*, "I'm not keen on blues purists who close their ears to all other forms of music . . . I like any music that is good, whether it is blues, popular or classical."

Peter Green's insistence via numerous press interviews that Fleetwood Mac wouldn't be tied to a narrow blues formula was made all the more apparent with the release of their next single in November 1968. When the band went into the studio in October to cut the track, they had already been recording fresh material with a view to a new album release in the USA, where *Mr. Wonderful* had never been released. But the October session was specifically for the new single, and the composition that Peter came up with

OPPOSITE: *Danny Kirwan (left) performing with his band Boilerhouse at the Marquee, London, 1967*

RIGHT: *Fleetwood Mac with new recruit Danny Kirwan (second from right), 1968*

> "Looking back on it, Danny [was] really contributing yet another level of musical openness that was to become a major part of Fleetwood Mac."
>
> MICK FLEETWOOD

was a far cry from the blues sound that had been the band's trademark.

According to Green, the instrumental "Albatross" was directly inspired by the 1959 hit "Sleep Walk" by the American guitar duo Santo & Johnny. For British audiences, the echo-laden guitar sound was also redolent of early 1960s guitar hits by The Shadows. The dreamy, laid-back guitar against a stark bass and drums backing produced a dreamy effect that Peter Green would describe as "Caribbean." However you defined it, "Albatross" was certainly the nearest thing yet to a pure pop record that Fleetwood Mac had attempted—and it paid off.

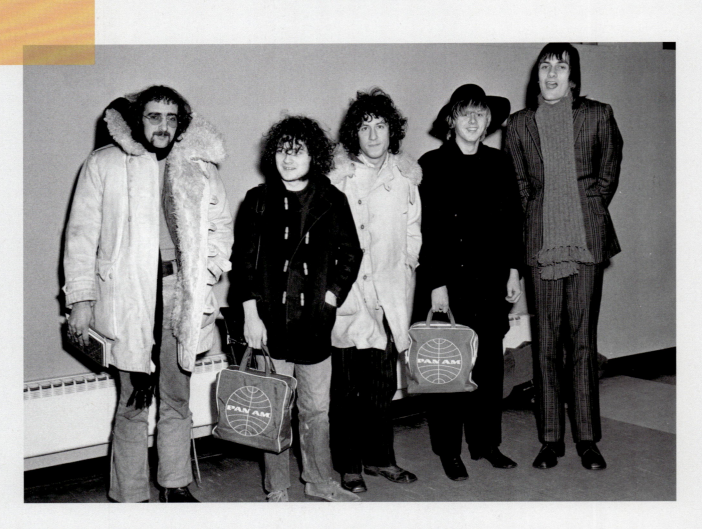

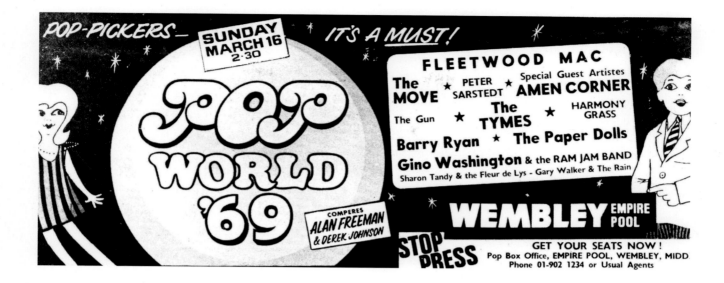

Released on November 25, 1968, the single shot to the top of the UK charts, also reaching the Top Five in Norway, Sweden, Holland, Switzerland, and Ireland. And conspicuously, on the band's first big hit (with Danny Kirwan's "Jigsaw Puzzle Blues" on the B-side), Jeremy Spencer was absent from the line-up that comprised Green, Kirwan, McVie and Fleetwood.

Ironically, the band were not able to enjoy this first flush of success at home. Just as "Albatross" was making the UK No. 1 spot in early December, Fleetwood Mac were embarking on their second tour of the United States. This would be a far more fulfilling trip than the first trek Stateside, starting on December 6, 1968, at the prestigious Fillmore East in New York, opening for the Grateful Dead. Between then and early February, when the tour wound up in Detroit, the band performed thirty-six concerts in seventeen cities, at largely sold-out venues—and not always playing at the bottom of the bill. A performance highlight was undoubtedly on December 28, when they played the Miami Pop Festival to a crowd of over a hundred thousand, on the same bill as Procul Harem, Country Joe and the Fish, Booker T & the MGs, and rock 'n' roll legend Chuck Berry. And prior to winding up the tour, in January 1969 the band went into the studio in New York to record their follow-up single to the hugely successful "Albatross," "Man of the World."

Returning from the USA in February, Fleetwood Mac found themselves being greeted as fully-fledged pop stars on account of their chart-topping single. Inevitably this drew accusations of selling out from the die-hard blues enthusiasts among their fan base, but both Peter Green and Jeremy Spencer were anxious to argue otherwise. They stressed it was merely a broadening of the band's style, not a rejection of their beloved blues. Released in March 1969, the new single did little to assuage those fears. Similarly atmospheric in texture to "Albatross," but this time with vocals that enhanced the reflective ambience of the song, Peter Green's composition "Man of the World" hit the UK No. 2 spot in the middle of April. As with the previous hit, Jeremy Spencer was nowhere to be heard on the track, which came over much as a Peter Green solo effort. He was, however, given pride of place on the flip side with "Someone's Gonna Get Their Head Kicked In Tonite," a knowing send-up of early rock 'n' roll (based on Spencer's on-stage routines) billed as by "Earl Vince and the Valiants."

OPPOSITE: *Off on tour, 1968. L-R: John McVie, Jeremy Spencer, Peter Green, Danny Kirwan, and Mick Fleetwood.*

ABOVE: *Fleetwood Mac top the bill of "Pop World 69" at London's Wembley Empire Pool*

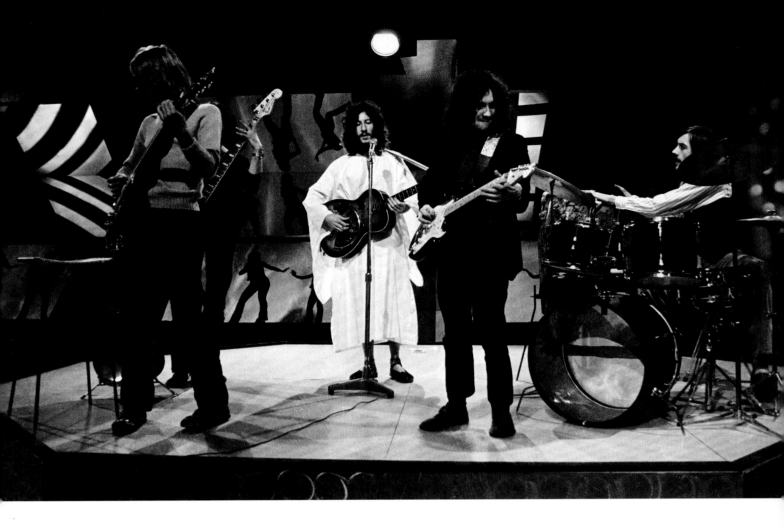

ABOVE: *Performing "Oh Well" on the set of the BBC's Top Of The Pops,* Lime Grove Studios, London, October 23, 1969

The single represented a key moment in the band's formative history. It signaled Fleetwood Mac had moved away from the Blues Horizon label that had both launched the group, and, under the auspices of Mike and Richard Vernon, nurtured their progress up to that point. A move to former Rolling Stones' manager Andrew Loog Oldham's label Immediate resulted from a crucial mistake on the part of Richard Vernon. The Vernon brothers had originally signed the band (via Peter Green) to a one-year contract, and Richard failed to pick up the option when the date became due. In stepped the band's manager Clifford Davis (who had been using the name Clifford Adams for song-writing credits), announcing that Fleetwood Mac were no longer under contract to Blue Horizon.

The Vernons were devastated; they had agreed a quarter-million-pound advance from CBS, and now Davis was negotiating a deal with the rival giant Warner Brothers. Loog Oldham seemed to be under the impression that the single release was to lead to a long-term deal with Immediate, but that was not to be. There was even talk of interest from John Lennon and that the band might sign to The Beatles' Apple label, but in the event it was once signed to Warner Brothers that Fleetwood Mac recorded their third album, *Then Play On*.

The move from Blue Horizon and the Vernon brothers was uncomfortable for the band themselves. This was particularly the case for Peter Green, who had been the first to sign with Mike and Richard, and nurture the relationship that had in effect launched the band as key players on the British blues scene. Green had a lingering doubt about the whole matter, feeling that the band were being guided for largely commercial reasons.

And his growing disenchantment with broader aspects of his career was already evident in other ways. While on the 1968-69 US tour he had renounced his Jewish faith, first in favor of Buddhism, then evangelical Christianity. Through the latter half of 1969 he began wearing long white robes on stage, with a large crucifix hanging from his neck, in the manner of some messianic shaman or Old Testament prophet.

And now, in a deliberate move to distance the group from the "blues band" tag, Jeremy Spencer didn't actually appear on any of the fourteen tracks on *Then Play On*. Peter Green, as always anxious to avoid the spotlight, deemed that the album would be split between his songs—five in all—and seven from Danny Kirwan (much to Kirwan's surprise), plus an instrumental track each from McVie and Fleetwood.

There was a marked contrast between Kirwan's no-nonsense but lyrically light approach, and Green's more introspective songs. And the two tracks from the bass player and drummer were the edited results of hours of jamming in the studio, as was Peter Green's moody "Underway." The stand-out track for many fans, however, was "Rattlesnake Shake," a studio version of one of their show stoppers.

The new recordings also marked a move away from the live set-up they aimed for in their previous two long-players, which had deliberately tried to create as far as possible the sound they achieved on stage. Now the band would use all the technical facilities at their disposal, with the band editing and overdubbing until a definitive work was achieved, an artifact in its own right.

A footnote to the UK release of *Then Play On,* on September 9, 1969, was the double-sided single "Oh Well" (parts one and two) which was recorded at the same sessions and released just a couple of weeks later. It was a radical decision to say the least. Apart from the fact that a track stretching to nearly nine minutes over two sides of a single was difficult to promote on radio, the music consisted of two short blues vocals by Peter Green, followed by an instrumental taking up the entire second side. The short A-side (lasting under two and a half minutes) featured a fast blues guitar riff played by Green and Kirwan, accompanied by McVie and Fleetwood (on cowbell) as a minimal rhythm section. The five-minute-plus "Part 2" instrumental flipside, which Mick Fleetwood would describe as a "concerto," featured the whole band including Green playing guitar and cello, plus Green's then girlfriend Sandra Elsdon on recorder, and Jeremy Spencer on piano, his only contribution to the entire *Then Play On* sessions.

Assuming the record would clock up meagre sales, McVie and Fleetwood each bet Peter Green five UK pounds (roughly eighty-five pounds, or one hundred US dollars at today's equivalent) that the single wouldn't even make the charts. But Green's instinct proved to be correct, when the single made UK No. 2, and hit No. 1 in Holland. Since then the song has been held up by fans, critics, and fellow musicians as an early example of the cross-over between blues rock and heavy metal. This influence was acknowledged by bands like Led Zeppelin, whose John Paul Jones cited it as an inspiration when composing his riff for the song "Black Dog."

BELOW: *"Oh Well Part I & II" vintage single record sleeve, 1969*

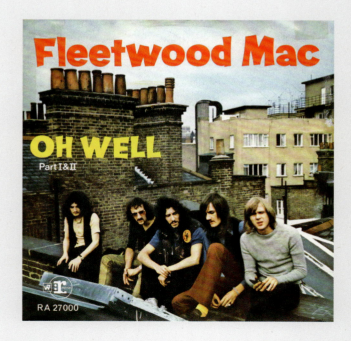

Original vinyl edition

THEN PLAY ON

Side one
Coming Your Way [Danny Kirwan]
Closing My Eyes [Peter Green]
Fighting For Madge [Mick Fleetwood]
When You Say [Danny Kirwan]
Showbiz Blues [Peter Green]
Underway [Peter Green]
One Sunny Day [Danny Kirwan]

Side two
Although The Sun Is Shining [Danny Kirwan]
Rattlesnake Shake [Peter Green]
Without You [Danny Kirwan]
Searching For Madge [John McVie]
My Dream [Danny Kirwan]
Like Crying [Danny Kirwan]
Before The Beginning [Peter Green]

Recorded: October 1968, June 1969, CBS Studios, London
Released: September 9, 1969 (UK), November 1969 (US)
Label: Reprise
Producers: Fleetwood Mac
Personnel: Peter Green (vocals, guitar, harmonica), Danny Kirwan (vocals, guitar), John McVie (bass guitar), Mick Fleetwood (drums)
Additional personnel: Christine Perfect (piano) uncredited, Jeremy Spencer played piano on "Oh Well (Pt. 2)" uncredited (US release only), Sandra Elsdon played recorders on "Oh Well (Pt. 2)" uncredited (US release only)
Chart position: UK No. 6, US No. 109

TRACK-BY-TRACK

COMING YOUR WAY
Energetic drumming intros the Danny Kirwan opener, like many of his compositions stronger on the instrumental side than his lyrics.

CLOSING MY EYES
Another laid-back Peter Green song, in the same echo-laden vein texture-wise as "Albatross," marking a distance from his blues roots. All in all, a rather lugubrious track.

FIGHTING FOR MADGE
Mick Fleetwood's only contribution credited on the writing side of things, an edited section of hours of studio jamming. Both this and John McVie's only credited tune on the album were dedicated to a long-standing UK fan.

WHEN YOU SAY
Again, an unremarkable song from Kirwan, instrumentally lacking any of the tension that dedicated Mac fans had come to expect.

SHOWBIZ BLUES
Peter Green back in the driving seat for something nearer to his heart, a sparse slide-guitar blues with just a tambourine for the percussion.

UNDERWAY
A brooding instrumental credited to Peter Green, again a result of some extended jamming in the recording studio.

ONE SUNNY DAY
Danny Kirwan fronts a tougher song than his previous two contributions. A solid rocker which provides a more successful link between the Mac of old and the new, somewhat sanitized version of much of the album.

Then Play On takes its name from the opening line of William Shakespeare's play *Twelfth Night*—"If music be the food of love, play on." It's the band's first release on Reprise (Warner Brothers) and to feature Danny Kirwan; the last to feature Peter Green.

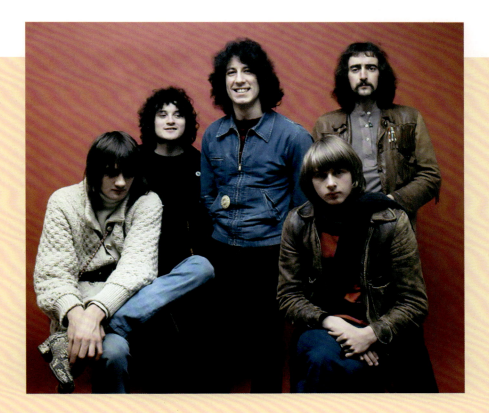

RIGHT: *Posing for a studio portrait. L-R: Mick Fleetwood, Jeremy Spencer, Peter Green, Danny Kirwan, and John McVie*

ALTHOUGH THE SUN IS SHINING
A more melodic Kirwan here, though again the trite lyrics undermine what amounts to a competent pop song.

RATTLESNAKE SHAKE
Green back in comfortable, down-home blues territory, with some searing guitar and strident vocals. This track was certainly the high point on the album for many traditional Mac fans, the song already a favorite at gigs.

WITHOUT YOU
A revisionist blues from Danny Kirwan. A classic twelve-bar construction, the guitars rich in echo and reverb. Although written and performed by the newcomer, possibly the most satisfying track for many long-term Mac fans.

SEARCHING FOR MADGE
The third instrumental taken from jammin' tapes, this time credited to John McVie, and again the Mac fan Madge is referenced in the title.

MY DREAM
Another instrumental, this time a guitar piece from Danny Kirwan that can fairly be described as pleasant but innocuous.

LIKE CRYING
Kirwan was apparently taken by surprise to have such a slice of the album action, This one's a more satisfying contribution than the others, at less than two-and-a-half-minutes an interesting foray into light country rock territory.

BEFORE THE BEGINNING
A Peter Green number winds things up. With some of the vocals in danger of being lost in the mix, instrumentally again it's an attempt at recreating the atmosphere that was successfully evoked in "Albatross."

"We were about to mutate into another kind of band altogether."

MICK FLEETWOOD

BLUES JAM AT CHESS

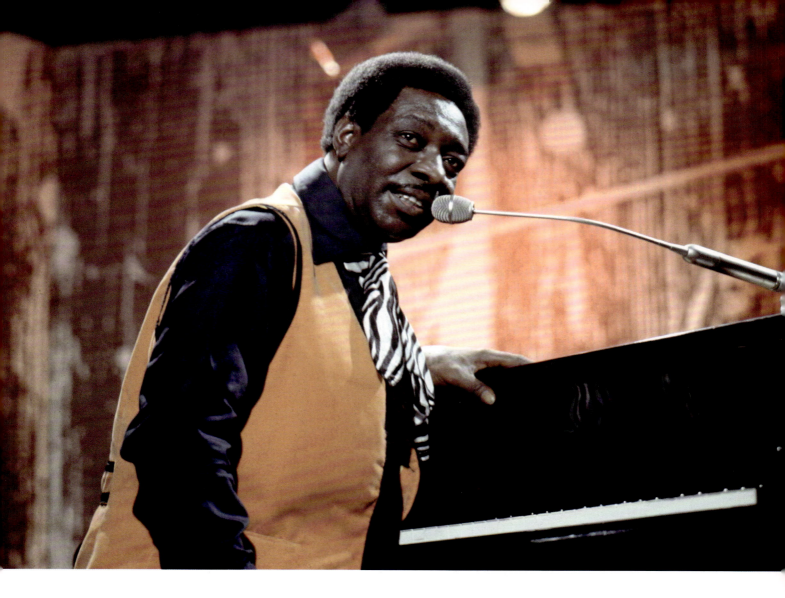

Still stinging from the loss of their biggest commercial prospects yet, at the end of 1969 Mike and Richard Vernon attempted to recoup at least some of their losses with the release on Blue Horizon of some historic jam sessions. Fleetwood Mac had recorded these at Chicago's Chess Studios, back in early January during their second American tour.

The band had opened at Chicago's Regal Theater for one of their musical idols, the great bluesman Muddy Waters. Prior to the concert, Mike Vernon had heard that the city's legendary Chess Studios—where the likes of Howlin' Wolf, Willie Dixon, Bo Diddley, and Chuck Berry had all made their most famous records—was threatened with closure. He had contacted Marshall Chess, the label's founder, and set up a recording session for Fleetwood Mac to play with some of the studio's illustrious regulars. The line-up of blues maestros included Waters' pianist Otis Spann, blues harmonica star Shakey Horton, the guitarists Buddy Guy and Honeyboy Edwards, and the trademark Chess double bass sound of Willie Dixon. For Fleetwood Mac, it was a daunting prospect to say the least.

Nervous to start with, the young Brits were conscious that their hosts were probably skeptical about these white kids from England making their mark as blues players. The seasoned veterans were soon convinced, however, that the youngsters could really

play the blues, with Peter Green and Jeremy Spencer in particular impressing them with their conviction and technical skill.

The resulting recording would not appear until December 1969, but the double album, *Blues Jam at Chess*, was vindication for those—including the Vernons—who had always claimed that Fleetwood Mac could play the blues alongside the best. But ironically it also marked the last album release of the Mac as a pure blues outfit. As Mick Fleetwood would point out in his account of the band: "We were about to mutate into another kind of band altogether."

Reviewing the collection on its 1976 US reissue on the Sire label as *Fleetwood Mac in Chicago*, the eminent rock journalist Greil Marcus wrote in *Rolling Stone*, "The Fleetwood Mac that cut this album was a rough, derivative band, full of enthusiasm and committed to their music . . . The shade of Elmore James smiled on the band, and never more so than on *Chicago* . . ."

> "The Fleetwood Mac that cut this album was a rough, derivative band, full of enthusiasm and committed to their music . . . The shade of Elmore James smiled on the band, and never more so than on *Chicago* . . ."
>
> GREIL MARCUS, *ROLLING STONE*

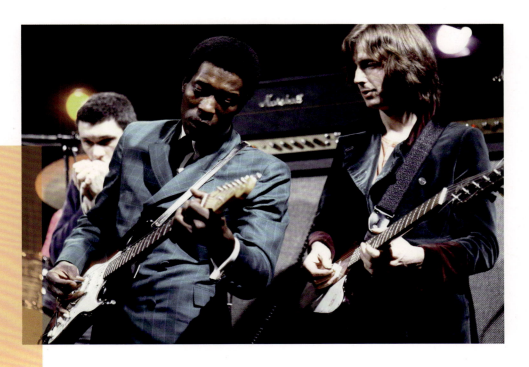

Two of Fleetwood Mac's Blues heroes who jammed and recorded with the band at Chess Studios, Chicago, January 1969. Above left: Pianist Otis Spann. Right: Guitarist Buddy Guy (left).

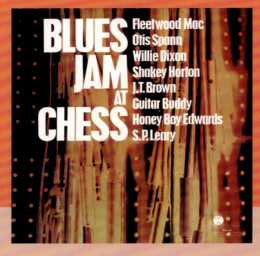

BLUES JAM AT CHESS

Side one
Watch Out [Peter Green]
Ooh Baby [Howlin' Wolf]
South Indiana (take 1) [Walter Horton]
South Indiana (take 2) [Walter Horton]
Last Night [Little Walter Jacobs]
Red Hot Jam [Peter Green]

Side two
I'm Worried [Elmore James]
I Held My Baby Last Night [Elmore James, Jules Taub]
Madison Blues [Elmore James]
I Can't Hold Out [Elmore James]
I Need Your Love [Walter Horton]
I Got The Blues [Walter Horton]

TRACK-BY-TRACK

WATCH OUT
A suitably laid-back opener with just the Fleetwood Mac quartet of McVie, Fleetwood, Kirwan, and Peter Green, without Jeremy Spencer. The song is credited to Peter Green, who takes the lead vocals.

OOH BABY
Mick Fleetwood sings here, just the trio with McVie and Green on a jaunty up-tempo blues written by Chester Burnett, a.k.a. the great Howlin' Wolf.

SOUTH INDIANA (TAKE 1)
The first track with a local guest player, harmonica virtuoso Walter "Shakey" Horton. Horton wrote the harp-based number, a relaxed instrumental featured in two parts.

SOUTH INDIANA (TAKE 2)
"Shakey" Horton (sometimes known as Big Walter Horton) was one of the great figures of blues harp playing, born in 1921 and forty-seven years old when these tracks were cut. Bass player Willie Dixon, an in-house fixture of the Chess Studios set-up, claimed Horton was the best harmonica player he had ever heard.

LAST NIGHT
Another track featuring "Shakey" Horton, who takes the vocals as well as self-accompanying on harp. The song was written by Little Walter Jacobs, famous in his own right for R&B hits on Chess including "My Babe."

RED HOT JAM
Mick Fleetwood and Peter Green are joined by a quartet of Chess star names: on double bass Willie Dixon, guitarists Buddy Guy and "Honeyboy" Edwards, and "Shakey" Horton on harp. Bass man Willie Dixon was something of an institution at Chess, and as a composer had come up with a host of R&B classics including "My Babe," "Little Red Rooster," and "Hoochie Coochie Man." A bouncy Peter Green instrumental on which Green, Guy, Edwards, and Horton take solos in turn, in true jamming tradition.

I'M WORRIED
Jeremy Spencer joins the action with (inevitably?) an Elmore James number, on which he sings and contributes trademark James guitar licks. House saxophone man J. T. Brown also adds some jump-band texture. Also known as Saxman Brown, Nature Boy Brown, and Bep Brown over a varied career, John Thomas Brown died in November 1969, a month before the release of the Fleetwood Mac album.

I HELD MY BABY LAST NIGHT
Another Elmore James song from Jeremy Spencer, a slow blues that gives saxman J. T. ample room to blow alongside Spencer's echo-laden guitar.

MADISON BLUES
And yet another James song given the Spencer treatment, with the same accompanying line-up of Fleetwood, Kirwan, Dixon on double bass, and J. T. Brown on tenor sax.

I CAN'T HOLD OUT
Spencer's oft-repeated riff tells us it's four in a row of Elmore James tunes.

Side three
World's In A Tangle [Jimmy Rogers]
Talk With You [Danny Kirwan]
Like It This Way [Danny Kirwan]
Someday Soon Baby [Otis Spann]
Hungry Country Girl [Otis Spann]

Side four
Black Jack Blues [J. T. Brown]
Everyday I Have The Blues [Memphis Slim]
Rockin' Boogie [Jeremy Spencer]
Sugar Mama [Howlin' Wolf]
Homework [Dave Clark, Al Perkins, Otis Rush]

RECORDED: January 4-5, 1969, Chess Ter-Mar Recording Studios, Chicago
RELEASED: December 5, 1969 (UK)
LABEL: Blue Horizon
PRODUCER: Mike Vernon, Marshall Chess
PERSONNEL: Peter Green (vocals, guitar, harmonica), Jeremy Spencer (vocals, slide guitar), Danny Kirwan (vocals, guitar), John McVie (bass guitar), Mick Fleetwood (drums)
ADDITIONAL PERSONNEL: Otis Spann (piano), Walter "Shakey" Horton (vocals, harmonica), Buddy Guy (guitar), "Honeyboy" Edwards (guitar), J. T. Brown (tenor saxophone), Willie Dixon (string bass), S. P. Leary (drums)

I NEED YOUR LOVE
Chess guitar session man S. P. Leary joins the proceedings, with the great Otis Spann on piano, for a "Shakey" Horton take on one of his best-known songs.

I GOT THE BLUES
"Shakey" Horton leads on vocals and harmonica, with McVie and Kirwan, plus Chess men S. P. Leary and Otis Spann on drums and piano respectively.

WORLD'S IN A TANGLE
Danny Kirwan contributes some smooth vocalizing and relaxed guitar on the Jimmy Rogers number, again with Leary and Spann. Guitarist and vocalist Rogers played for some years with Muddy Waters' band, and under his own name had several R&B hits for Chess.

TALK WITH YOU
Kirwan takes the lead again, on a number of his own composition. Sympathetic backing from ex-Muddy Waters piano man Otis Spann.

LIKE IT THIS WAY
A stop-start intro adds to the jam atmosphere for another Kirwan original.

SOMEDAY SOON BABY
Otis Spann is the only Chess player on this self-penned, atmospheric track. The pianist takes the lead vocal, and leaves much of the backing to the Brit kids.

HUNGRY COUNTRY GIRL
The same line-up of Spann, Green, Kirwan, McVie and Fleetwood. Again written by Spann, who provides the vocals, with a typical spoken introduction leading into solid vocals and some barrelhouse piano.

BLACK JACK BLUES
Saxophone man J. T. Brown contributes a song of his own, plus the vocals. Spencer and Fleetwood are the only Macs present, alongside guitarist "Honeyboy" Edwards.

EVERYDAY I HAVE THE BLUES
The old Memphis Slim stand-by, delivered with gusto by Jeremy Spencer. The spirited, echo-laced backing features Brown's sax, and Edwards' raunchy guitar—plus Peter Green, with a daunting rhythm section comprising Willie Dixon and Mick Fleetwood.

ROCKIN' BOOGIE
Jeremy Spencer leads a roaring instrumental performance from Green, Brown, Edwards, Dixon and Fleetwood.

SUGAR MAMA
A Howlin' Wolf number delivered with Peter Green's vocals, backed by Kirwan, McVie and Fleetwood—with Otis Spann the only Chicago man on the track.

HOMEWORK
The same combination closes the collection. Written by guitarists Dave Clark and Al Perkins with bluesman Otis Rush, it's a jaunty up-tempo piece of more contemporary R&B outside the stricter blues parameters set by the rest of the double album.

"There was talk of, 'If we give all the money away that we make, then maybe we can do this and that . . .'"

MICK FLEETWOOD

KILN HOUSE

Early in 1970, all the members of Fleetwood Mac leased two old kiln houses in the rural English countryside between Hampshire and Surrey. Kiln houses were traditionally built specifically for the drying of hops when brewing beer, and the two buildings were imaginatively known as Kiln House. It also became home to the band's wives, girlfriends, children, and roadies: John and Christine McVie, Mick Fleetwood and girlfriend Jenny Boyd (who were married in June 1970), Jeremy Spencer with his wife Fiona and son Dicken, Danny Kirwan and girlfriend Claire, plus road mangers "Dinky" Dawson and Dennis Kean.

"Getting it together in the country" had become something of a fashionable *modus operandi* for recording among successful UK rock bands at the time, and Fleetwood Mac were no exception. The isolation formula didn't always pay off in creative dividends, of course, and the forthcoming recordings looked to be in jeopardy from the start, when Peter Green announced he was leaving the band.

Green's erratic behavior had become increasingly evident since the latter months of 1969. At press interviews he was more inclined to describe his search for God, and began suggesting that the band should be donating all their money to charity. "There was talk of 'If we give all the money away that we make, then maybe we can do this and that,'" Mick Fleetwood would recall, adding "and John was half-interested." Thankfully for the rest of the band, McVie's interest in Green's philanthropic proposal was short-lived. At the end of 1969, while Peter was obsessing about his search for religion, Fleetwood Mac were riding high, featuring in the *Melody Maker* annual readers' poll.

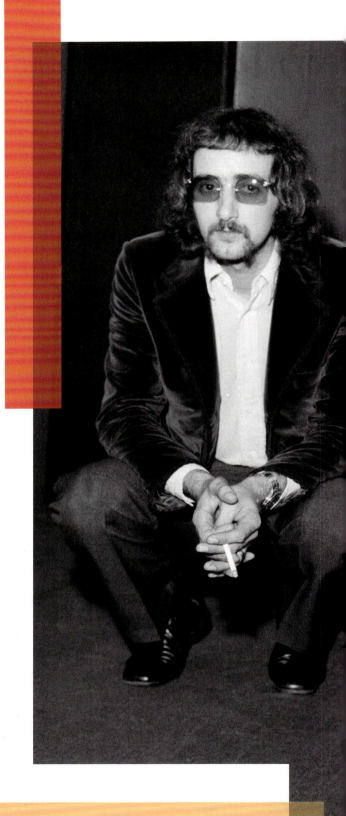

RIGHT: *Fleetwood Mac at the 1969* Melody Maker *Reader's Pop Poll. L-R: John McVie, Danny Kirwan, Jeremy Spencer (front), Mick Fleetwood, and Peter Green*

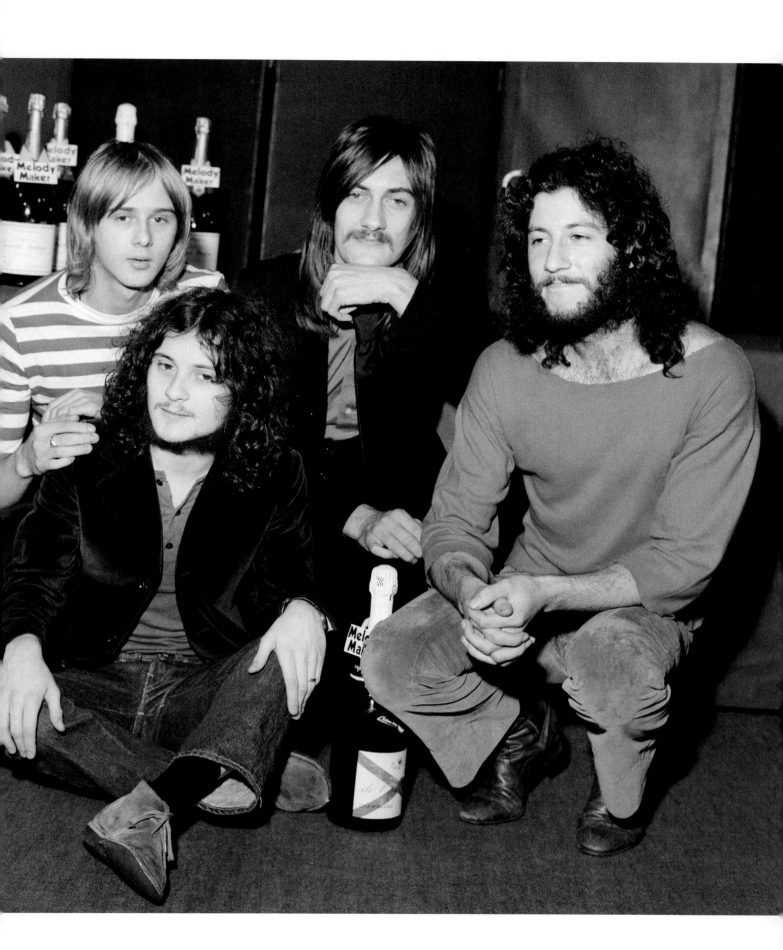

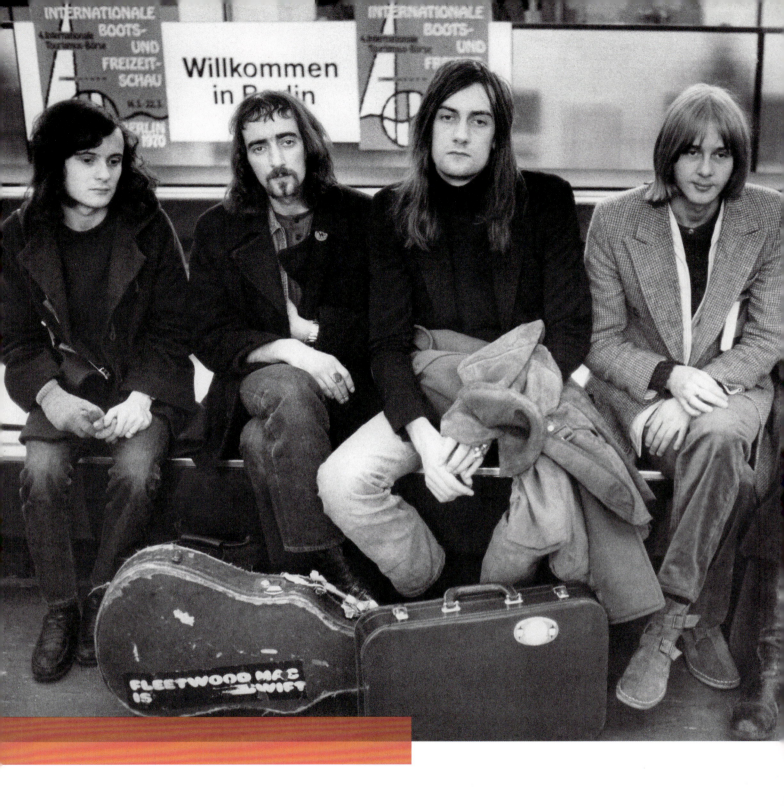

"All it took was a couple of tabs . . . and he never came back."

JOHN MCVIE ON PETER GREEN

But as the rest of the band were aware, Peter Green's increasing mental turmoil wasn't just rooted in a search for spiritual enlightenment. A year earlier, during the early part of their second American tour, they had all experimented with LSD, but Peter had become a more regular user. And, according to those around him, the tipping point for Green came on the night of March 22, 1970, when the band were in Munich, Germany, during a twenty-four-date European tour. After the concert Green went to a party with a bunch of Munich well-to-do hippies, at which he was given what was later claimed to be "impure" LSD. As a result, he suffered from a bad trip from which he never fully recovered. In the event, the rest of the band had to "rescue" him from his new-found gang of hangers-on, who followed the group to England and continued to supply Green with potent acid.

Peter Bardens, who had remained a close friend of Green since their days together in Peter B's Looners in the mid-1960s, would comment on the Munich episode: "It's not just Pete, but other people who've been spiked, especially with acid, not knowing what it is, it can turn the whole world upside down. Maybe he never really recovered from that, it certainly screwed things up." As John McVie put it in a 2009 documentary: "All it took was a couple of tabs . . . and he never came back."

There were other issues that weighed heavily on Peter Green's mind. He was frustrated by working with a fixed line-up, which he felt restricted his ability to explore various areas musically; he didn't feel that Mick Fleetwood always kept perfect time; he disliked McVie's often excessive drinking and he was irked by what he felt was Danny Kirwan's "glamor boy" image. He revealed his intention to leave to manager Clifford Davis—and the rest of Fleetwood Mac—while they were on the final dates of the European tour in April 1970.

It was a bombshell for the band—though not one that was entirely unexpected—and for their legions of fans. Peter agreed to fulfill their immediate commitments through to the end of May 1970, although his presence on stage became increasingly unreliable and chaotic with his virtual non-stop intake of hallucinogens. And as one final creative gesture, Green came up with the band's next single, recorded after the band's return

LEFT: *Fleetwood Mac tour Germany, 1970*

from Europe in late April. According to its troubled composer, "The Green Manalishi (With The Two Prong Crown)" was written in the wake of a traumatic nightmare—the title referring to the devil, during a musical descent into the realms of hell. Released on May 15, the single hit the UK chart the following week at No. 10, just five days before Peter Green's last ever gig with Fleetwood Mac, at London's Roundhouse on May 28, 1970.

CHRISTINE

Meanwhile, Christine McVie had left Chicken Shack in August 1969, at the height of the band's popularity. She departed with a view to simply becoming a housewife, and being able to see more of her husband John. But she couldn't escape the bright lights that easily, and after being named female vocalist of the year in *Melody Maker* (on the strength of her membership of Chicken Shack), she was persuaded to resume her career as a solo artist. Still contracted to Blue Horizon, she took her own band on the road, and later released an album *Christine Perfect* which featured John McVie and Danny Kirwan in the personnel. By the time the album was released, however, in December 1970, Christine had once more retired to domesticity, before being recruited to play on Fleetwood Mac's next album.

Through June and July of 1970 the band rehearsed and recorded *Kiln House*. The album, released in September 1970, featured two distinct styles that were emerging to define the band at the time: Danny Kirwan's melodically based songs, leaning towards what would be the mainstream sound of rock in the 1970s, and Jeremy Spencer's country-tinged, rockabilly numbers. Spencer's prominent presence on the album was in complete contrast to his absence on *Then Play On*; it was open to conjecture whether he was pressured into making a positive contribution or he naturally assumed the role after Peter Green's departure.

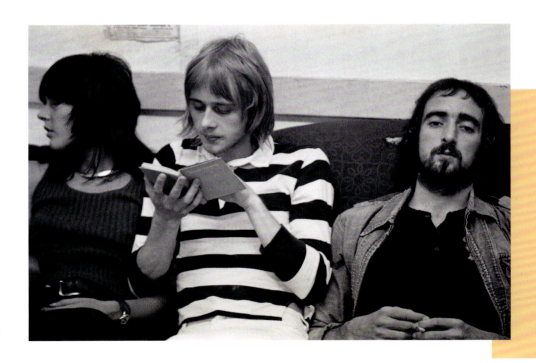

LEFT: *Danny Kirwan and John McVie backstage at the Boston Tea Party, Massachusetts, USA, September 1970*

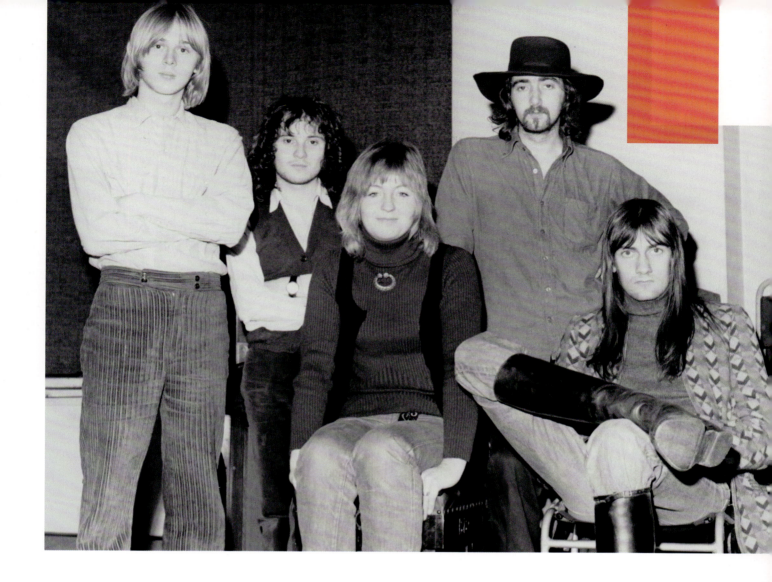

It was also, by the time of its release, the first Fleetwood Mac album to feature Christine McVie as a permanent member of the band. When she was invited to play on the *Kiln House* sessions, Christine was still signed to Blue Horizon. For contractual reasons, she was only credited with creating the sleeve illustration, receiving a straightforward session fee for her musical contribution. Then after the recording was completed, Fleetwood Mac set about preparing for another American promotional trip. Without the third guitar of Peter Green, they felt that the sound was too thin for the demands of on-stage appearances—it seemed perfectly natural to ask Christine McVie to join.

Christine jumped at the chance, and subsequently made her debut as an official member of Fleetwood Mac early in August 1970, at the Warehouse Café in New Orleans. Her presence in the line-up on keyboards added a new texture to the guitar-based Fleetwood Mac sound, as did her soulful vocals, and when the tour ended in early September it certainly helped the sales. While only making it to UK No. 39—a disappointing performance after their previous Top Ten appearances—the record reached US No. 69, sales figures no doubt aided by the impact of the recent tour appearances. And on their return to the UK, a high-powered tour of Britain kept them in front of audiences until the end of the year—now with Christine McVie a well-established part of the band.

ABOVE: *Fleetwood Mac pictured with Christine McVie (center), circa 1970*

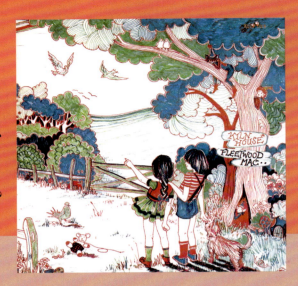

Original vinyl edition

KILN HOUSE

Side one
This Is The Rock [Jeremy Spencer]
Station Man [Danny Kirwan, Jeremy Spencer, John McVie]
Blood On The Floor [Jeremy Spencer]
Hi Ho Silver [Joe Turner]
Jewel Eyed Judy [Danny Kirwan, Mick Fleetwood, John McVie]

Side two
Buddy's Song [Ella Holley]
Earl Gray [Danny Kirwan]
One Together [Jeremy Spencer]
Tell Me All The Things You Do [Danny Kirwan]
Mission Bell [Jesse D. Hodges, William Michael]

Recorded: June–July 1970, De Lane Lea Studios, London
Released: September 18, 1970 (UK)
Label: Reprise
Producers: Fleetwood Mac
Personnel: Jeremy Spencer (vocals, slide guitar, piano), Danny Kirwan (vocals, guitar), John McVie (bass guitar), Mick Fleetwood (drums)
Additional personnel: Christine McVie (vocals, piano) uncredited
Chart position: UK No. 39, US No. 69

TRACK-BY-TRACK

THIS IS THE ROCK
A vintage-sounding piece of echo-laden rockabilly from Jeremy Spencer. His vocals even attempt an early Elvis impersonation at times.

STATION MAN
Co-written by Danny Kirwan, Jeremy Spencer and John McVie. Typical of the way Kirwan was influencing the direction of the band: a fine, beautifully produced track veering towards the US country rock emerging in the early 1970s.

BLOOD ON THE FLOOR
Another 1950s confection from Jeremy Spencer. An evocation of the kind of country schmaltz that the music's many critics delighted in citing, complete with sexual betrayal, murder, and capital retribution.

HI HO SILVER
Spencer's track takes its title from the refrain based on "Hi yo Silver" featured in the 1950s TV series *The Lone Ranger*. Previously, the song had been released many times as "Honey Hush," an R&B song originally written and recorded by the Kansas City blues shouter Big Joe Turner in 1953. Curiously, on the original release of *Kiln House*, the composer credit for the song cited 1930s piano star Fats Waller and Ed Kirkeby (Waller's manager). The mistake came from the fact that Waller—who died ten years before the Turner recording—released an entirely different song called "Honey Hush," back in 1939.

JEWEL EYED JUDY
Again, Kirwan joins song-writing forces with Fleetwood and McVie. A gentle ballad, in a contrasting groove to Spencer's tracks, which sounds clearly under the influence of Paul McCartney at his most wistful.

The first Fleetwood Mac album to feature Christine McVie as a permanent member of the band. She is only credited with creating the sleeve illustration for *Kiln House* as contractually she was still signed to Blue Horizon.

BUDDY'S SONG
Jeremy Spencer's tribute to Buddy Holly is a pastiche based on Holly's "Peggy Sue Got Married," with lyrics referencing other Holly titles. The song, along with various other Holly tribute numbers, was created by Holly's mother Ella Holley and is credited as such, though some references to the album wrongly cite it as a Fleetwood Mac original.

EARL GRAY
A somewhat pedestrian instrumental penned by Danny Kirwan, with the guitarist's lead taking centre stage.

ONE TOGETHER
Spencer taking a less derivative stance than he does on most of his tracks, on a lightly pitched love song which has the rest of the band joining in on harmonized backing vocals.

TELL ME ALL THE THINGS YOU DO
Danny Kirwan in tougher mood than on the rest of the album, the guitar breaks tailor-made for some hot dynamics when the number was performed live.

MISSION BELL
The overtly sentimental balled had reached No. 7 in the US *Billboard* chart in 1960, performed by the rockabilly singer Donnie Brooks. Another example of Spencer's fascination with rock 'n' roll's sometimes patchy past taking over from his original commitment to the blues. An odd finisher to the album, and one that drew into sharper focus the seeming lack of direction in the band, as Mick Fleetwood, John McVie—and now Christine McVie—found themselves in a pivotal position between the mainstream rock ambitions of Danny Kirwan, and the increasingly eccentric indulgences of Jeremy Spencer.

BELOW: *Christine McVie and Jeremy Spencer onstage at Reading University, UK, as part of Fleetwood Mac's* Kiln House *tour, December 14, 1970*

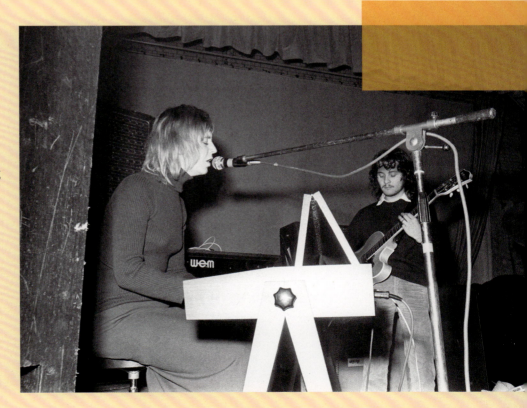

"They were in a strange situation where they were just beginning to be accepted in the States, but they had already been big stars in England and had gone down from there."

BOB WELCH

FUTURE GAMES

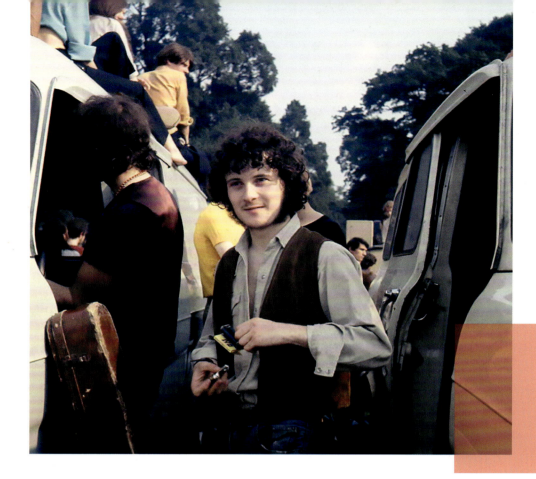

LEFT: *Jeremy Spencer, circa 1970*

The first track to feature Christine McVie as an official member of the band was "The Purple Dancer", on the B-side of "Dragonfly," recorded towards the end of 1970 and released in March 1971. Fleetwood Mac were once again barnstorming their way across America. The top side was written by Danny Kirwan, with his lyrics an adaptation of a poem by the Welsh poet W. H. Davies (most celebrated for his 1908 memoir *The Autobiography of a Super-Tramp*). It was the first Fleetwood Mac single to have appeared since Peter Green's exit from the band at the time of "The Green Manalishi," and just featured the trio of Kirwan, McVie, and Fleetwood. Christine's single debut also included Jeremy Spencer in the line-up, who by the time of its release had also quit the band—in the most bizarre of circumstances.

The American tour had begun on February 11, 1971, with four consecutive nights at the Fillmore Auditorium, San Francisco. Renamed the Fillmore West after promoter Bill Graham opened his counterpart Fillmore East in New York, the West Coast venue was one of the original catalysts of the rock and counterculture revolution centered on the Californian city since the late 1960s. The band were in good form from the start, and the audiences particularly receptive. *Kiln House* had done better in the US than any of their previous albums, getting widespread airplay, and things were looking good for the oncoming trek.

Following the four nights at the Fillmore, the band were scheduled to fly to Los Angeles for some sold-out gigs at the Whisky a Go Go club. The day before they were due to arrive, however, the city was hit by a big earthquake; everyone was alarmed, of course, but Jeremy Spencer—who was apparently enduring a poor recovery from a

recent use of the hallucinogenic drug mescaline—seemed traumatized by the event. He told Mick Fleetwood he simply didn't want to go, not just in light of the tremors but because, as he put it, the city had "bad vibes."

After the rest of the group persuaded Spencer there would be no problems for them in LA, they arrived at the Hollywood Hawaiian hotel as arranged, on February 15, the day they were to open at the Whisky. Almost immediately after checking in, Spencer said he was going to buy some reading matter at a local bookstore he was familiar with, just a short walk away on Hollywood Boulevard. It was only mid-morning, and when by six in the evening he still hadn't returned, the band decided to cancel that night's gig and inform the police.

The police reported back that an officer had indeed seen Spencer that morning, talking to some members of the messianic religious cult known as the Children of God. The quasi-Christian sect were notorious on the streets of LA (as were a variety of similar groups in the big cities of post-hippie America), accosting members of the public in the hope of enticing them to their headquarters. There, according to the police, potential converts were "brainwashed" into joining an evangelical "army."

Jeremy Spencer had always been a sincere Christian. In stark contrast to some of his extrovert antics on stage—the Elvis impersonations and so on—his reading matter when on tour with the band was more often than not the Bible. And when his wife Fiona had a second child—while they were living at Kiln House with the rest of the group—the couple would spend hours studying the scriptures and discussing Christian teaching. This religious resolve would, of course, have been severely tested during their enforced separation when the band were on tour. If what the LA police suggested was accurate, the guitarist could well have been a likely target for the cult's indoctrination.

They had been searching for their absent guitarist for four days, with his picture on local TV and a plea for information broadcast on radio, when a tip-off revealed the address of the cult's HQ in downtown LA. Manager Clifford Davis went straight there with one of the roadies, Phil McDonnell.

BELOW: *A Children of God pamphlet designed by founder and leader, David Brandt Berg (also known as King David, Mo, Moses David, Father David, Dad, or Grandpa)*

When they arrived at the dreary warehouse the sect called their headquarters, the pair were initially greeted by flat denials that Spencer was with them. When the cult leaders finally produced Jeremy (who was now only answering to the name Jonathan), Davis and McDonnell were shocked by his appearance. He was dressed in unkempt, ragged clothes, and his shaven head was a far cry from the curly hair familiar to fans and friends. When he addressed the two—speaking as if to strangers— he described that after engaging with cult members on the street, he was invited onto their bus, and that led to his finding a new way in life.

Ignoring pleas that this would jeopardize the tour, and the whole future of the band, Jeremy continued to insist that it mattered not, that he had seen the light. When Davis mentioned Spencer's wife and children, the reply was "Jesus will take care of them." It seemed very likely that they had lost Jeremy Spencer completely, and when they returned to the hotel and told the others, the band were absolutely devastated.

And it also dawned on them that if it was indeed the last they would see of the guitarist, then there was an immediate tour to consider. There were a string of dates under contract—if they canceled, with the enormous losses that would trigger, it would more than likely mean the end of Fleetwood Mac.

The only immediate way of avoiding financial collapse, the remaining band members soon figured, was by plugging the gap left by Jeremy Spencer with their other guitar deserter, Peter Green. As far as they knew, their old colleague (and founder of the band) had retired from the music business, but in desperation they delegated Clifford Davis to perform the unenviable task of approaching their former guitarist. Not surprisingly, Peter was hesitant at first, but agreed as long as he could bring his friend Nigel Watson (as it happened, Clifford's brother-in-law) to play congas on stage with the band. The pair arrived in LA two days later, and played their first gig on the re-scheduled tour the same night, at the Swing Auditorium in San Bernardino.

With Green unfamiliar with most of the band's current stage repertoire, much of it being material from *Kiln House*, for the rest of the tour the band reverted to songs like "Black Magic Woman" and other crowd-pleasing standards from their vintage past, and a considerable amount of blues-based jamming. Peter Green—while insisting he be billed as "Peter Blue" for the tour—excelled himself, to the delight of the rest of the band. And audiences were equally enthusiastic, with the near-doomed tour turning out to be Fleetwood Mac's most financially successful US trip yet.

Nevertheless, once they were back in England the band were once again faced with the problem of finding a new guitarist. As far as the band's stability was concerned, it seemed that as one crisis was solved, another raised its head. In an interview in the *New Musical Express*, Christine spoke for the whole group: "Over the past year, it seems as if we have just been battered and beaten about the head with a giant club." Both Christine

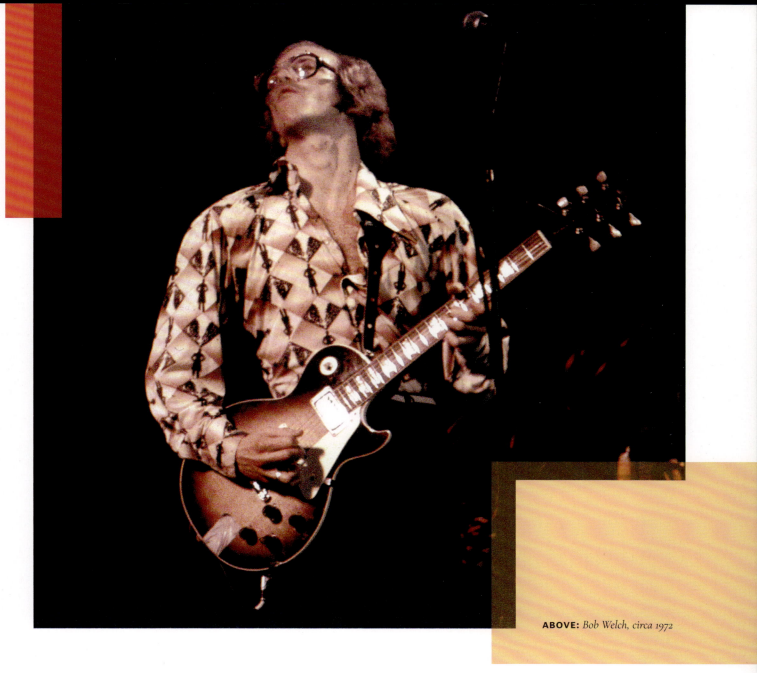

ABOVE: *Bob Welch, circa 1972*

and Danny concurred with Mick and John, that they needed that third instrumental contribution (including, ideally, a songwriter).

BOB WELCH

Bob Welch was born on August 31, 1945, in Los Angeles. He played on the West Coast R&B scene through the mid-1960s with an outfit called the Seven Souls, and when they disbanded in 1969 he traveled to Europe as part of a trio, Head West. By the spring of 1971, they too had wound things up, leaving Welch without a band and little prospect, chancing his luck—to no great success—in Paris. When an old high school friend, Judy Wong, rang him to tell him that Fleetwood Mac were looking for a guitarist, and she could arrange a meeting, he leapt at the chance.

Wong was a good friend of the band from San Francisco who'd since moved to England when she married Glenn Cornick. He was the bass player with Jethro Tull,

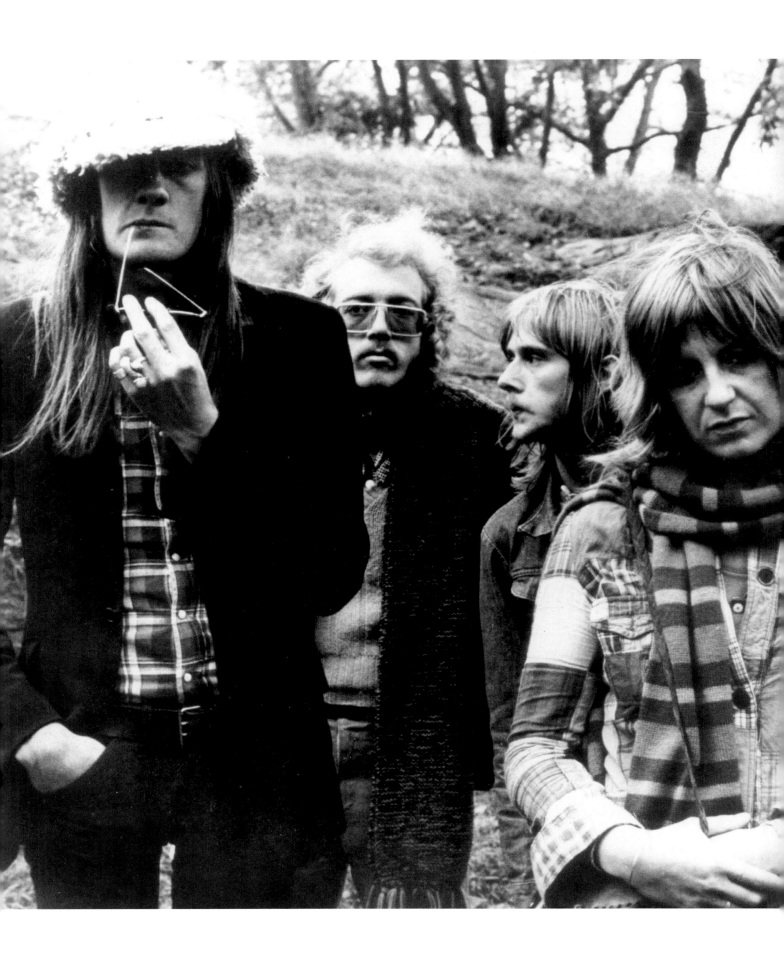

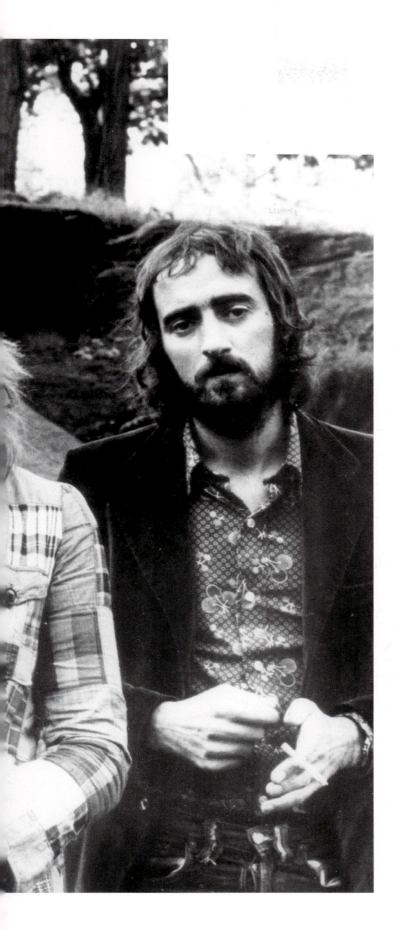

> "For the first few months all we did was socialize—just drink tea and talk about how weird the world was, a lot of that. Ultimately, we just started playing."
>
> BOB WELCH

Fleetwood Mac's buddies from the UK blues scene. An audition with Welch was arranged at Benifold, the grand, twentieth-century century mansion that the band had bought after the lease on Kiln House expired at the end of 1970.

Initially Welch just hung out with what remained of Fleetwood Mac, to see if things gelled, as he recalled in *Creem* magazine in 1978: "They had a great, big, sixteen-room old house south of London and I went over there and met everybody and just sort of hung out. Everybody lived in the house—the whole band, the road crew—one of those trips. We just hung around for months. It was almost a semi-hippie, communal situation. For the first few months all we did was socialize—just drink tea and talk about how weird the world was, a lot of that. Ultimately, we just started playing."

The band didn't offer him the job right away, but certainly liked his playing. Danny and Christine were particularly interested in hearing some of the material Welch had written, and in late April 1971—after his third visit to the communal mansion—he was offered the job.

From the beginning of June 1971 to the end of July, Bob Welch underwent a rigorous initiation, playing clubs,

LEFT: *Fleetwood Mac, circa 1971. L–R: Mick Fleetwood, Bob Welch, Danny Kirwan, Christine McVie, and John McVie.*

colleges, and dance halls on the UK gig circuit. Welch was having to learn whatever the band chose from their back catalogue, alongside new material which they were trying out on audiences for the first time. He was fitting in well with the rest of Fleetwood Mac, and they even tried out some of Bob's own material when they began recording *Future Games*, in the middle of June, in preparation for release in early September

With both Peter Green and Jeremy Spencer now part of the band's history, the new album—the sixth by Fleetwood Mac—represented a very deliberate step away from their original blues base, and into more melodic, mainstream territory. It had been a long process and would be essential to their future success, especially in the USA. And the presence of Bob Welch at this stage would be key to that evolution in the band's music.

On its release on September 3, 1971, *Future Games* failed to make much of an impression in the UK, but aided by an American tour that began a few weeks later, it did rather better on that side of the Atlantic. It made it to US No. 91—not a sensational break-through by any means, and chart-wise a drop from the No. 69 position achieved by *Kiln House*. But its greater success in the American market was a sign of the times for the band, which Welch would acknowledge: "When I joined Peter had been gone for a year, and Jeremy had just left, and they were in a strange situation where they were just beginning to be accepted in the States, but they had already been big stars in England and had gone down from there. So most of the work we did from the time that I was in was in the States."

Future Games earned the band their first-ever US Gold disc, and was met by generally favorable reviews—though not universally. Loyd Grossman, reviewing the album in *Rolling Stone*, described it as "a thoroughly unsatisfactory album," going on to conclude his scathing dismissal: "If Fleetwood Mac have tried to make the transition from an energetic rocking British blues band to a softer more 'contemporary' rock group, they have failed."

FUTURE GAMES

Side one
Woman Of 1000 Years [Danny Kirwan]
Morning Rain [Christine McVie]
What A Shame [Bob Welch, Danny Kirwan, Christine McVie, John McVie, Mick Fleetwood]
Future Games [Bob Welch]

Side two
Sands Of Time [Danny Kirwan]
Sometimes [Danny Kirwan]
Lay It All Down [Bob Welch]
Show Me A Smile [Christine McVie]

Recorded: June-August 1971, Advision Studios, London
Released: September 3, 1971
Label: Reprise
Producers: Fleetwood Mac
Personnel: Danny Kirwan (vocals, guitar), Bob Welch (vocals, guitar), Christine McVie (vocals, keyboards), John McVie (bass guitar), Mick Fleetwood (drums, percussion)
Additional personnel: John Perfect (saxophone) on "What a Shame"
Chart position and awards: US No. 91, Gold disc

TRACK-BY-TRACK

WOMAN OF 1000 YEARS
A full-bodied acoustic guitar intro brings in a multi-tracked vocal, led by the song's composer Danny Kirwan. A totally atmospheric track that fans still believe is underrated.

MORNING RAIN
A Christine McVie song. Some funky keyboards bring in a smooth slice of West Coast soft rock. New man Bob Welch adds to the instrumental energy. Again, close harmony vocals evoke the sound of the early 1970s.

WHAT A SHAME
After the record company said they wouldn't release the album with just seven tracks, this hastily contrived instrumental jam made up the numbers. The honking saxophone was provided by Christine's brother, John Perfect.

FUTURE GAMES
The eight-minute-plus title track written by Bob Welch. More laid-back rock that distances the band from their blues group origins, with Welch's guitar to the forefront. He later re-recorded the song for his 1979 solo album *The Other One*, while this version cropped up in the 2000 movie *Almost Famous*.

SANDS OF TIME
Over seven minutes long, Danny Kirwan's song was released as a single in America and some other territories (excluding the UK) in a strictly edited version, making no impression sales-wise. From its fade-in intro, it's another example of Kirwan's injection of melodic storytelling into the band's increasingly easy-on-the-ear music.

SOMETIMES
Kirwan fronts the vocals again, with a slice of hummable, but ultimately forgettable, mainstream rock.

LAY IT ALL DOWN
Another Bob Welch original. Heavier than most of the collection, an insistent riff backs the guitarist's strident vocals, while Mick Fleetwood and John McVie sound like the good-time rhythm section of old.

SHOW ME A SMILE
Christine McVie's contribution as songwriter and lead vocalist. The contrast of light and shade from verse to chorus gives the number a welcome structural dynamic, lacking in some of the album's more laid-back pieces.

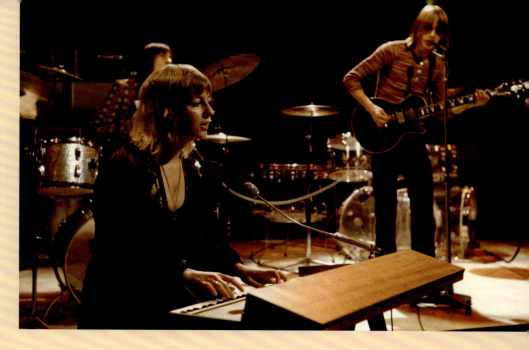

ABOVE: *Christine McVie, Mick Fleetwood, and Danny Kirwan on the set of* Top of the Pops, *London, 1971*

> "A thoroughly unsatisfactory album. If Fleetwood Mac have tried to make the transition from an energetic rocking British blues band to a softer more 'contemporary' rock group, they have failed."
>
> LOYD GROSSMAN, *ROLLING STONE*

"Peter Green most definitely haunted them. It was never expressed in so many words, I would have been more happy if it had been."

BOB WELCH

BARE TREES

From the start, during his auditions at Benifold, Bob Welch was aware of the trauma caused by the departure within a year of both Peter Green and Jeremy Spencer. The loss of Peter Green in particular, with the blues band legacy he represented, seemed to Welch to have a lingering influence on Fleetwood Mac's collective psyche.

Green's enormous effect on the background of the band was confirmed when, in November 1971—while they were winding up the American tour—CBS released *Greatest Hits*, the first such collection by Fleetwood Mac. Tellingly, of the twelve tracks featured, nine were written by Peter Green. And in the US, their first two American albums were re-released as a two-disc set entitled *Black Magic Woman*.

Meanwhile, not long after the release of *Future Games* in September 1971, another US tour commenced, seeing Fleetwood Mac on the road coast-to-coast through to the end of the year. By now the band were firmly established as bill-toppers on the American concert circuit, with the likes of Van Morrison opening for them.

And as if to underline that the band's immediate horizon lay to the west of the UK, in December an edited single of "Sands of Time" from *Future Games* was released for the US market but not in the UK. The single, which was drastically cut from its original seven minutes and twenty-four seconds to just three minutes, featured Bob Welch's "Lay It All Down" (another from the album) on the B-side. Also released in New Zealand and elsewhere, the single made no mark in the charts.

OPPOSITE: *John McVie, 1972*

BELOW: *A vintage vinyl record sleeve of Fleetwood Mac's Greatest Hits, 1971*

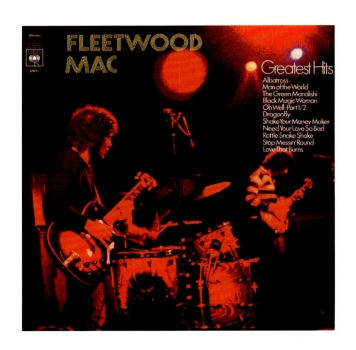

For Bob Welch, of course, the fall US tour constituted a triumphant homecoming; after scrabbling round for work in Paris just a few months earlier, he was now with a Gold disc-winning band whose future seemed generally on the up-and-up. Although, as the newcomer to the band, he was particularly sensitive to relations within the group becoming strained as the tour progressed.

For Christine and John McVie, the basic life on the road posed its own problems for a young married couple trying to have a normal relationship. Living out of suitcases from hotel room to hotel room, with just the band and crew for regular company, could cause the not infrequent flare-up. Christine was becoming

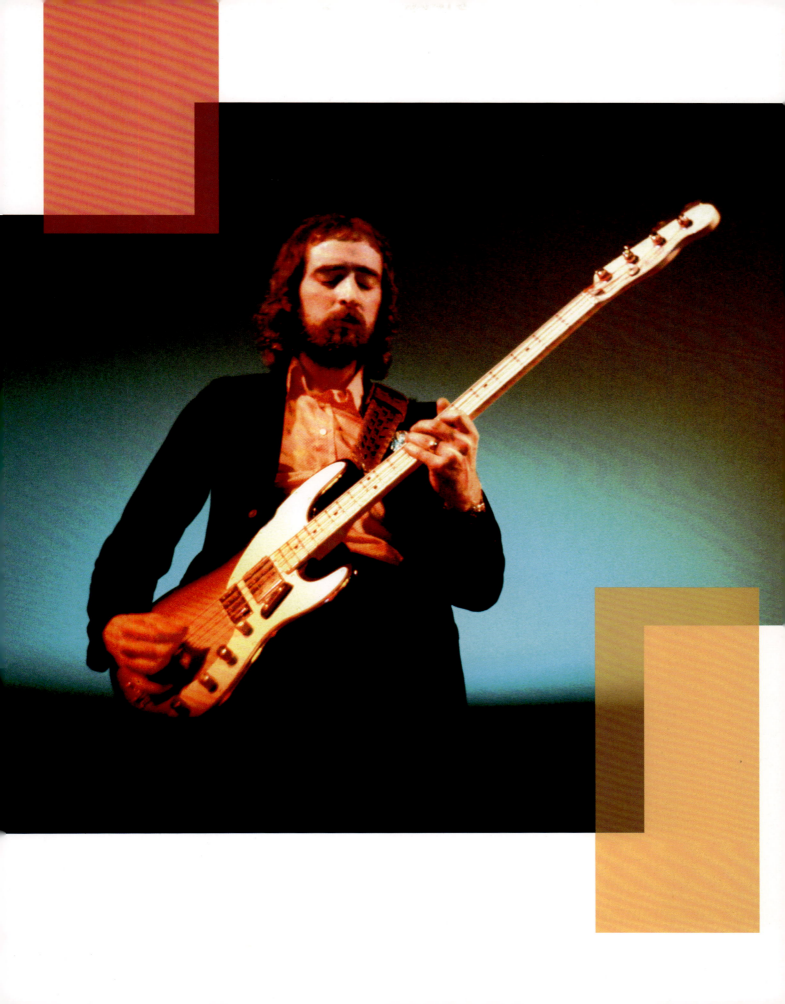

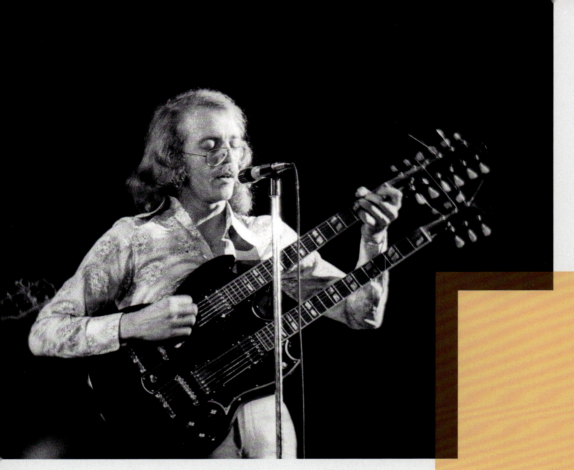

Bob Welch (left) and Danny Kirwan (right); friction between the two is a problem for the band

concerned about John's heavy drinking. Mick meanwhile would, as always, try to keep the peace—his prime function, in addition to his role behind the drum kit, seemed to be to keep the boat on an even keel, no matter how turbulent the waters around them.

Likewise, Mick would play the peacemaker when friction between Welch and Kirwan became apparent. Bob Welch was becoming visibly frustrated by Danny Kirwan's general attitude; the latter would frequently miss rehearsals, spending more time practicing and song-writing alone. But when Welch told the others he couldn't work with Kirwan any longer, Christine and Mick rose to Danny's defense—despite the latter having increasingly worrying problems with both drugs and drink, the alcohol being of greater concern as time went on.

Following the US tour, a string of UK dates kept the band busy through to the end of February 1972, while at the same time allowing Fleetwood Mac enough time in the studio to lay down the material for their next album, *Bare Trees*.

Recording (apart from the final track) took place at the De Lane Lea studios in Wembley, west London. With five of the ten tracks written by Danny Kirwan, in many ways it was his finest hour with the band. From the quasi-biographical opener "Child of Mine" to the melancholy of the penultimate song "Dust," Kirwan shines as the prominent voice in the band at that moment.

As Bud Scoppa enthused in his *Rolling Stone* review, "With his multiple skills, Kirwan can't help being the focal point. It is his presence that makes Fleetwood Mac something more than another competent rock group. He gives them a distinctiveness, a sting. He makes you want to hear these songs again." But as things transpired, it was also Danny Kirwan's swansong.

More so than the downbeat *Future Games*, the album represented the point where Fleetwood Mac finally broke with their blues-based past, identifying instead with the early-1970s style of singer-songwriter rock. And the stark cover photograph of barren trees in the mist of winter, taken by John McVie, reflected the theme of both the title track, and the closing poem "Thoughts on a Grey Day."

Like the band's previous album, *Bare Trees* failed to chart in Fleetwood Mac's home market, but it debuted on the US *Billboard* chart at No. 175 in late April, and peaked seven weeks later at No. 70. One of the bands most consistent sellers over time, the album was certified Platinum in 1988, having sold over a million copies in the United States.

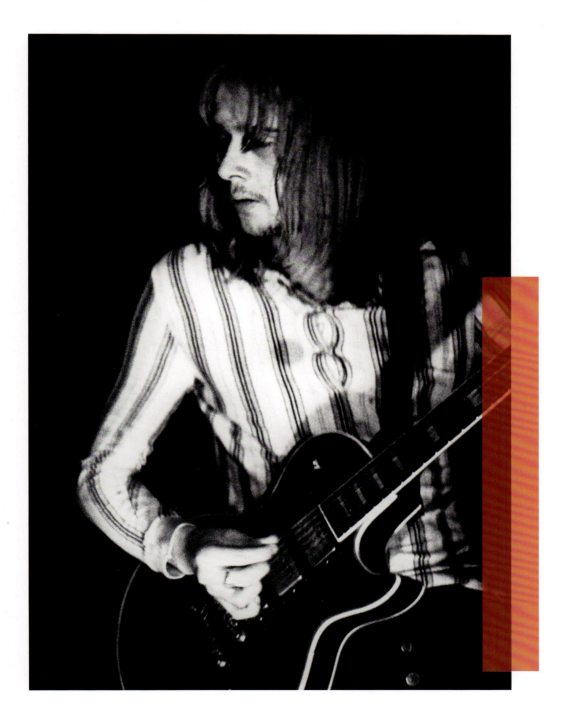

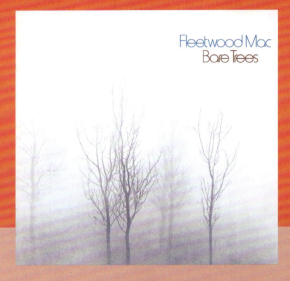

BARE TREES

Original vinyl edition

Side one
Child Of Mine [Danny Kirwan]
The Ghost [Bob Welch]
Homeward Bound [Christine McVie]
Sunny Side Of Heaven [Danny Kirwan]

Side two
Bare Trees [Danny Kirwan])
Sentimental Lady [Bob Welch]
Danny's Chant [Danny Kirwan]
Spare Me A Little Of Your Love [Christine McVie]
Dust [Danny Kirwan]
Thoughts On A Grey Day [Scarrott]

Recorded: January-February 1972, De Lane Lea Studios, London (final track at Mrs Scarrot's home in Hampshire)
Released: March 1972
Label: Reprise
Producers: Fleetwood Mac
Personnel: Danny Kirwan (vocals, guitar), Bob Welch (vocals, guitar), Christine McVie (vocals, keyboards), John McVie (bass guitar), Mick Fleetwood (drums, percussion)
Additional personnel: Mrs Scarott (poetry reading)
Chart position and awards: US No. 70, Platinum disc

TRACK-BY-TRACK

CHILD OF MINE
A straight-ahead country rock song from Danny Kirwan opens, with lyrics a tad more personal than the jaunty delivery evokes. In fact, the song references Kirwan never being in a meaningful contact with his biological father, Kirwan being the name of his stepfather.

THE GHOST
The first of only two songs from Bob Welch. A lightly textured performance by all concerned, which Welch later re-recorded for his 2006 album *His Fleetwood Mac Years and Beyond, Vol. 2*.

HOMEWARD BOUND
The first genuinely powerful track on the album, Christine McVie delivers the vocals—declaring her antipathy to touring, and flying in particular—with a tough confidence matched by her purposeful keyboard breaks.

SUNNY SIDE OF HEAVEN
An effective instrumental penned by Danny Kirwan, demonstrating the highly personal guitar style which went a long way to earning him a place in the Mac line-up in the first place.

BARE TREES
One of two songs by Kirwan gleaned from the spoken-word poem that features at the end of the album. While the lyrics pertain to the ominous notions of age and ultimate mortality, the upbeat treatment is delivered with an almost optimistic pitch.

SENTIMENTAL LADY
Despite some lightweight lyrics, an enjoyable love song from Bob Welch, which he originally wrote for his first wife Nancy. His re-recording from his solo album *French Kiss*, released in 1977, was the best-known version of the song.

> "With his multiple skills, Kirwan can't help being the focal point. It is his presence that makes Fleetwood Mac something more than another competent rock group. He gives them a distinctiveness, a sting. He makes you want to hear these songs again."
>
> BUD SCOPPA, *ROLLING STONE*

That version, which made it to the Top Ten singles chart in America, featured backing assistance from Mick Fleetwood, Christine McVie, and (by then Fleetwood Mac guitarist) Lindsey Buckingham.

DANNY'S CHANT
An instrumental (save for the non-verbal backing chants) from Danny Kirwan, featuring some in-your-face wah-wah pedal guitar effects that verge on the gimmicky.

SPARE ME A LITTLE OF YOUR LOVE
An early hint of the song-writing talents of Christine McVie which would bear fruit in the years that followed. The number was a regular inclusion in the band's concert repertoire from 1972 to 1977, with reviewers at the time drawing comparisons of Christine's vocals with the style of Dusty Springfield.

DUST
Although not credited as such on the album, Danny Kirwan's heartfelt-sounding lyrics were actually taken from a somber poem about death by Rupert Brooke, written in 1910. The melancholy treatment is complemented by the smooth sound of Kirwan's languid guitar backing, almost in anticipation of the final, evocative track

THOUGHTS ON A GREY DAY
Not a Fleetwood Mac performance, but the intimate recording of an elderly lady, Mrs Scarrott, who lived near the band's country base of Benifold. Recorded at her home, primarily by Mick Fleetwood, it's a delightfully reflective poem evoking the "bare trees" of the album's title.

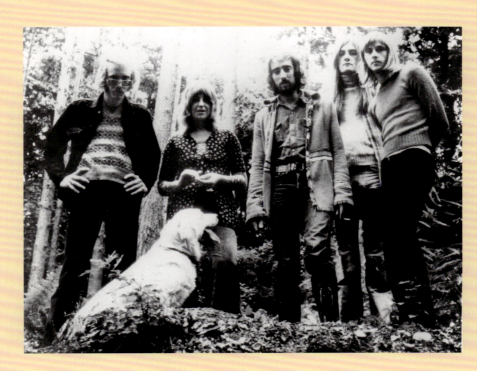

BELOW: *L-R: Bob Welch, Christine McVie, John McVie, Mick Fleetwood, and Danny Kirwan, circa 1971*

"Fleetwood Mac had always been a collaboration. It was rather bizarre to now have a stereotypical 'lead singer.'"

MICK FLEETWOOD

PENGUIN

With the USA now very much the band's regular touring base, in 1972 they made two trips to America and Canada, the first from late February through the spring to the end of May. During the trip, they played some dates as part of a package show under the banner "The British are Coming," headlined by the UK blues outfit Savoy Brown, and also featuring (below Fleetwood Mac on the bill) the London R&B vocalist Long John Baldry. Both bands impressed the Mac, particularly Savoy's lead vocalist Dave Walker, and Baldry's young guitarist Bob Weston, who would both feature in a yet another Fleetwood Mac shake-up later in the year.

During the second North American trek, that opened on August 14, things finally came to a head as far as Danny Kirwan's place in the group was concerned. It was becoming increasingly apparent that he was not ideally suited to the on-the-road, rock 'n' roll lifestyle, with his behavior becoming increasingly irksome. Danny now began to grate on the rest of the band, not just with Bob Welch. His constant criticism and negative attitude didn't sit well with any of them, and while the diplomatic Mick Fleetwood had long been giving Kirwan the benefit of the doubt, he too was despairing of the guitarist's influence on group morale. "Danny had been a nervous and sensitive lad from the start . . . He was never really suited to the rigors of the business. Touring is hard and the routine wears us all down."

Even so, all present were taken by surprise during an early date in the tour, as a wrangle backstage between Kirwan and Welch quickly escalated.

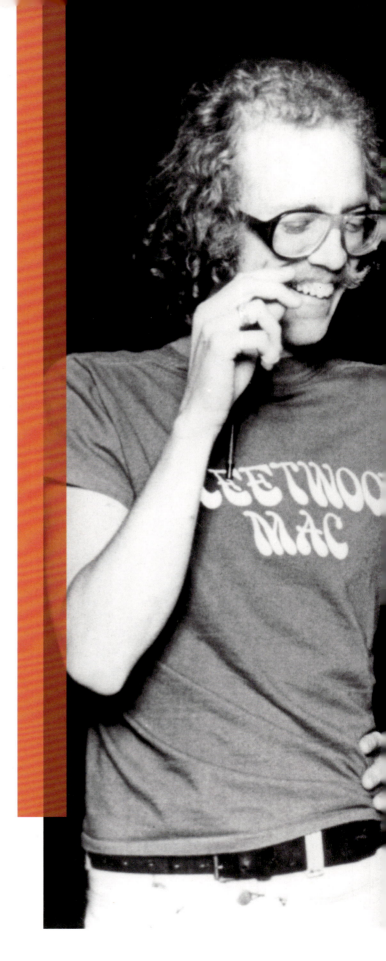

RIGHT: *The departure of Kirwan makes Fleetwood Mac a foursome once more . . . although not for long*

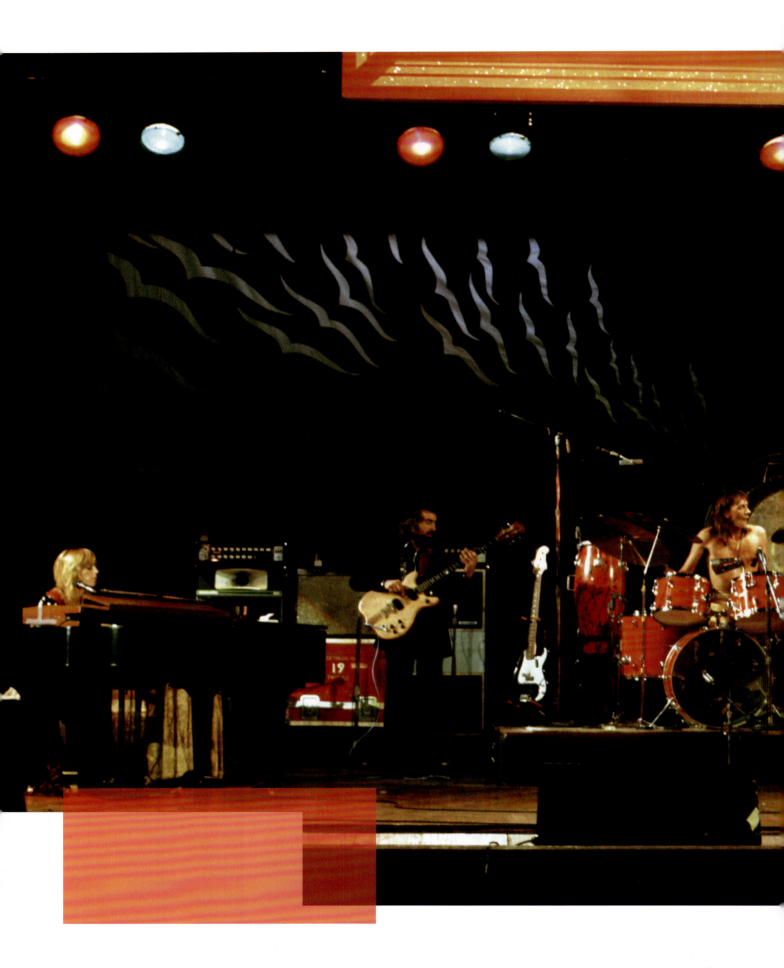

"We all felt a blow-up was brewing, but we didn't expect what happened . . ." Mick recalled. "We were sitting backstage waiting to go on. Danny was being odd about tuning his guitar. He went off on a rant about Bob never being in tune . . . He got up suddenly . . . and bashed his head into the wall, splattering blood everywhere. I'd never seen him do anything that violent in all the years I'd known him. The rest of us were paralyzed, in complete shock. He grabbed his precious Les Paul guitar and smashed it to bits. Then he set about demolishing everything in the dressing room as we all sat and watched."

Kirwan refused to go on stage, sitting at the mixing desk and hurling abuse at them while they struggled through their set without him. Welch recalled it as one of the most difficult (and embarrassing) gigs he'd ever had to play and back at the hotel the band agreed that it was time for Danny to go. With Clifford Davis back in the UK, it was down to Mick Fleetwood to tell Kirwan that, by mutual agreement, he was sacked.

Some months later Fleetwood voiced his appreciation of Kirwan's contribution, while concluding that the guitarist's presence—personal tensions aside—didn't always create the best musical environment for the rest of the band: "Danny Kirwan was a very strict writer. As his songs were so set, there was only one way to play them, which isn't as rewarding for the other members in the band. Now it's more rewarding for those that don't write because there's room to do things with arrangements."

And despite his fractious relationship with Kirwan, Bob Welch would concede that the guitarist was a talented player: "Danny Kirwan was a wonderful musician," Welch told an online fan site in 1999, "and we

LEFT: *Fleetwood Mac performing onstage, Los Angeles, California, 1973*

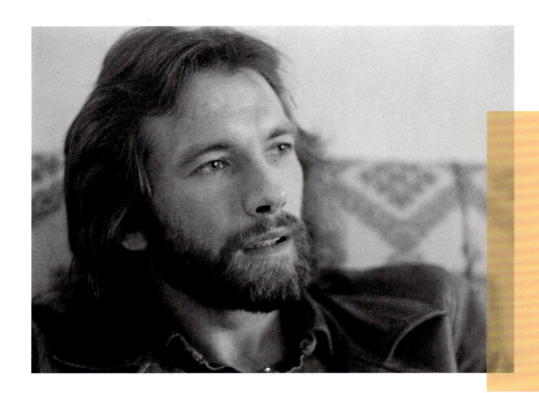

New recruits Dave Walker (left) and Bob Weston (right)

had no problem there at all. It was just his personality (he was 'ill' I think, even then). In the end, Danny was making all of us feel very uncomfortable. But he was a talented, gifted musician, almost equal to Pete Green in his beautiful guitar playing and faultless string bends."

In a rare interview for the UK's *Independent* newspaper in 1993, Kirwan admitted, "I was lucky to have played for the band at all . . . I did it for about four years, to about 1972, but I couldn't handle the lifestyle and the women and the traveling." At the time of this interview, his life had deteriorated to the point where he was living in a hostel for the homeless in central London.

WALKER AND WESTON

With the rest of the tour canceled, the band headed home to the UK to decide what their next step would be. After their previous setbacks, the McVies, Fleetwood, and Welch were determined that this certainly wouldn't mean the end of the band. After some intensive discussion with Clifford Davis, they decided to look for a specific lead vocalist, rather than having two guitarists and Christine handling all the vocals.

Their thoughts turned to the Savoy Brown singer Dave Walker, who had made an impression on them during the "British are Coming" dates early in the year, with his forceful, blues-based voice and strong stage presence. Walker, who it turned out wasn't happy with his deal with Savoy Brown, accepted their invitation immediately.

During the decision-making process, the band realized they still needed two guitar players to achieve the sound they wanted. With that in mind, they were also on the lookout for a direct replacement for Kirwan—bringing the group line-up to a six-piece. Their thoughts immediately returned to the package concerts from their springtime tour,

> "I was lucky to have played for the band at all...but I couldn't handle the lifestyle and the women and the traveling."
>
> DANNY KIRWAN

and Long John Baldry's guitarist Bob Weston—who, like Dave Walker, didn't need to be asked twice.

The band rehearsed with the new recruits for a month or so at Benifold, before embarking on a short tour of Norway and Sweden. The gigs were well received, with audiences accepting the stage dynamic including a lead vocalist. The two newcomers, however, were very conscious of feeling like "the new boy at school," as Bob Weston would later recall. And the change in the internal balance of the band didn't sit easily with the long-term veterans—Christine, John, and Mick—though they didn't necessarily recognize it immediately. As Mick would describe in his autobiography, "Fleetwood Mac had always been a collaboration. It was rather bizarre to now have a stereotypical 'lead singer'."

At the time, Dave Walker didn't see his place on stage as being anything but satisfactory, for both himself and the rest of the group: "On performances I'm not the front man" he'd tell *New Musical Express* "I'm just another guy in the band—just another member. We all work together and we'll all do our little bits. If one of us goofs there are no terrific inquests after the gig. Generally the feeling in the band is very, very relaxed. We all try and help each other. No one takes anyone else for granted."

Back in the UK after the Scandinavian trip, through

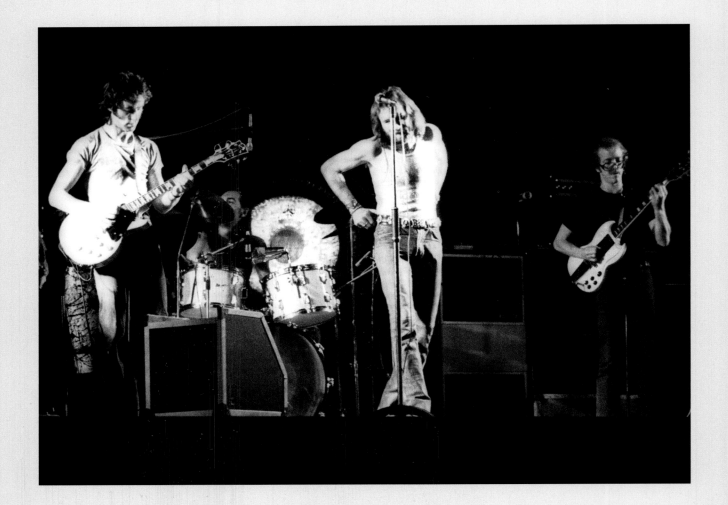

ABOVE: *Fleetwood Mac perform live onstage at Newcastle City Hall, UK, May 1973. Pictured are (L-R): Bob Weston, Mick Fleetwood, Dave Walker, and Bob Welch.*

January 1973 Fleetwood Mac began recording their seventh studio album, which would be called *Penguin*. For the sessions, rather than using a regular studio they utilized the Rolling Stones' mobile studio, parked in the grounds of their Hampshire mansion.

Despite some noteworthy moments—including Christine's splendid "Dissatisfied," and an uncredited appearance by Peter Green on Bob Welch's "Nightwatch"—the album, released in March 1973, simply didn't hold up as a coherent reflection of the band as it stood at that point in time. Crucially, Dave Walker's contribution, with the singer appearing on only two tracks, was hardly representative of his presence at live gigs.

His absence was indicative of doubts emerging with the rest of the band about having recruited a lead singer in the first place. They all agreed he was a good front man, but Fleetwood Mac had done without *any* front man up to now. And on record, his vocal contribution was workmanlike, but didn't add anything special to the overall sound of the band.

Of course, at the time of the album's release no such doubts were voiced, not publicly at least. As Mick Fleetwood (as the band's main spokesman and ever the diplomat) rationalized to Barbara Charone in the pages of *New Musical Express*: "On future albums we're going to try and come off more as a band rather than three separate entities vocally. Instead of Dave singing a song alone—and then Christine—we'd like to feature them together . . . Dave is a vocalist; he can't stand around all night doing nothing so

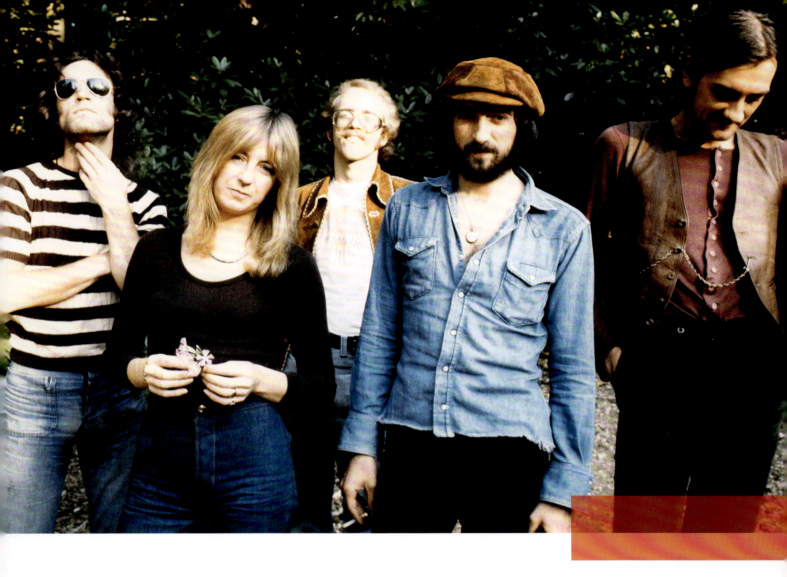

we've got to use him. To a certain extent, though, we've found that a little bit difficult. We haven't quite furthered ourselves as much as we'd like to. In that way the material on the album is not as well integrated as we'd like."

But whatever reservations Fleetwood and the others might have been nurturing regarding Dave Walker, the immediate result—aided by another American tour right after the album's March release date—was their most successful US chart performance yet, nudging into the Top 50 at No. 49.

The cover art was of significance, featuring as it did the penguin image which had become something of a mascot for the band. The first appearance of the bird in Fleetwood Mac iconography was on the back cover of 1971's *Future Games*, when John McVie used it to replace a picture of himself. And its history goes back to when John and Christine lived near London Zoo, before moving to Kiln House with the rest of the band. As a member of the Zoological Society, John had frequently photographed the penguins at the zoo, and since then the symbol has appeared on Fleetwood Mac material throughout their career.

Back on the road in America, the tensions between Dave Walker and the rest of the band were becoming more apparent. Night after night the lead singer did what lead singers were supposed to do, taking control of the stage and electrifying audiences in the process. But Mick, John, and Christine in particular, were having to admit that,

ABOVE: *Fleetwood Mac, September 1973*

logically, it also relegated the rest of them to the role of backing group—certainly not what Fleetwood Mac was ever about. And as the atmosphere between Walker and the rest of the band became more fraught, so the singer's heavy drinking became more problematic.

Meanwhile back in the UK, their ex-label boss Mike Vernon had managed to re-release their 1968 hit "Albatross" and, while the band were crisscrossing America in April 1973, the single hit the No. 2 spot on the British charts. And when BBC TV aired an old clip of the band performing the song on their top music show *Top of the Pops*—featuring Peter Green on guitar—the host announced that Fleetwood Mac had now broken up! A sure sign that while they were on a roll to success in the United States, the band were in danger of being virtual has-beens in their home country.

On their return to the UK in early May, after a few concerts around the country they once again hired the Rolling Stones' mobile recording studio to start their next album. But very soon, the matter of Dave Walker's future finally came to a head. The singer's drinking was becoming more of a problem, with him spending more time in the local pub (accompanied by John McVie more often than not) than in the studio; Mrs McVie, meanwhile, would be working with Bob Welch on possible material for Walker to sing on the new album.

Finally, Christine, Mick, and John met with manager Clifford Davis, insisting that the singer had to go, and as manager he should be the one to do the firing. Reluctantly, Davis agreed, despite still feeling that a prominent lead vocalist was what the band needed. It was June 1973, and for the second time in less than a year Fleetwood Mac had to let a member go. So for the new album, *Mystery to Me*, they were once more operating as a five-piece.

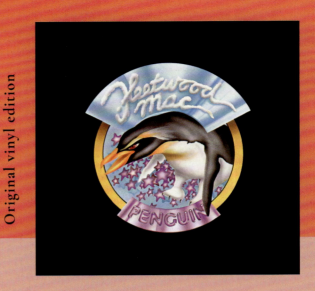

Original vinyl edition

PENGUIN

Side one
Remember Me [Christine McVie]
Bright Fire [Bob Welch]
Dissatisfied [Christine McVie]
(I'm A) Road Runner [Brian Holland, Lamont Dozier, Edward Holland Jr.]

Side two
The Derelict [Dave Walker]
Revelation [Bob Welch]
Did You Ever Love Me [Christine McVie, Bob Welch]
Night Watch [Bob Welch]
Caught In The Rain [Bob Weston]

Recorded: January 1973, Rolling Stones Mobile Studio
Released: March 1973
Label: Reprise
Producers: Fleetwood Mac, Martin Birch
Personnel: Bob Welch (vocals, guitar), Bob Weston (vocals, guitar), Christine McVie (vocals, keyboards), Dave Walker (vocals, harmonica), John McVie (bass guitar), Mick Fleetwood (drums, percussion)
Additional personnel: Steve Nye (organ, steel drums), Ralph Richardson (percussion), Russell Valdez (percussion), Fred Totesant (percussion), Peter Green (guitar) uncredited
Chart position: US No. 49

TRACK-BY-TRACK

REMEMBER ME
A short, lively opener courtesy of Christine, with some solid (albeit workmanlike) guitar from Bob Welch. Released as a single, it failed to make the charts in any part of the world.

BRIGHT FIRE
Bob Welch dominates on lead vocals on his composition. Smooth sounding, and characteristic of the "adult rock" direction the band seemed to be heading for at the time.

DISSATISFIED
Another memorable song from Christine which lifts things considerably. A portent of things to come with the multi-tracked vocals that would add up to a distinctive Mac sound a little further down the line.

(I'M A) ROAD RUNNER
An odd choice to highlight the talents of vocalist Dave Walker, one of only two tracks on the album to do so. A cover of the 1966 Motown classic by Jr Walker & The All Stars, which also features Dave Walker on harmonica in an unlikely nod to Fleetwood Mac's past (and indeed his own in Savoy Brown) as part of the Brit blues boom.

THE DERELICT
The other Walker track on the collection, adding up to a surprisingly limited contribution for a lead singer. Written by Walker, the folksy-tinged song features guitarist Bob Weston on both banjo and harmonica.

REVELATION
Bob Welch features on another self-penned track, with some grandstanding lead guitar which nevertheless adds up to nothing much more than an indulgence.

DID YOU EVER LOVE ME
A standout track co-written by Christine McVie and Bob Welch, and also released as a single which made little impression sales-wise. Christine shares the lead vocals with the other Bob (Weston), again in a hint at what would be a classic Mac format in years to come.

NIGHT WATCH
Penned by Bob Welch, reflecting the close harmony sound of much early 1970s US rock. There's some sparkling guitar towards the end by none other than Peter Green, presumably persuaded to come in and jam in the (mobile) studio, but uncredited on the album cover.

CAUGHT IN THE RAIN
Bob Weston ends the album with an effective acoustic guitar piece, a languid instrumental which is enhanced by some evocative, non-verbal backing vocals. But for long-term Fleetwood Mac fans, an anti-climax to an album that seems waiting for a lift throughout, and never quite achieving it.

> "On future albums we're going to try and come off more as a band rather than three separate entities vocally...we've found that a little bit difficult. In that way the material on the album is not as well integrated as we'd like."
>
> MICK FLEETWOOD

"For years I had been more married to Fleetwood Mac than to her."

MICK FLEETWOOD ON JENNY BOYD

MYSTERY TO ME

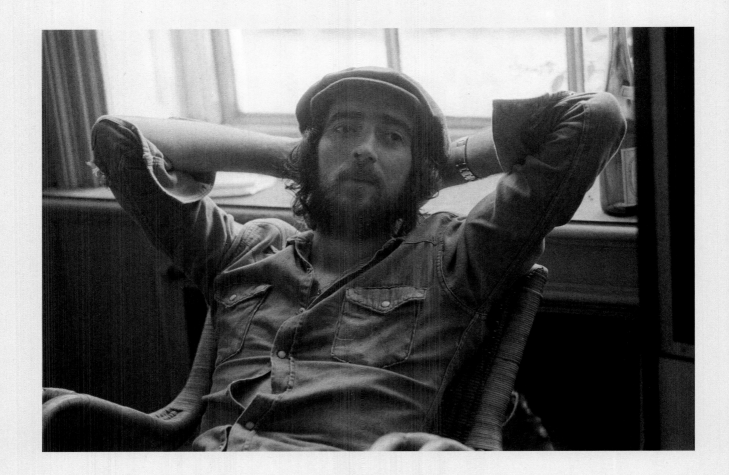

John (above) and Christine McVie (opposite). Cracks are starting to show in their marriage, but both agree to stay together for the sake of the band.

When Dave Walker was made redundant, the band had already begun sessions for the next album. But the singer didn't feature on any of the tracks on the final release, although initially Christine McVie and Bob Welch had been working on new material with him in mind. The resulting flavor of *Mystery to Me* was consequently another step in the direction of the easier-listening, "album-oriented" rock that would be the key to Fleetwood Mac's enormous success a few years later.

But by that summer of 1973, while the band were laying down *Mystery to Me*, Christine and John McVie's marriage had reached a crisis point. As Christine would later comment, being in the same band as your partner could be the "kiss of death" for a relationship. John's drinking didn't help things, and their proximity to each other, twenty-four-seven, resulted in frictions that might not have occurred in more conventional circumstances.

It was also common knowledge among the residents of Benifold that Christine was having an affair with the group's recording engineer—and now co-producer on their records—Martin Birch. When Fleetwood Mac set off on their next American tour in the September, there was a tacit agreement between John and Christine that, in the interest of the band, they would carry on as normal, as far as possible. The couple would co-exist on that level for another two years or so, before eventually getting divorced in 1976.

A potentially far more serious crisis was on the horizon, however, when Mick Fleetwood learned that his wife Jenny was having an affair with guitarist Bob Weston. Mick and Jenny Boyd had married three years earlier; the professional model was the

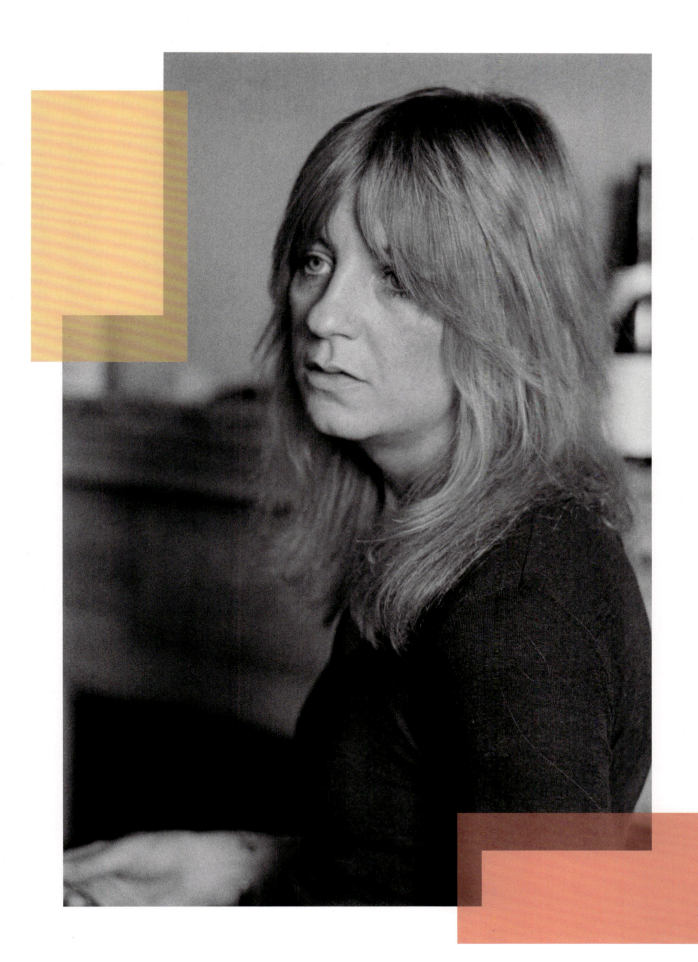

sister of Pattie Boyd (then the wife of George Harrison), and very much part of the trendy London scene. But being married to a dedicated musician like Mick had its downside, and even when Fleetwood Mac wasn't on tour he would admit the band took priority: "For years I had been more married to Fleetwood Mac than to her."

Things erupted a short time later when Jenny met up with the band during a break in LA. Weston was now openly paying her attention in public, and Mick told Bob Welch he felt he was at the end of his tether. When the tour resumed, Fleetwood was increasingly upset by the situation and at a show in Lincoln, Nebraska, on October 23, decided that Bob Weston had to leave the band. Tour manager John Courage had the tough call of telling Weston he was fired. They simply said it was for the best if he left there and then, they handed him a plane ticket, and drove him to the airport. Then the band had the trickier task of breaking the news to Clifford Davis, who was still in London.

Manager Davis was incandescent with rage. The band tried to reassure him they weren't about to break up, but needed to cancel some dates while they sorted things out. Reminding them that they would face huge cancelation fees, Davis pleaded for them to carry on, but Mick was adamant, agreeing to do the Nebraska gig and no more. And with that, Fleetwood Mac effectively disbanded, for the short term at least.

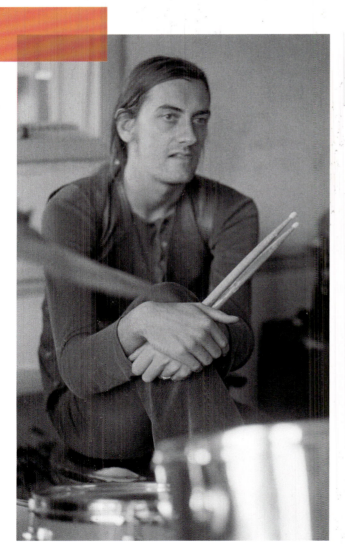

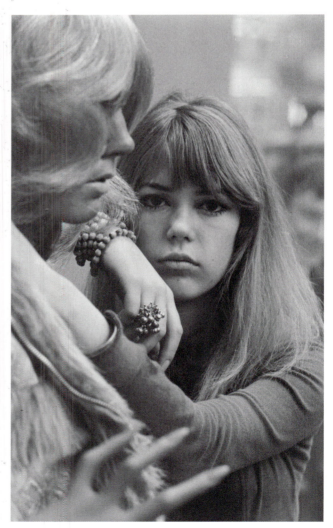

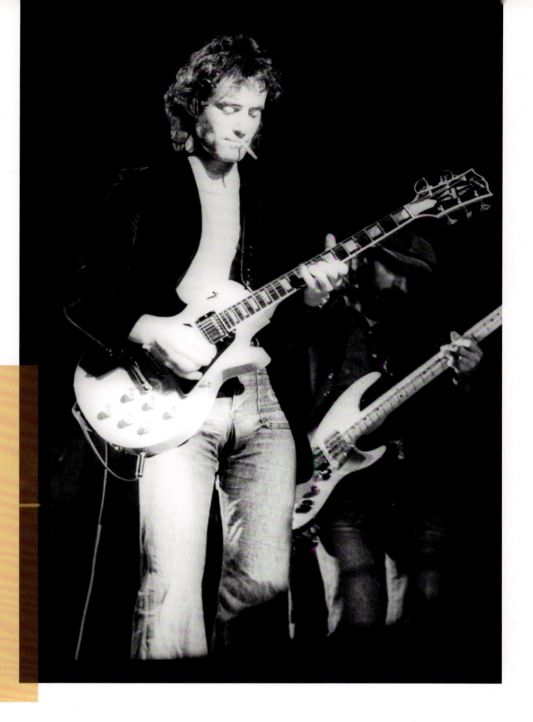

Mick Fleetwood (opposite, left), his wife Jenny Boyd (opposite), and Bob Weston (right). After learning of an affair between Bob and Jenny, Mick demands that Bob leaves the band

Meanwhile, the new album, which had been released just a few days before the Nebraska debacle, was greeted with mixed reviews, but did better than might have been expected in the circumstances. It marked another move towards the soft rock genre that would attract American record buyers, but still be less attractive for the more traditional Mac fans in the UK and Europe. One critic described it as "super-amplified folk rock," with half the twelve numbers written by Bob Welch, alongside four by Christine McVie. And there were some standout tracks, including Christine's closer "Why," Bob Welch's "Hypnotized"(originally written as a vehicle for Dave Walker), and a re-working of the 1965 Yardbirds' hit "For Your Love." The latter two would subsequently appear on either side of a single, released in March 1974. In the US, *Mystery to Me* sold steadily, getting to No. 67 and eventually earning a Gold disc in 1976 for over half a million sales.

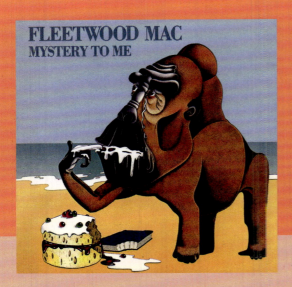

Original vinyl edition

MYSTERY TO ME

Side one
Emerald Eyes [Bob Welch]
Believe Me [Christine McVie]
Just Crazy Love [Christine McVie]
Hypnotized [Bob Welch]
Forever [Bob Weston, John McVie, Bob Welch]
Keep On Going [Bob Welch]

Side two
The City [Bob Welch]
Miles Away [Bob Welch]
Somebody [Bob Welch]
The Way I Feel [Christine McVie]
For Your Love [Graham Gouldman]
Why [Christine McVie]

Recorded: June 1973, Rolling Stones Mobile Studio
Released: October 15, 1973
Label: Reprise
Producers: Fleetwood Mac, Martin Birch
Personnel: Bob Welch (vocals, guitar), Bob Weston (vocals, guitar), Christine McVie (vocals, keyboards), John McVie (bass guitar), Mick Fleetwood (drums, percussion)
Additional personnel: Richard Hewson (string arrangements)
Chart position and awards: US No. 67, Gold disc

TRACK-BY-TRACK

EMERALD EYES
Bob Welch's smooth opener gives the album its title in the phrase quoted from the chorus. The echo-laden guitar breaks became the *de rigueur* sound for easy listening rock through the 1970s and beyond. Welch's vocals are greatly assisted by Christine McVie's faultless backing.

BELIEVE ME
Christine in up-tempo mode in a country-influenced rocker that heralds the crowd-pleasing Mac anthems of later in the decade. And Mick Fleetwood holds things together when the instrumental fade-out is in danger of getting a bit wishy-washy.

JUST CRAZY LOVE
Another positive contribution from Christine, with multi-tracked vocals that keep things going to the faded ending. The song would feature prominently on her solo tour in 1984.

HYPNOTIZED
At first hearing, Welch's lyrics are a narrative account of a UFO sighting, but on repeated listening reveal hidden depths. With its crooning backing vocals and jazz-tinged guitar licks, the song became a minor hit on FM radio in America. Bob Welch had originally written the song as a vehicle for Dave Walker, before the singer's departure from the band.

FOREVER
Credited to Welch, Weston, and John McVie, a ska-tinged up-tempo number—with a nod to the sound of South African rock exemplified over a decade later in Paul Simon's *Graceland* album. McVie and Fleetwood shine as rhythm section anchormen supreme.

Mystery to Me was the last album to be recorded in the UK, and the last to feature Bob Weston, who had been fired from the band on account of his affair with Fleetwood's wife.

KEEP ON GOING
Unusually for Fleetwood Mac, the composer doesn't take the lead vocal on this string-backed ballad fronted confidently by Christine McVie. Writer Bob Welch decided that Christine's voice was better suited to the number, and who could argue?

THE CITY
A delve back into the twelve-bar-blues territory of the earlier incarnations of the band. Welch fronts with soulful vocals and some wailing right-on guitar backing, in a slice of back-to-basics for the whole band.

MILES AWAY
Some bombastic guitar leads into a lyrically rich up-tempo ballad from Bob Welch. With references to Andy Warhol, Don Juan, and Hare Krishna, a catalogue of personal preoccupations left behind after a broken love affair.

SOMEBODY
The third consecutive Bob Welch track to appear on side two of the original vinyl release, and another example of Welch's song-writing balancing act shifting between the esoteric and the frivolous. As with much of the album, the track is redeemed by the almost sixth-sense connectivity between the bass and drums of McVie and Fleetwood.

THE WAY I FEEL
A short straightforward ballad that hints at Christine McVie as a singer-songwriter who would merit comparisons with the likes of Carole King, in an alternative life *sans* Fleetwood Mac.

FOR YOUR LOVE
An odd choice, a cover of the Yardbirds' 1965 hit (written by Graham Gouldman) which adds little to the proto-psychedelic feel of the original. It was suggested at the last minute by Bob Weston, in place of yet another Bob Welch number "Good Things (Come To Those Who Wait)," which was actually listed on the first printings of the album cover.

WHY
The album closes with another stand-out contribution from Christine McVie. An evocative slide guitar intro morphs seamlessly into one of her finest performances of the period. Again, delivering her own material puts her into a class of her own, her sensuous vocals enhanced by swirling strings and layers of backing vocals.

"It wasn't a bad band, to tell you the truth. We performed those old Fleetwood Mac numbers quite well . . . it's just that none of the original Fleetwood Mac were there."

JOHN WILKINSON, TEMPORARY FLEETWOOD MAC KEYBOARD PLAYER

HEROES ARE HARD TO FIND

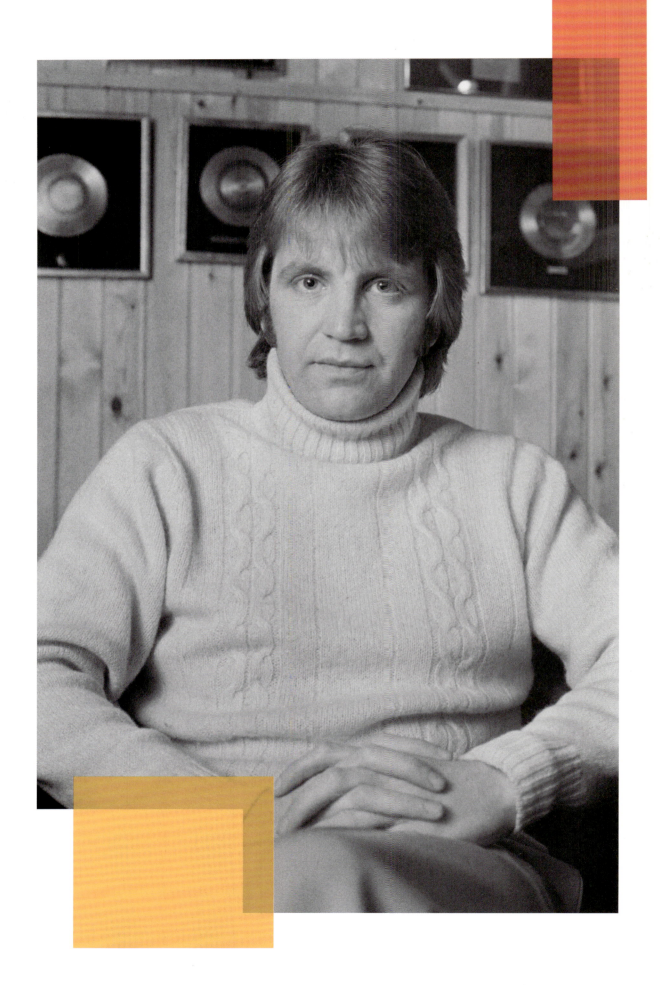

ABOVE: *Kirby Gregory, (right) 1972*

With the cancelation of the tour after the Nebraska bust-up, Fleetwood Mac (albeit temporarily) disbanded. Mick and Christine returned to England, John took a vacation in Tahiti, and Bob Welch bided his time in Los Angeles, waiting to see what might happen next. Their understandably frustrated manager Clifford Davis, however, decided to take the matter into his own hands—with a response that was totally outlandish, even by rock music standards.

While initially heralding a new line-up of Fleetwood Mac that would still include Christine McVie and Mick Fleetwood, Davis put a band together which actually consisted of no previous members of the band at all. He claimed that as he owned the rights to the name Fleetwood Mac, he was able to put together any ensemble he wished under the title. "I want to get this out of the public's mind as far as the band being Mick Fleetwood's band . . ." Davis declared, "This band is my band. This band has always been my band."

The first Mick and Christine heard about the proposed new personnel was after Bob Welch saw a poster in LA announcing dates by "The New Fleetwood Mac," that featured a picture of Christine. Davis informed the music trade press that John McVie and Bob Welch had left the band, and a new line-up led by Mick and Christine would be fulfilling the canceled concerts. According to Bob Welch, Davis booked gigs for a Mac tour that the band had not agreed to. "We all got letters from Clifford Davis indicating his intentions to put a new band back on the road. He issued an ultimatum to all of us. In effect, what happened was that we got offered gigs, which is not really his place to do."

Davis' version of the situation was that Mick Fleetwood was aware that a new bass player, keyboard player (hence no Christine, despite her picture on the posters), and guitarist were lined up, but only a stand-in drummer until Mick felt available. Fleetwood, on the other hand, insisted he knew nothing of these arrangements, claiming later that he didn't even know the names of the musicians involved. For the record, the musicians were Elmer Gantry on vocals and guitar, Kirby Gregory on guitar, bassist Paul Martinez, John Wilkinson on keyboards, and the drummer Craig Collinge.

OPPOSITE: *Fleetwood Mac manager Clifford Davies pictured in 1976*

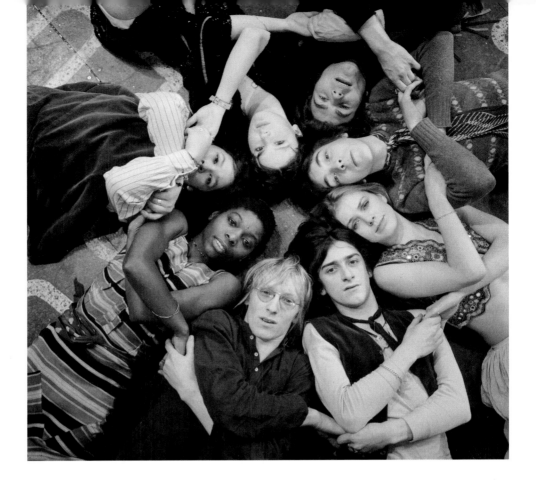

RIGHT: *Elmer Gantry (bottom left with glasses) among the cast of hit musical* Hair, *1971*

The finer details of who knew what surrounding the bizarre arrangement are now lost in the mists of time and fading memories. In his autobiography Mike Fleetwood described the situation as "The last thing we needed. It was also the most preposterous thing we'd ever heard, and the greatest betrayal from one of our own that we could have imagined." But a contradictory version of events by Elmer Gantry, as told in a BBC Radio interview in 2017, insisted that Fleetwood's part in the exercise went far deeper: "Mick Fleetwood came to our house and we talked through the new band, and it all seemed fine. Mick said 'Well, I can't actually come and rehearse with you'—it was fairly imminent, going to America to tour—'but if you get [a temporary] drummer, I'll join you for the tour.'" Kirby Gregory also stated, in the same BBC piece, that he and Gantry had played Little Feat's "Dixie Chicken" to Fleetwood to show off their style, and Mick had approved a set list of the Fleetwood Mac songs they had chosen.

Whatever the detail of their formation, the "fake" Fleetwood Mac embarked on their US tour in January 1974. The trek was soon aborted, however, as US fans demanded their money back as soon as the phony line-up hit the stage. Keyboard man John Wilkinson later described the ensuing furor wherever they played: "It wasn't a bad band, to tell you the truth. We performed those old Fleetwood Mac numbers quite well . . . it's just that none of the original Fleetwood Mac were there. When we got back to New York, people were saying 'Where the hell's Mick Fleetwood?', 'We want the real Fleetwood Mac,' and things like that . . . it was the first time in my life I really did think I was going to get shot."

Contracted for a four-month stretch of dates, the tour had to be aborted after just a few weeks, as promoters canceled one after the other, when they heard it was a bogus line-up. The matter dragged on for some time after that, however, as the genuine

Fleetwood Mac tried to reorganize, and at the same time had to resort to legal action to resolve the "fake Mac" issue once and for all.

Initially Mick Fleetwood, and John and Christine McVie, imagined the problem was behind them; the bogus band's tour had ended in financial disaster, and Clifford Davis was left carrying the can. But the issue persisted as a thorn in their side, as Mick and the McVies hired legal representation to get an injunction served in the British high court against the phony band, which Davis immediately challenged. "We couldn't work, not until we'd proved he didn't own the name," Christine would recall, describing it as "the only time I really got panicky."

It became apparent very quickly that long, drawn-out litigation could take months, if not years, and any money they had would soon trickle away in legal fees. Added to that, most of their earnings—including future royalties from record sales—were basically frozen, as their contracts assigned the royalties to the management, not the individuals in the group. But ironically, the dilemma became the key to the next major stage in Fleetwood Mac's career, when Bob Welch—living in Los Angeles since the band effectively broke up in October 1973—suggested they move to LA on a permanent basis.

> "I helped them survive, as a working band, long enough to get to LA (it was my suggestion that we move there), and get a new deal on Warner Brothers separate from their former manager Clifford Davis."
>
> BOB WELCH

EXODUS

Since the "fake Mac" debacle, Welch had been biding his time in LA as a continuing member of the band, and sounding out their position with local legal experts. As a result, he suggested to the rest of the group that the only way out of their predicament was to move to the West Coast.

Outside the jurisdiction of the British courts, they could also be in close contact with their record company, Warner Brothers. Until then the company hadn't encountered the band on a personal level. To them, Fleetwood Mac were just another name on their books, who supplied records for release, and toured to support the records. Welch told the others that they needed to prove to Warners that they were the genuine article, the band that the fans wanted to see, and to hammer out a new record deal.

The most enthusiastic response was from Mick Fleetwood, who thought it was worth a try, as all they had seen of the States previously was on tour. With the Bob Weston affair now a bad memory, his wife Jenny also said she'd welcome a change from what was now a mundane life in Benifold. John McVie was happy to give the idea a chance, as was Christine after some initial doubts. Consequently, late in April 1974 they made the move.

On the advice of Bob Welch (who was now in effect acting as their manager in the legal wrangles), they hired a no-nonsense American lawyer, Mickey Shapiro, to fight Clifford Davis. They reasoned that if they won the case in the US courts, at least they could work on that side of the Atlantic. And Warner Brothers, naturally cautious about the actual ownership of the name Fleetwood Mac, insisted on being indemnified against any damages should Davis actually win. After months of inactivity, the band's relocation to the US meant that they could start working on a new album, free from any UK court ruling. Welch would reflect on numerous occasions how his unofficial "manager" role at this time had probably saved Fleetwood Mac from extinction: "I helped them survive, as a working band, long enough to get to LA (it was my suggestion that we move there), and get a new deal on Warner Brothers separate from their former manager Clifford Davis."

As with *Mystery to Me*, *Heroes Are Hard to Find* focused on the song-writing of Bob Welch and Christine McVie. Welch wrote seven of the eleven tracks, and Christine the other four. It constituted a further move away from their blues-based territory, and into the area of more radio-friendly music.

The band were all conscious that they needed to do something fresh, distancing themselves from the musical stereotypes they had gradually created. On the one hand they sought to be on-trend with the sound of mid-seventies rock, but not at the cost of becoming just another smooth-sounding West Cost cliché. They were treading a cautious path between the two, and not sure where it would lead.

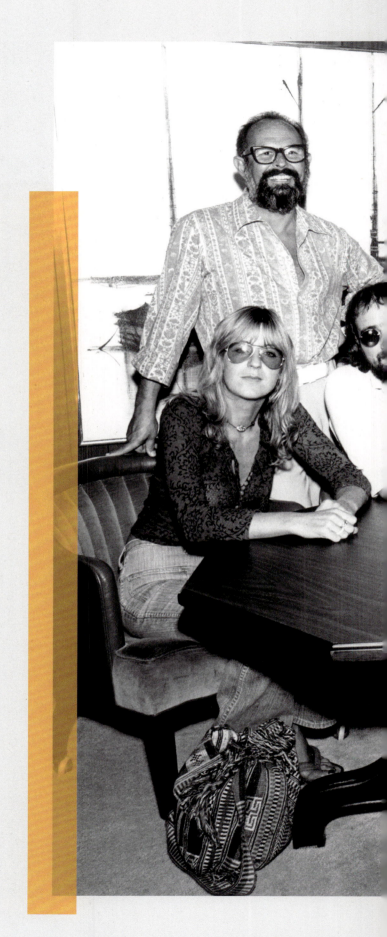

RIGHT *Record executives Mo Austin (back, left) and Joe Smith (back, second left) meet with members of Fleetwood Mac, at Warner Bros. Records Inc., circa 1974, Los Angeles, California*

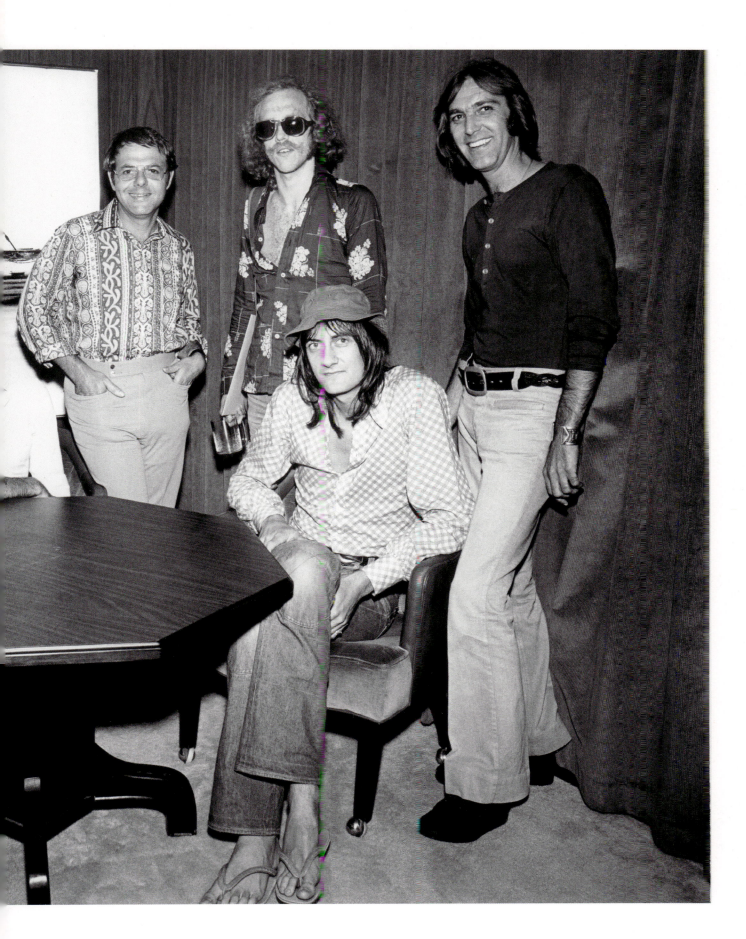

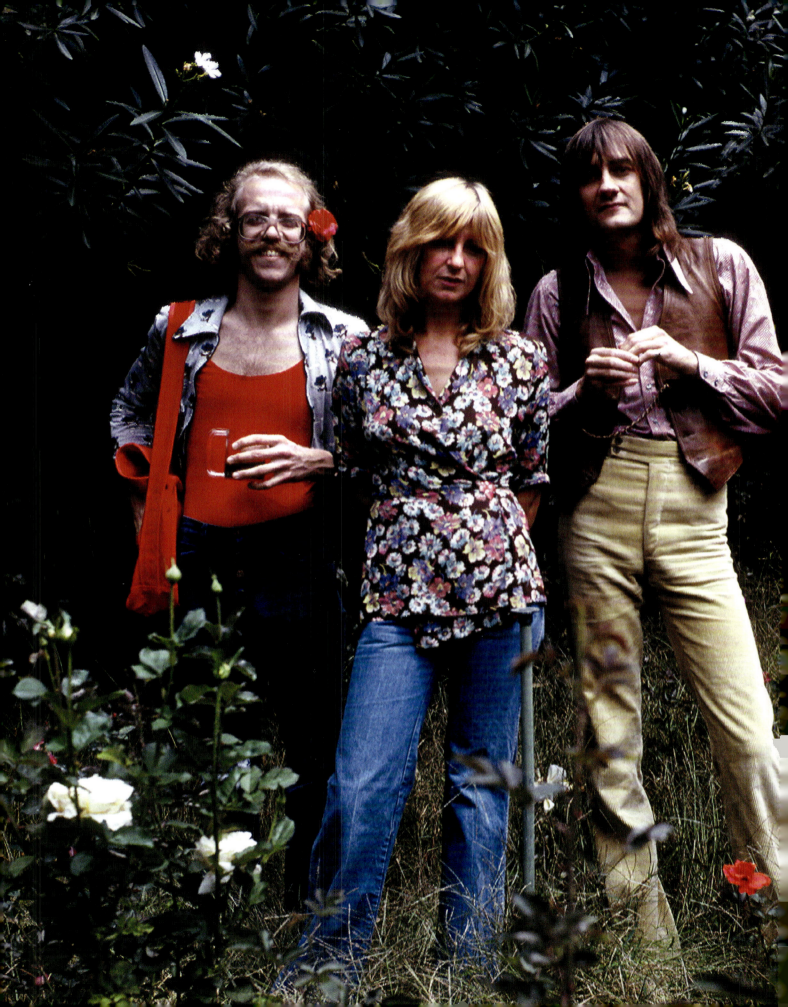

Although not their most memorable long-player, in the event it was their most successful yet in terms of the US charts, hitting the No. 34 spot in the *Billboard 200* in November 1974, two months after its release. And now the band was together once again as Fleetwood Mac, they set out on the road to promote their latest album.

The tour, although without incident, took a toll on the band in general, and Bob Welch in particular. Playing the part of unofficial manager when dealing with the band's legal affairs did not come easily to Welch, who was basically a musician. And although the lead vocals were shared with Christine, he was the dominant front person on stage. He had been responsible for, along with Christine, the artistic vitality of the band—and some of their most popular songs—over the previous three years or so. But as the tour completed its final dates towards the end of the year, he realized his musical goals were not going to be achieved in the context of the band. Added to which, he was aware of a sense of fatigue among the other members, not surprisingly, given the traumas of personnel changes and legal hassles over the previous eighteen months. As he would reflect in 1995, "I was just full of anxiety. I was tired of the atmosphere. I think we were all tired of each other."

As the tour came to a close in December 1974, Welch told the others that he was leaving. They were understandably shocked, not to mention aggrieved: Welch had been a musical mainstay, who they had relied upon more and more during his tenure with them. Once again Mick Fleetwood and the McVies were faced with the unenviable prospect of having to find someone to fill the yawning gap in the front line. The solution would be totally unexpected and settle the direction that the band would take next—which would see them achieve their biggest successes yet.

LEFT: *Los Angeles, August 1974. L-R: Bob Welch, Christine McVie, Mick Fleetwood, and John McVie.*

Original vinyl edition

HEROES ARE HARD TO FIND

Side one
Heroes Are Hard To Find [Christine McVie]
Coming Home [Bob Welch]
Angel [Bob Welch]
Bermuda Triangle [Bob Welch]
Come A Little Bit Closer [Christine McVie]

Side two
She's Changing Me [Bob Welch]
Bad Loser [Christine McVie]
Silver Heels [Bob Welch]
Prove Your Love [Christine McVie]
Born Enchanter [Bob Welch]
Safe Harbour [Bob Welch]

Recorded: July 1974, Angel City Sound, Los Angeles
Released: September 13, 1974
Label: Reprise
Producers: Fleetwood Mac, Bob Hughes
Personnel: Bob Welch (vocals, guitar, vibraphone), Christine McVie (vocals, keyboards, ARP strings), John McVie (bass guitar), Mick Fleetwood (drums, percussion)
Additional personnel: Sneaky Pete Kleinow (pedal steel guitar)
Chart position: US No. 34

TRACK-BY-TRACK

HEROES ARE HARD TO FIND
Latest in what was by now a string of memorable (albeit often underrated) songs from Christine, and a jubilant album opener with some light-touch harmonies and lively, horn-led instrumental backing. To the surprise of many, it failed to chart when released as a single in an edited version.

COMING HOME
Another nod towards psychedelia from Bob Welch. Atmospheric instrumental effects take us into an odd mix of cocktail jazz and straight pop song delivery.

ANGEL
A straightforward rock performance from Welch who, as on previous albums, proves that his guitar prowess was not always appreciated. Again, a song whose strength is undermined by the understated delivery of the vocals.

BERMUDA TRIANGLE
A haunting melody, despite Bob Welch's vocals being somewhat one-dimensional. The instrumental backing from Fleetwood and McVie gives some necessary lift to what might otherwise have been a lackluster item.

COME A LITTLE BIT CLOSER
A minor classic from Christine McVie, with a strikingly pretty melody and some evocative pedal steel guitar from a maestro of the instrument, ex-Flying Burrito Brothers' Sneaky Pete Kleinow.

SHE'S CHANGING ME
The most disappointing track on the album, a country-flavored slice of middle-of-the-road music from Bob Welch, redolent of much mid-seventies rock at its most bland.

BAD LOSER
Another class item from Christine, with great vocal harmonies and one of Welch's best solo breaks on records. Again, where the overall performance could be in danger of sagging, it's rescued by the always reliable McVie and Fleetwood rhythm section.

SILVER HEELS
An unnecessary mix of country-tinged melody and understated funk renders Welch's song one of the least effective tracks on the album. More generic seventies rock that suggested the band were still searching for their identity.

PROVE YOUR LOVE
Not among Christine's best, but an effective, melody-driven song all the same. "Very pleasant" as one reviewer called the album as a whole, and "exquisitely pretty" referring specifically to this track.

BORN ENCHANTER
Bob Welch in funky territory again which, as in "Silver Heels" and "Angel," doesn't sit well with the band's overall sound. Not for the first time on the album, the vocals are relegated to a secondary role in favor of the overall "atmosphere" being evoked—and not entirely successfully.

SAFE HARBOUR
The album closes with an almost exclusively instrumental track (apart from a brief hint of vocal at the end) on which Welch demonstrates his ability to create an effective, sensitive mood. A delicate guitar piece which would evoke memories of "Albatross" in long-standing fans of Fleetwood Mac.

BELOW: *Bob Welch performing with Fleetwood Mac, June 5, 1973*

Heroes Are Hard to Find moves the band further from their blues-based territory, and into the area of more radio-friendly music.

"Mick came back and said he'd found this fantastic guitar player, and we didn't know who the girl was at the time."

CHRISTINE MCVIE

FLEETWOOD MAC (1975)

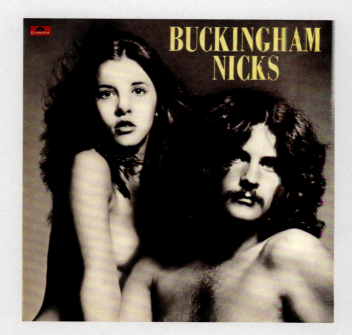

Late in the November of 1974, just a couple of weeks before Bob Welch announced his departure, Fleetwood Mac were taking a break from the tour at their Los Angeles home. Checking out a local studio, Sound City located in the Van Nuys district, Mick Fleetwood chanced upon a track called "Frozen Love," with an impressive guitar part by Lindsey Buckingham, a musician he'd never heard of. Simultaneously, Fleetwood had noticed a pretty girl rehearsing vocal parts in the next studio, and it transpired her name was Stevie Nicks.

BUCKINGHAM NICKS

Lindsey Buckingham was born in Palo Alto, California, on October 3, 1949. He first played guitar (or at least a toy Mickey Mouse guitar) when he was seven, strumming along to his elder brother's collection of records which included classics by Elvis Presley, Buddy Holly, Little Richard and so on. He'd later describe how it was like having the history of rock 'n' roll right there.

Keen to encourage him, his parents bought him a Harmony guitar for thirty-five dollars, and that set him on the road to professional music making. By his mid-teens he was accomplished enough to join a folk group in Menlo-Atherton high school, influenced by the boom in folk music (and the music of the Kingston Trio in particular) that had become a huge trend in America in the early 1960s. That soon evolved into rock music, where a pupil in the year above him was Stevie Nicks.

Known to family and friends as Stevie from her earliest years, Stephanie Lynn Nicks was born in Phoenix, Arizona, on May 26, 1948. Her grandfather was Aaron Jess Nicks, a little-known country singer who had little Stevie accompanying him on duets of down-home classics by the time she was four.

Due to her father's job as an executive in the food business, Stevie's childhood years were spent in a variety of places and it was while she was in high school in Los Angeles that she joined her first band, The Changing Times. She wrote her first song—

OPPOSITE: *Stevie Nicks, 1975*

ABOVE: *The eponymous debut and sole studio album by Lindsey Buckingham and Stevie Nicks, 1973*

> "I was aware they came as a package pretty early on. But there was a point when I was truly after Lindsey Buckingham, and the fact that Stevie was an afterthought is why she never forgave me."
> MICK FLEETWOOD

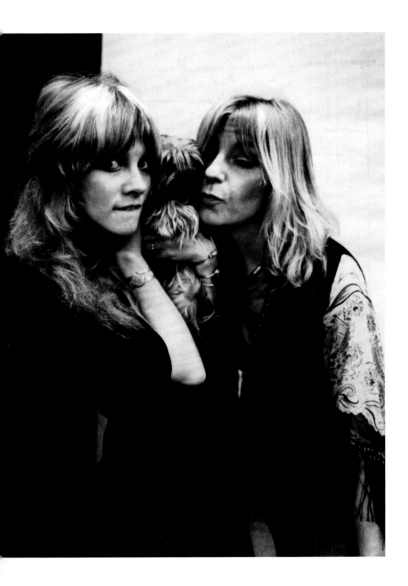

with a guitar that was a sixteenth birthday gift from her parents—called "I've Loved and I've Lost, and I'm Sad but Not Blue."

It was after her father moved the family yet again, to San Francisco, that she joined Menlo-Atherton high where she encountered Lindsey Buckingham for the first time. Years later she would recall the circumstances of their first meeting, which was at a gathering organized by the Young Life Christian group: "Lindsey walked into the room and sat down and started playing a song. I just happened to know every word and harmony perfect, 'California Dreaming,' and I thought he was absolutely stunning. So I kind of casually maneuvered my way over. He was somewhat, I guess ever-so-slightly, impressed. Not to let me know it, but he did sing another song with me, which let me know he did like it."

Buckingham and Nicks both attended San Jose State University—by which time they were a regular item—where they formed a group, Fritz. The five-piece consisted of guitar, keyboards, and drums, with Buckingham on bass, backing Stevie's vocals. Gigging with Fritz was an education in itself for Stevie, especially the chance to

LEFT: *Christine and Stevie (holding dog) take a break from recording, October 1975, New Haven, Connecticut, USA*

OPPOSITE: *Lindsey Buckingham, circa 1975*

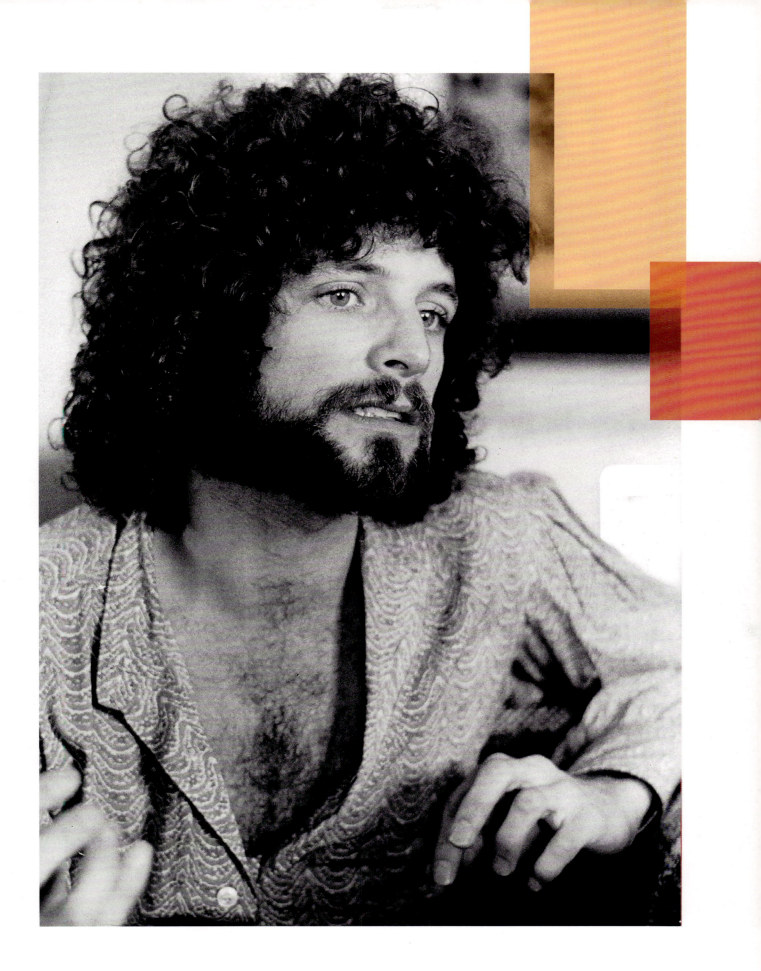

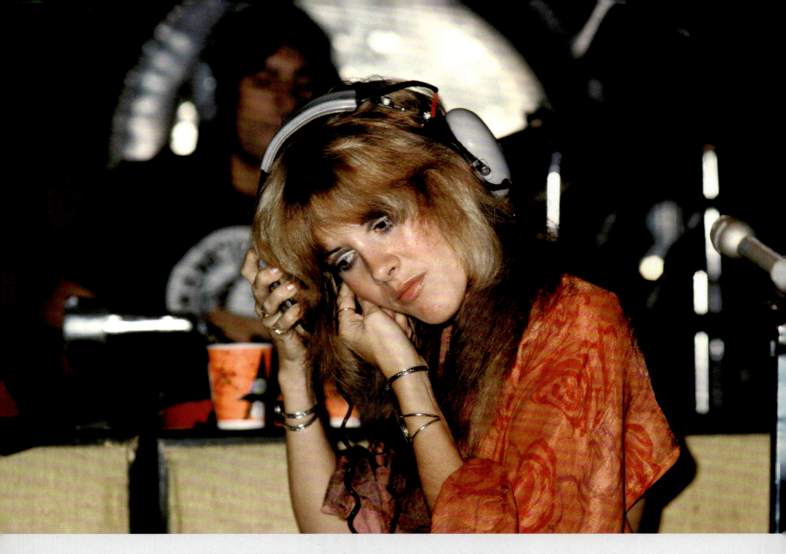

see live performances by some of the acts they supported. One star in particular who impressed the youngster with her dynamic stage presence was Janis Joplin: "You couldn't have prized me away with a million-dollar check," Stevie recalled years later.

When Fritz eventually disbanded in 1971, the couple dropped out of college and moved to Los Angeles to pursue their chosen career in music. Through 1972 they performed around LA as a duo, at the same time hawking demo tapes. Eventually Polydor signed them to a contract in 1973, which resulted in the release of an album, *Buckingham Nicks*. But despite getting some good press reviews, the album failed to make any impact sales-wise.

While the pair were working on their next album, they were both struggling to make ends meet on the LA music scene. While Lindsey began producing demos for their next release, Stevie was working as a cleaner and waitressing just to pay the bills. She even cleaned the house of their record producer Keith Olsen, who would be pivotal in their receiving an invitation to join Fleetwood Mac.

After Bob Welch declared he was leaving the band, Mick Fleetwood recalled his own visit to the Sound City studios and the guitarist who'd sounded so impressive on "Frozen Love." He'd forgotten the name of the musician, so rang the producer—this was Keith Olsen—who told him that Lindsey Buckingham was in a singer-songwriter duo with his girlfriend, Stevie Nicks. When Fleetwood mentioned that Fleetwood Mac were looking for a guitarist and Buckingham could be a possibility, Olsen pointed out that he

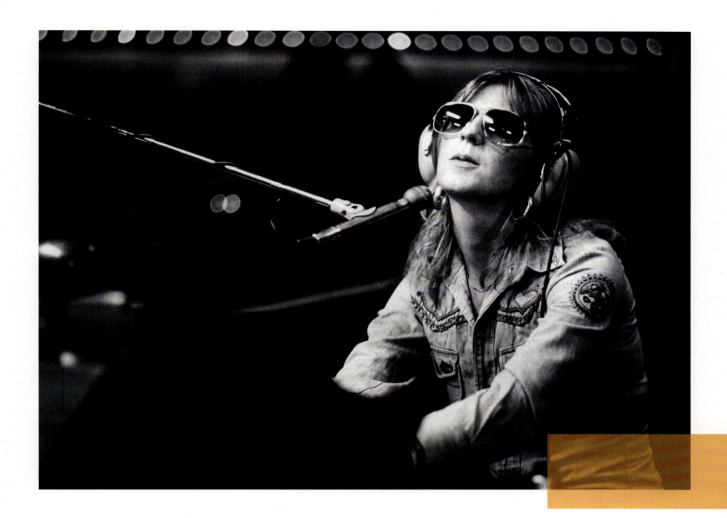

would only be interested if any offer also included Nicks; in other words, they came as a package.

Mick played a copy of *Buckingham Nicks* to John and Christine to see what they thought, also stressing that the duo had to come as a pair, even though they were only looking for a new guitar player at that stage. "Mick came back and said he'd found this fantastic guitar player, and we didn't know who the girl was at the time," Christine would recall " . . . 'cos it was really only the guitar player we were interested in."

Fleetwood confirmed later that Stevie came as part of the deal "I was aware they came as a package pretty early on. But there was a point when I was truly after Lindsey Buckingham, and the fact that Stevie was an afterthought is why she never forgave me."

The band had always been happy with Christine as the only female voice, but they decided to invite Buckingham and Nicks to consider joining the line-up. "For the next three days I went to the record store and bought all the Fleetwood Mac records, and listened to them back to front," Stevie would recall, "and I made the decision then. I said, 'I think we can add something to this band.'"

It was during the New Year's holiday of 1975, over dinner at a Mexican restaurant, that Lindsey Buckingham and Stevie Nicks actually met the members of Fleetwood Mac for the first time. It was the start of a musical and personal relationship which would impact on all their lives for the rest of their careers.

Stevie (opposite) and Christine (above) in the recording studio, New Haven, USA, 1975

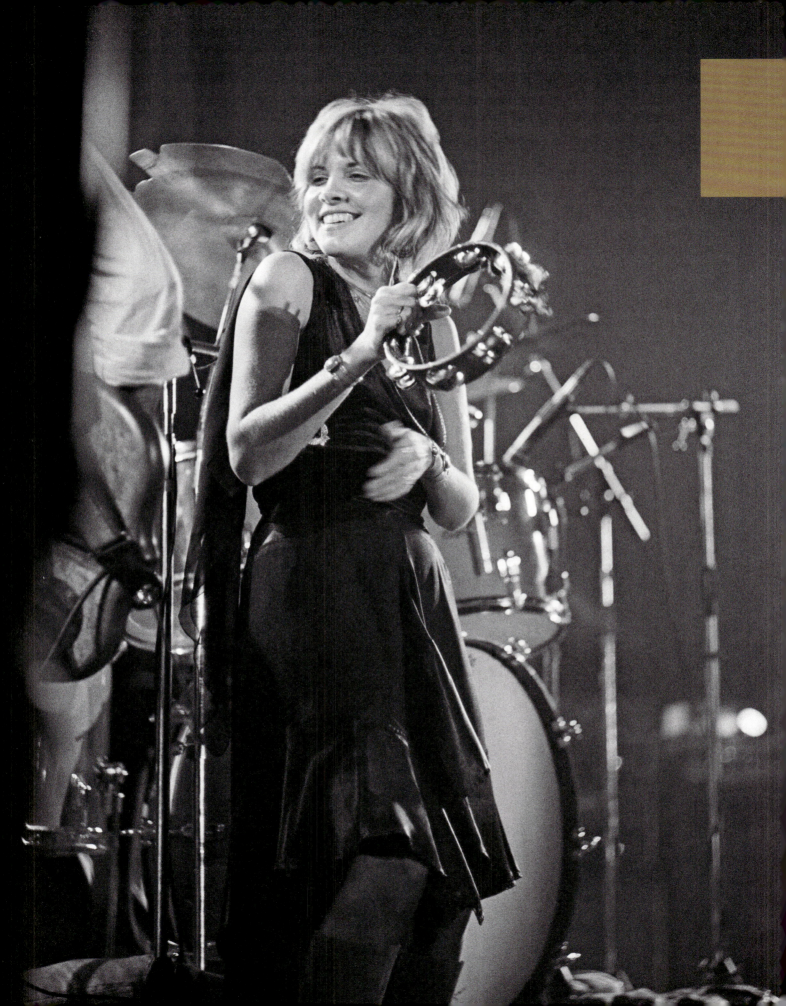

OPPOSITE: *Stevie Nicks live onstage at Yale Coliseum, New Haven, Connecticut, USA, November 20, 1975*

"It felt right. It was very quick. In fact, they joined the band before we'd even played a note. It was just right," Mick would tell Chris Salewicz in the *New Musical Express* in July 1976. "We all met. We all liked each other and that was it. Rehearsed for ten days and went in and made the album. That was it. It was just a great sense of circumstance. I think it's wrong to start analyzing it for whys and wherefores. That was it."

Christine remembered with affection that any doubts about another girl being in the band quickly melted away after that first meeting. "The last thing I was thinking about at the time was to have another girl in the band. I had been so used to being the only girl. We met them both. We all really got on well together. Stevie was a bright, very humorous, very direct, tough little thing. I liked her instantly, and Lindsey too."

After some preliminary jamming between John, Mick, and Lindsey, all six gathered in the basement of their booking agency's office, for their first full-on rehearsal. Christine would describe how her skin "turned to goose flesh" when Lindsey and Stevie first joined in on the chorus of one of her songs. In fact, things went so well, that it was only a matter of a couple of weeks—despite some apprehension by Warner Brothers at the prospect of yet another personnel shake-up—before the new five-piece were in the studio, cutting their first album together.

It was February 1975, and less than three months since Mick Fleetwood had first encountered the work of Buckingham and Nicks, when the new Fleetwood Mac convened at the same Sound City studio to begin recording. And for good measure, Lindsey and Stevie's former champion Keith Olsen was in the producer's chair.

The two new arrivals were naturally apprehensive about how any of their own existing material would be used in a Fleetwood Mac context, but needn't have been concerned; their own songs sounded even better in the expanded musical environment. "It all seemed to come together very quickly . . ." Lindsey recalled in a 1997 interview " . . . Stevie and I had a backlog of material, and it was easy for the three people to make choices of something that would hang together with Christine's material. And certainly the vocal blend was very important; just the personalities of the three writers hanging together as a trio."

To the surprise of many long-time followers of the band, they decided to simply call the album *Fleetwood Mac*, as they had titled the band's debut album back in 1968. That distant long-player had introduced a new group on to the UK blues scene at the time, and they hoped this would likewise herald the appearance of the latest line-up in a positive way, making a definitive statement that *this* was Fleetwood Mac.

Prior to the album's release, the band decided to tour in May, contrary to normal promotional practice. Warner Brothers had misgivings, but the tour was a huge success, leaving fans eagerly anticipating the new album when it appeared in July. And the release was followed by a further, full-blown promotional tour of the United States that

lasted until the end of the year, a true baptism of fire for Lindsey and Stevie who had never performed at that intensity before.

With the new line-up—particularly the up-front presence of Stevie Nicks—the band had acquired a new stage image. With her strikingly pretty appearance, flimsy dresses, and long, blond hair, Stevie came over as sensitive and sensual at the same time. And her assured but delicate vocal style contrasted well with the more worldly, blues-based delivery of Christine McVie.

By the end of August *Fleetwood Mac* had entered the US Top Forty in *Billboard* magazine, eventually making it to No. 1. And it was still in the Top Ten album chart a year later, earning seven Platinum discs in the US. Even in Fleetwood Mac's home territory of the UK, where their star had faded somewhat since the glory days of the British blues boom and Peter Green and Jeremy Spencer, the album was awarded a Gold disc after peaking at No. 23 in June 1976.

The album also enjoyed largely favorable notices in the music press. Referencing the new presence of Buckingham and Nicks, Bud Scoppa wrote in *Circus* magazine, "These two have enabled the band to bring about the musical-cultural transition quite smoothly, and they're largely responsible for making this new LP Fleetwood Mac's best since 1973's lovely *Bare Trees*," concluding, "Fleetwood Mac, which not long ago seemed to be unravelling, has new life and plenty of newfound charm. This is an easy-going, immensely playable record." Not all journalists took to the album of course, or the

Letting off steam in between recording. Below: John McVie (left) and Lindsey Buckingham. Opposite: Mick Fleetwood (left) and John McVie

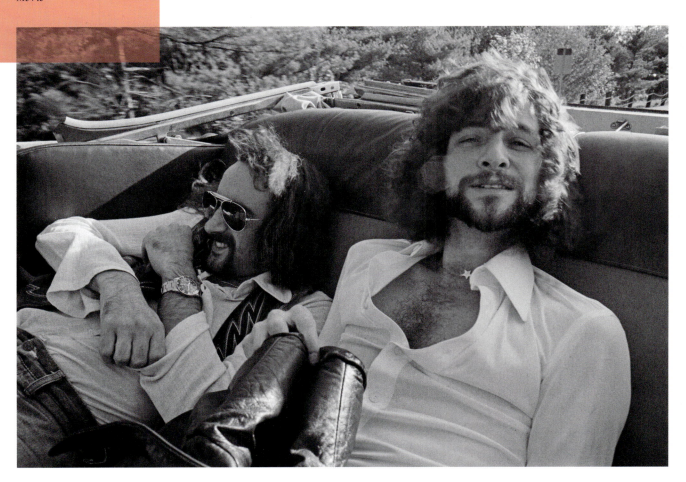

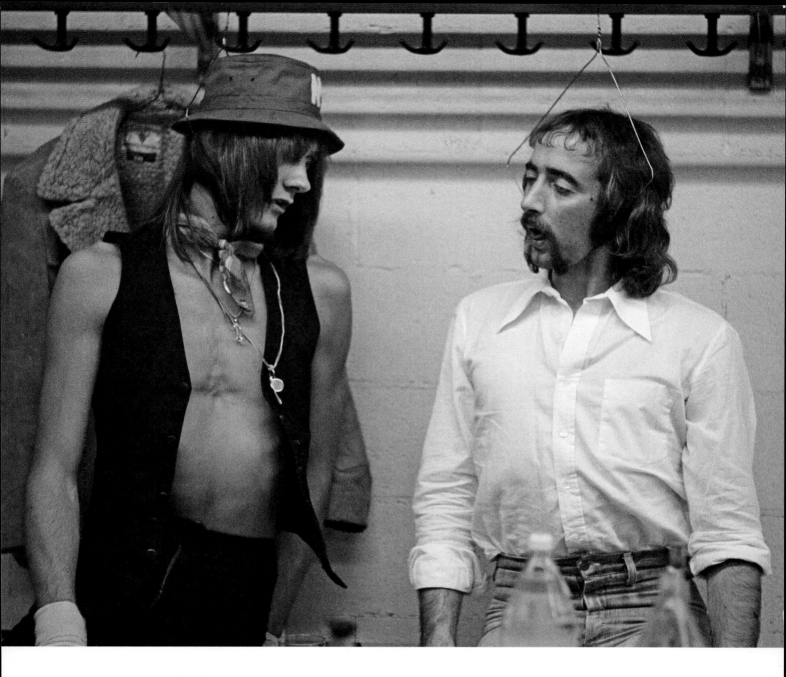

new personnel for that matter: Roy Carr in the UK's *New Musical Express* concluded a somewhat scathing piece: "With careful planning and Christine McVie singing lead, it's still not too late for Fleetwood Mac to recapture its lost spirit and make a great album, as opposed to a safe one. I'll be staying tuned."

A key factor in the overall success of *Fleetwood Mac* was the performance of three US hit singles during the first six months of 1976. First to be released was Christine McVie's "Over My Head," which hit the shops in America in December 1975 and made No. 20 in the singles chart early in the New Year. Then came Stevie Nicks' "Rhiannon" in the February, just avoiding the Top Ten at No. 11, and a trio of hits was completed in June 1976 by Christine's "Say You Love Me," which also hit the No. 11 spot.

The immediate challenge for the band following the success of *Fleetwood Mac* and its spin-off singles was having to follow it up. This they did with the overriding triumph of *Rumours*, released in the early months of 1977.

FLEETWOOD MAC (1975)

119

Original vinyl edition

FLEETWOOD MAC

Side one
Monday Morning [Lindsey Buckingham]
Warm Ways [Christine McVie]
Blue Letter [Rick Curtis, Mike Curtis]
Rhiannon [Stevie Nicks]
Over My Head [Christine McVie]
Crystal [Stevie Nicks]

Side two
Say You Love Me [Christine McVie]
Landslide [Stevie Nicks]
World Turning [Lindsey Buckingham, Christine McVie]
Sugar Daddy [Christine McVie]
I'm So Afraid [Lindsey Buckingham]

Recorded: February 1975, Sound City, Van Nuys, California
Released: July 11, 1975
Label: Reprise
Producers: Fleetwood Mac, Keith Olsen
Personnel: Stevie Nicks (vocals), Lindsey Buckingham (guitar, vocals), Christine McVie (vocals, keyboards, synthesizer), John McVie (bass guitar), Mick Fleetwood (drums, percussion)
Additional personnel: Waddy Wachtel (rhythm guitar)
Chart position and awards: UK No. 23, Gold disc, US No. 1, seven Platinum discs

TRACK-BY-TRACK

MONDAY MORNING
A lilting, country-flavored song written by Lindsey Buckingham—who delivers the lead vocals—prior to his joining the Mac. Some slide guitar adds to the Nashville feel, with Mick Fleetwood's shuffle backing keeping the number on course as a driving opener.

WARM WAYS
The soulful ballad from Christine establishes the stylistic diversity of the new line-up. With her electric piano as the instrumental basis, mixed with a combination of acoustic and electric guitar picking, the track was the main single release from the album in the UK, where it just hit the Top Forty.

BLUE LETTER
With lead vocals by Lindsey and harmonies by Stevie, the upbeat slice of California country was originally destined for the second Buckingham Nicks album, which never happened. The song was written by the brothers Michael and Richard Curtis (who were making demos in an adjoining studio at Sound City) in 1974.

RHIANNON
A song destined to be one of Fleetwood Mac's all-time showstoppers. This introduction of Stevie Nicks to Fleetwood Mac fans magically combines an atmospheric ballad with a strong bass line, incisive guitar flourishes, and some rich vocal harmonies. The lady in the title could be traced to an ancient Welsh legend, but Nicks initially came across the reference in a 1970s novel—only learning that the character Rhiannon was based on Welsh mythology after she had actually written the haunting lyrics.

> "Fleetwood Mac, which not long ago seemed to be unravelling, has new life and plenty of newfound charm. This is an easy-going, immensely playable record."
>
> BUD SCOPPA, *CIRCUS*

OVER MY HEAD
Christine already had the song ready to record before the band convened in the studio. As with all her lead vocals on the album, her slightly husky vocal texture delivers what amounts to a perfect slice of 1970s pop singing, with some effective rhythmic embellishments on bongos by Mick Fleetwood.

CRYSTAL
Another Stevie and Lindsey contribution (from *Buckingham Nicks* in 1973), a soft country-ish track featuring acoustic guitar and electric piano. Buckingham sings the lead vocals, with Stevie providing most of the backing harmonies.

SAY YOU LOVE ME
More perfect pop from Christine, the simplicity of her piano phrases augmented by Lindsey's equally minimalistic guitar parts. In common with McVie's other contributions, she achieves the perfect balance between making an instant rapport with listeners and an undeniable sensitivity.

FAR RIGHT: *Billowing sleeves, top hat, and tambourine: Stevie's signature stage style starts to evolve*

LANDSLIDE
Fingerpicked acoustic guitar licks support the lightest of vocal touches from Stevie. The cool ambience of the lyrics is evoked perfectly by the sparse instrumental backing.

WORLD TURNING
Lindsey and Christine take turns on the lead vocals, on the only Buckingham/McVie collaboration on the album. That's after a lengthy intro that features some blues-tinged guitar, supported by dynamic percussion action from Mick.

SUGAR DADDY
As a composition not as striking as her other tracks on the album, nevertheless Christine delivers—as usual—a strong vocal. Her backing is dominated by an effective mix of piano and organ.

I'M SO AFRAID
Mick Fleetwood's rolling drums evoke an almost somber mood, on Buckingham's closer. The dramatic mood is enhanced by Lindsey's vocals and some stirring lead guitar, that fades out as a histrionic conclusion to Fleetwood Mac's most noteworthy album yet of their post-blues incarnations.

"When we sat down listening to what we had, we realized every track was written about someone in the band."

MICK FLEETWOOD

RUMOURS

The tour promoting *Fleetwood Mac* proved to be something of a traumatic experience for all concerned, with personal pressures coming to a head as the trek wound to a halt at the end of 1975. But in the wake of the hugely successful *Fleetwood Mac*, Mick Fleetwood—as were the others—was determined to get a new collection underway.

With that in mind, as *Fleetwood Mac* was heading for Platinum disc status and "Rhiannon" was released as a single, in February 1976 Mick booked some studio time in a new location, the Record Plant. Located in Sausalito near San Francisco, the studio was a self-contained complex. Chris and Stevie chose to live in rented accommodation nearby, while the three men ensconced themselves in the house attached to the studio. Some would think the wooden, windowless building somewhat claustrophobic, but Mick decided it was just what was needed, and booked the studio for nine weeks.

The band recruited Richard Dashut, the sound engineer who'd worked on *Buckingham Nicks* back in 1973, alongside his colleague Ken Caillat. And rather than rehiring Keith Olsen, who'd produced both *Buckingham Nicks* and *Fleetwood Mac*, the band made the decision to actually produce the recordings themselves.

It's surprising, in retrospect, that any creative work was achieved at all, given the volatile personal situations that had developed during the months of touring. There was a chilly atmosphere around the McVies in particular, who consciously tried to avoid each other, as Christine would recall: "We did not talk, period, except for the civilities in life like 'What key is this song in?' . . . so we just spent six months in the studio avoiding each other." After eight years of marriage, Christine had come to feel she couldn't live with John any longer, a situation exacerbated by his heavy drinking. And while the band were rehearsing for the album, John heard that his wife was having an affair with a member of the road crew, the lighting director Curry Grant. Consequently, Grant was fired, but the rift between the McVies proved more fundamental, and the couple split. Not, of course, in such a way as to affect the future of Fleetwood Mac—as always with both John and Mick, the prime consideration was always the band.

While Jenny's affair with Bob Weston was now a thing of the past, her marriage to Mick Fleetwood was far from satisfactory. Mick had taken on the job as de facto manager since the departure of Bob Welch and his priorities were

BELOW: *Fleetwood Mac's official backstage pass from their concert at the MECCA Arena (now the UW– Milwaukee Panther Arena), Milwaukee, Wisconsin, USA, June 24, 1976*

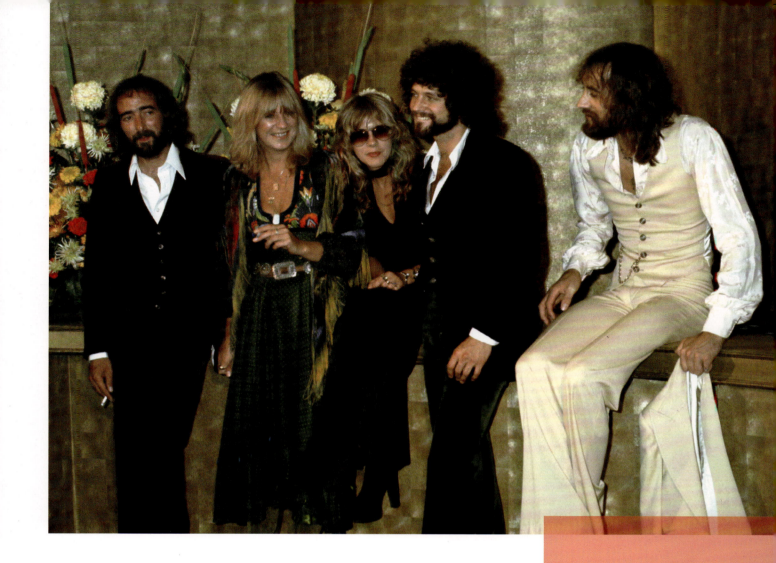

ABOVE: *At the Don Kirshner Rock Music Awards, 1976*

even more focused on the band. Jenny increasingly resented playing second fiddle to her husband's musical commitment, especially after they moved to a rented house in Topanga, some way outside LA itself. As Mick would admit in his autobiography, "Soon Jenny started to feel cut off, and we started to have some real problems at home. I wasn't seeing anyone else, but I was either in the studio or on the road and she felt ignored." After a very public row during a barbecue party at Topanga, during which Jenny physically attacked Mick, the couple separated and subsequently divorced—although they reunited, and married again, after just four months apart.

And the partnership seemingly made in heaven between Stevie and Lindsey was also starting to disintegrate. Still unmarried, the pair had been together since 1970, but whereas Lindsey had been the driving force as far as running their career was concerned, now Stevie was contributing equally as both a lead voice and songwriter. Buckingham started appearing with a variety of girlfriends, while Nicks would begin a relationship with the Eagles' drummer and vocalist, Don Henley.

Meanwhile, John McVie was seeing Sandra Elsdon, an ex-girlfriend of Peter Green, while Christine carried on her affair with ex-lighting man Curry Grant, now outside the perimeter of the group. And during her split with Mick Fleetwood, Jenny was involved with Andy Silvester, a former roommate of Mick's who played bass with Chicken Shack back in the day, and was now resident in LA.

RUMOURS

125

Mick Fleetwood, once again, tried to turn what seemed a totally destructive set of circumstances to the group's collective advantage and away from the musical activity as much as possible. As he saw it, the emotional maelstrom swirling around the other four might, he hoped, be anchored to produce some creative dynamic. And amazingly, it worked, the creation of the new album feeding off the emotional turmoil surrounding the band. Rather than being a distraction from the creative process, the angst and agony became a vital part of the inspiration for the songs being laid down in the studio.

Stevie and Lindsey, for instance, collaborated as they always had done, and Stevie was the first to admit that her songs on the album, "Dreams," "I Don't Want to Know," and "Gold Dust Woman," were all personal: "My songs are all about Lindsey, and Lindsey's songs are all about me." And while Buckingham would later describe the material as "just a selection of songs," his numbers like "Go Your Own Way" were autobiographical.

Likewise, Christine's songs could be directly related to her turbulent love life. "You Make Loving Fun" referred to her affair with Curry Grant before the lighting director was fired, while "Don't Stop" addresses the fact that she still had feelings for John despite their separation. Similarly, the poignant "Songbird," which became a highlight of Christine's onstage repertoire, was often thought of as a mark of the affection she still

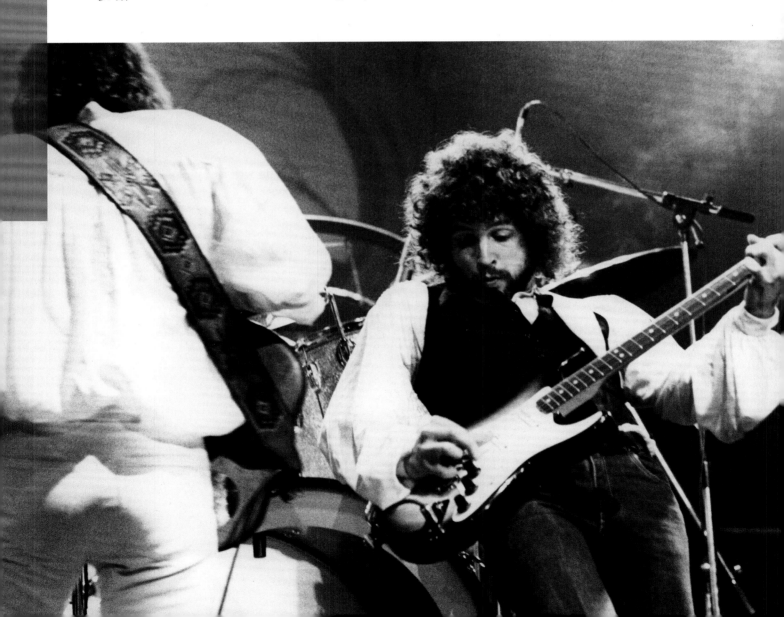

BELOW: *Lindsey Buckingham and John McVie performing live onstage, 1977*

felt for her former partner. Indeed, John McVie would remember how, even during her later appearances with Fleetwood Mac, Christine's rendition of the song would affect him: "Me and Mick would stand in the wings, and she'd play 'Songbird,' and grown men would weep—and I'd do it every night."

There were other distractions during the Record Plant sessions of course, not least the easy access to drugs, given the band's apparently limitless budget. Cocaine was the main narcotic of choice, during night-long sessions at which the band would start recording when they were in no fit state. One of the Record Plant's owners, Chris Stone, would recall how a typical evening panned out: "The band would come in at seven at night, have a big feast, party till one or two in the morning, and then when they were so whacked-out they couldn't do anything, they'd start recording."

As the major musical driving force in many ways, Lindsey Buckingham was clearly frustrated at the progress—or lack of it—during the Record Plant sessions. After more than two months at the studio, by the spring of 1976 it seemed they were getting nowhere.

Lindsey—despite being as distracted as the rest when it came to self-indulgence—became more exasperated at the lack of direction in sessions characterized by a constant state of chaos that nobody seemed in a position to control. He was constantly at loggerheads with Mick over who was running things; as far as Fleetwood was concerned, it was a team effort with no one individual in charge. But after two months during which they had not produced one finished track, Mick decided to rest the band for a couple of days before relocating the sessions to other Record Plant facilities in LA.

There was a veritable mountain of disparate material that had accumulated in Sausalito, all of which needed to be edited, overdubbed, adjusted, and added to, before achieving something approaching a finished product. But now most of the forthcoming album could be worked on without the entire band being there at any one time, thus relieving much of the nervous tension arising from the personal differences. As Richard Dashut would explain, "What you hear on the record is the best pieces assembled, a true aural collage."

After a total of five months ensconced in studios, the band went back on the road at the end of June 1976. The forthcoming album was still far from completed, but the live gigs were at least a welcome distraction from the personal affairs and fallouts of the band members.

Normal record company practice would be for a band to tour with a new album to promote, but previous long-player *Fleetwood Mac* was still ascending the American charts—a year after its July 1975 launch. Added to that, "Say You Love Me," the third single from the album, had appeared in the Top Forty list, and in September, over a year after its release, *Fleetwood Mac* topped the *Billboard* chart at No. 1.

Ironically, had the new album not suffered delays, the success of both would have been severely compromised by being around at the same time. And for *Fleetwood Mac*, success was almost an understatement, as the band received the best group and best album awards at the prestigious Don Kirshner-produced Rock Music Awards at the end of September. The band were stunned with their sudden promotion into the realm of superstars, but that was only the start.

There was still final work to be done on the new album, which now had a provisional title, *Yesterday's Gone*, taken from what would be a major song on the release, "Don't Stop."

ABOVE: *L-R: Stevie Nicks, Lindsey Buckingham, Christine McVie, John McVie, and Mick Fleetwood backstage at the Los Angeles Rock Awards, September 1, 1977, Los Angeles, California*

OPPOSITE: *Stevie Nicks live onstage, the Berkeley Community Theater, California, February 1977*

But as they were completing the final mixes, the band gradually realized that in fact the collection—though not a "concept album" as such—had a common theme in charting their complicated, and usually traumatic, personal relationships. Mick Fleetwood compared the album to a soap opera: "When we sat down listening to what we had, we realized every track was written about someone in the band . . . The album will show sides of people in this group that were never exposed before."

The title change for the album came about with the increasingly sensationalized press speculation about the band's personal affairs. Rumors were rife, some nearer the truth than others, and some totally fictitious. Christine would recall that it was possibly John who first came up with the idea of calling the album *Rumours*; not just because of the press speculation, but the fact that the material was highly confessional, a factor they didn't recognize as a group until all the songs were presented together.

TRIUMPH

Distancing the album from the continuing success of its predecessor, the release date for *Rumours* was scheduled for February 1977. With the Christmas market in mind, however, a single was released in the United States in December. "Go Your Own Way" hit No. 10 in the *Billboard* chart in January, just before the album itself was released on February 4, 1977.

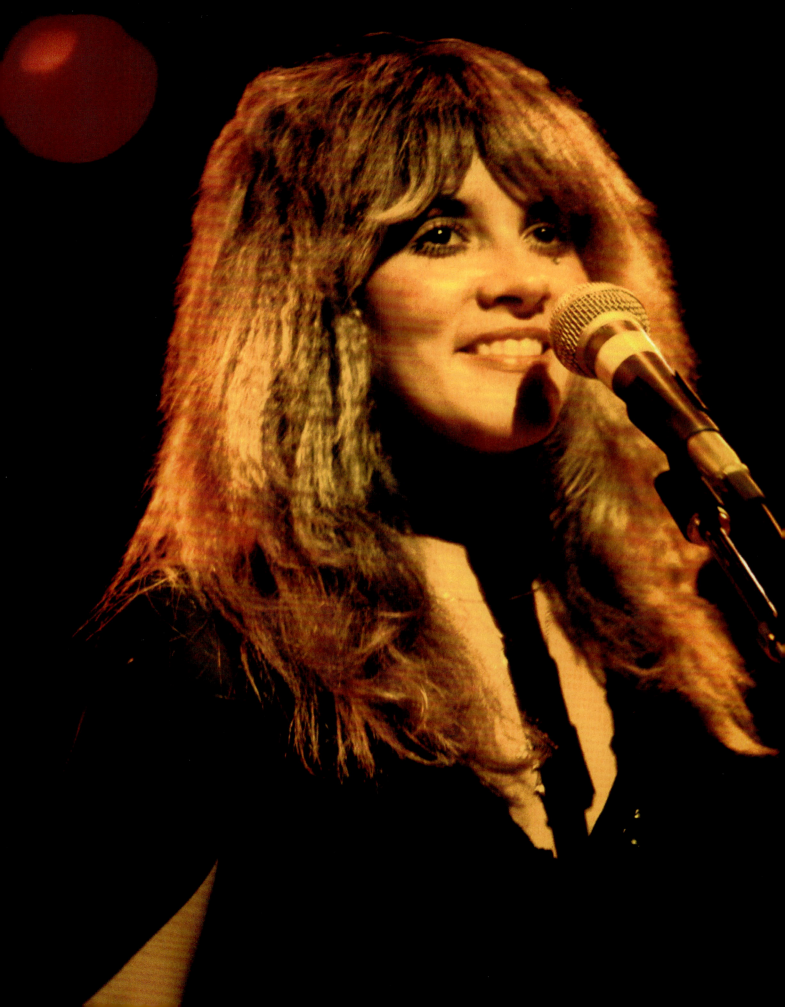

"We did not talk, period, except for the civilities in life like 'What key is this song in?' . . . so we just spent six months in the studio avoiding each other."

CHRISTINE MCVIE

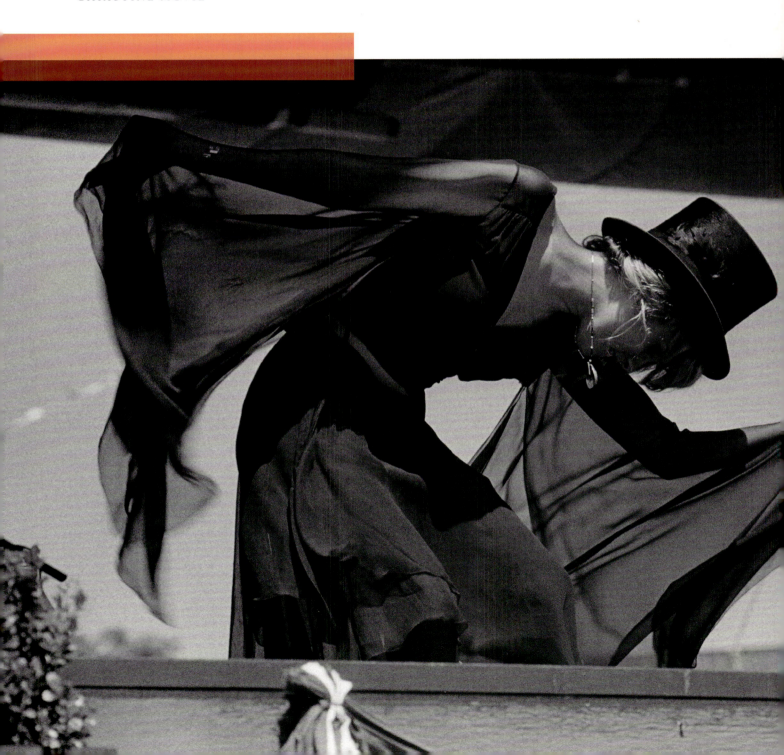

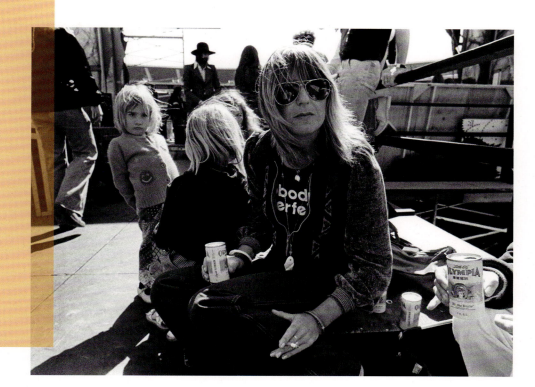

RIGHT: *Christine backstage at the Oakland Coliseum, California, 1977*

LEFT: *Stevie bewitches the audience, Oakland Coliseum, California, 1977*

As the album climbed up the US charts, the media obsession with the band's private affairs showed no sign of abating as their fame grew. *Rolling Stone* magazine—once the vanguard of radical hipness when it launched in 1967, and a decade later catering to a mainstream young adult readership—ran a cheeky cover photo of the band in bed together. The work of the renowned rock photographer Annie Leibovitz, the picture featured Christine, Lindsey, Stevie, and Mick entwined in each other's arms, while John, uninvolved, nonchalantly gazed at a girlie magazine. The picture flagged up an article inside by Cameron Crowe, "True Life Confessions of Fleetwood Mac."

Having managed themselves for some time, first under the unofficial auspices of Bob Welch, followed by Mick Fleetwood taking care of things, it was a logical next step for the band to create their own management company. Based in Beechwood Drive, Hollywood, Seedy Management was formed by John McVie and Mick Fleetwood; it included two publishing arms, Limited Management which handled other artists, and Penguin Promotions which looked after the band's touring. And soon after the release of *Rumours*, Penguin began organizing the band's next tour.

The trek, which started at the end of February, took the band around the United States for a month before hitting the UK and mainland Europe. The stage repertoire, which hardly varied night to night, concentrated heavily on the track lists from *Fleetwood Mac* and *Rumours*. The sold-out US dates were dominated by big venues, holding ten to fifteen thousand fans, while in England they played in smaller halls catering for three thousand or so. The band were apprehensive of how their traditional UK fans would react to the "new look" mainstream Mac, but the success of *Rumours* was repeated in the British chart, making No. 1 and remaining in the best-seller list for an amazing 938 weeks—at twelve years-plus, it holds the record for a continuous period in the UK chart for a studio album. As of 2021, it is also the eleventh best-selling album of all time

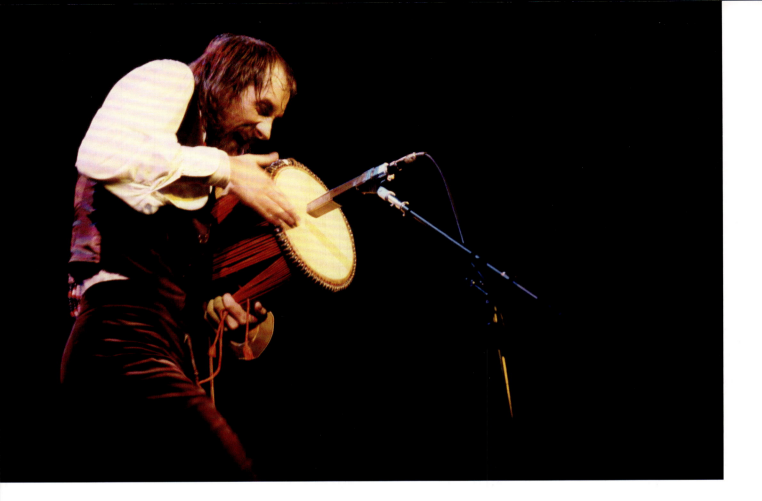

ABOVE: *Mick Fleetwood playing the hand drum live onstage, 1977*

in US history, and was selected for preservation in the National Recording Registry, as "culturally, historically, or aesthetically significant" by the Library of Congress in 2017.

Inevitably, some of the followers of old-school Fleetwood Mac didn't approve of the transition in the band's style, both in the UK and Europe, but they were as a voice in the wilderness. For every fan longing for the old days of Peter Green and Jeremy Spencer, there were hundreds sending *Rumours* into the album charts in Holland (where it made No. 1), Germany, France, Austria and elsewhere.

As was the case with *Fleetwood Mac*, sales of *Rumours* were invigorated by the release of more singles from the album through 1977. "Dreams" was released in the US at the end of March, becoming the band's only single to hit the top of the US chart a month later. The album itself topped the American long-player chart on May 21, with another single release—"Don't Stop"—in early July, which made No. 3. Then in September, "You Make Loving Fun" hit the No. 9 spot, completing a quartet of singles which accelerated the still burgeoning sales of *Rumours*.

Compared to many retrospective evaluations, the immediate response of most critics to the album was muted but encouraging. Tim Lott, in the UK music paper *Sounds*, conceded that it was possibly more memorable than first hearings might suggest: "It's not quite singalong, because it's not that uncomplicated—in fact the essence of the album is that it possesses enough underlying complexity to make it last and last, way past a few cursory listens." While in *Rolling Stone*, John Swenson recognized a continuity from Brit blues to California soft rock, especially evident in the vocal style of Christine McVie: "Without altering her basic sensibility McVie moves easily into the thematic trappings

of the California rock myth," concluding, "So Fleetwood Mac has finally realized the apotheosis of that early sixties blues crusade to get back to the roots. It's just that it took a couple of Californians and a few lessons from the Byrds, Buffalo Springfield and the Eagles to get there."

The album was breaking records throughout 1977. With initial orders from record stores totaling 800,000, it had the biggest advance sale in Warner Brothers' history. It was the label's biggest-ever seller by the end of the year, by which time it had shifted more than eight million copies. It topped the American chart continuously for six months, was earning a Gold disc award (for a half million sales) twice a month, and a Platinum disc (for a million sales) every month.

Years later, Mick Fleetwood acknowledged that were it not for the success of the album, the band may well have ground to a halt: "It was the most important album that we ever made," he declared in a 1997 TV documentary about the making of *Rumours*, ". . . it allowed Fleetwood Mac to continue for years and years after it, and I really feel that if we hadn't made that album, we may have hit the ultimate brick wall, and it may have stopped."

By the end of 1977, Fleetwood Mac were dominating the US music scene, and that position was mainly achieved through the overwhelming success of *Rumours*. At the annual readers' poll in *Rolling Stone*, the band was voted first in four categories: artist of the year, best album for *Rumours*, best single for "Dreams," and band of the year. Additionally, Stevie Nicks was voted second in the best female vocalist section, and the band (along with co-producers Richard Dashut and Ken Caillat) were fourth in the producer category for their work on the album. And a prime accolade came from the record industry itself, when *Rumours* won the Grammy award for 1977's Best Album of the year at the ceremony held in February 1978.

RIGHT: *At the 20th Annual Grammy Awards, 1978. L-R: Stevie Nicks, Mick Fleetwood (back), Lindsey Buckingham, Christine McVie, and John McVie (back)*

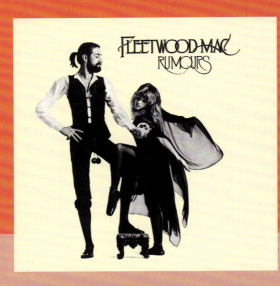

Original vinyl edition

RUMOURS

Side one
Second Hand News [Lindsey Buckingham]
Dreams [Stevie Nicks]
Never Going Back Again [Lindsey Buckingham]
Don't Stop [Christine McVie]
Go Your Own Way [Lindsey Buckingham]
Songbird [Christine McVie]

Side two
The Chain [Lindsey Buckingham, Mick Fleetwood, Christine McVie, John McVie, Stevie Nicks]
You Make Loving Fun [Christine McVie]
I Don't Want To Know [Stevie Nicks]
Oh Daddy [Christine McVie]
Gold Dust Woman [Stevie Nicks]

Recorded: 1976, Record Plant, Sausalito and Los Angeles, California; Wally Heider Studios, Los Angeles; Criteria Studios, Miami, Florida; Davlen Recording Studio, North Hollywood, California; Zellerbach Auditorium, Berkeley, California
Released: February 4, 1977
Label: Warner Bros. Records Inc.
Producers: Fleetwood Mac, Ken Caillat, Richard Dashut
Personnel: Stevie Nicks (vocals), Lindsey Buckingham (guitar, vocals), Christine McVie (vocals, keyboards), John McVie (bass guitar), Mick Fleetwood (drums, percussion)
Chart positions and awards: UK No. 1, fifteen Platinum discs, US No. 1, twenty Platinum discs, also No. 1 in Australia, Canada, Netherlands, New Zealand, and South Africa

TRACK-BY-TRACK

SECOND HAND NEWS
An incessantly upbeat opener, for which Lindsey Buckingham was originally inspired by the Bee Gees' "Jive Talkin'." The song, which was born out of an acoustic demo, features four audio tracks of electric guitar overlaid to achieve a jangling, folky rhythm off-set by a deliberately simplistic bass line. It starts the album on the autobiographical note—reflecting in this instance Buckingham's break-up with Stevie Nicks—that would be a constant throughout.

DREAMS
Stevie Nicks' ethereal persona, which was established with the iconic "Rhiannon" on the previous album, takes on the still-fresh trauma of her split with Buckingham, but with an optimistic hint in the lyrics. An insistent bass figure holds the whole thing together, backing Nicks' delicate vocals, which in turn benefit from some rich harmonic support in the choruses.

NEVER GOING BACK AGAIN
Another light-touch ballad from Lindsey, starting with a simple acoustic guitar and Mick Fleetwood using brushes to retain the almost fragile texture. A confessional, written as Buckingham was reeling from a short affair following his separation from Stevie.

DON'T STOP
A note of optimism is struck in Christine's spellbinder, which became an anthemic, singalong milestone in the Fleetwood Mac repertoire from thereon. The percussive keyboard sound was achieved by "tack" piano—nails fixed in the instrument where the hammers hit the strings achieve a distinct effect. Such was the hopeful message of the song—

> "It was the most important album that we ever made... it allowed Fleetwood Mac to continue for years and years after it, and I really feel that if we hadn't made that album, we may have hit the ultimate brick wall, and it may have stopped."
>
> MICK FLEETWOOD

the line "yesterday's gone" often being assumed to be the title—that Bill Clinton used it in his successful presidential campaign in 1992.

GO YOUR OWN WAY

Described by Mick Fleetwood as "a bittersweet testimony from one partner to another partner," Lindsey's pessimistic message to Stevie is the most aggrieved testament of personal angst on the album. Nevertheless, the solidly strident guitar backing and catchy vocal hooks make the track instantly memorable.

SONGBIRD

A tear-jerker which closed the first side of the vinyl album, Christine McVie's solo was not recorded in the studio but in the Zellerbach Auditorium at Berkeley University. The echo-laden atmosphere adds to the power of the quietly introspective lyrics. The song was later featured strongly in the repertoire of the singer Eva Cassidy, and used as the title of her posthumous 1998 album, two years after her death.

THE CHAIN

The only song on the album in which all members of the band receive a writing credit, and with its message of unity, a fitting collaboration. With effective changes of tempo, it adds up to a four-and-a-half-minute epic. Multi-layered to great effect, with parts of existing demos and edited studio out-takes from other songs being part of the collage, the overall message is one of harmony as far as the band as a totality is concerned.

YOU MAKE LOVING FUN

A casually swinging love song, written by Christine specifically about her boyfriend, the band's former lighting manager Curry Grant. Her keyboards include the sound of a clavinet, an electronic version of the clavichord (which dates from Renaissance times). The instrument was famously introduced in modern R&B music by Stevie Wonder on his 1972 hit "Superstition."

I DON'T WANT TO KNOW

Written by Stevie Nicks, the song dates back to the pre-Fleetwood Mac days of Buckingham Nicks in 1974. With a prominent, twelve-string guitar and close harmony vocals, the feel is one of folk rock—and composed under the admitted influence of the melodic rock 'n' roll of Buddy Holly.

OH DADDY

The final song from Christine McVie on the album, written about Mick Fleetwood and his wife Jenny Boyd, who had just reunited after a period apart. The song was created fairly spontaneously, including improvised bass guitar and keyboard interjections from the McVies. The title refers to the nickname the band had for their six-and-a-half-foot tall drummer, "The Big Daddy."

GOLD DUST WOMAN

Another languid ballad from Stevie, addressing the often volatile rock lifestyle in a city like Los Angeles. There's an element of free-form jazz, in a heady instrumental mix that includes music from a harpsichord, a country-style dobro, an acoustic guitar, and electric Stratocaster. And even, for added effect, the sound of breaking glass courtesy of Mick Fleetwood, some glass sheeting, and a large hammer.

"They changed their attitude about the music after they realized it wasn't going to sell as many copies. That's not really the point of doing it. The point is to shake people's preconceptions about pop."

LINDSEY BUCKINGHAM

TUSK

Hot on the heels of their US and UK-Europe treks, following the release of *Rumours*, in May 1977 the band commenced another North American tour. Stretching a full five months from May until early October, it was certainly one of their most exhausting string of appearances yet. And with *Rumours* selling heavily around the world, after just a month's break Fleetwood Mac then embarked on a tour of New Zealand, Australia, Japan, and Hawaii, which took them to the beginning of December.

But while the band were riding high on the phenomenal success of *Rumours*, filling stadiums and concert venues across North America, there was a new movement afoot at the grass roots level of club-based rock music. Punk had emerged in both London and New York, young upstarts (and their vociferous followers) who scorned the rock music establishment as typified by acts like Rod Stewart, Led Zeppelin and Elton John—and, of course, Fleetwood Mac.

Groups like the UK's Sex Pistols and The Damned, plus Ramones, Television and their contemporaries in America, despised the comfortable, middle-of-the road rock of the old guard. Instead, they introduced a no-holds-barred new wave which was injecting a fresh dynamic into music being produced at street level. And although he could hear that most of the new music was crude and spontaneous in its deliberate lack of cohesion, Lindsey Buckingham was fascinated by what was going on. When Fleetwood Mac were touring the UK in 1977, he made it his business to check out groups like The Clash, and began to take on board some of their ideas when thinking about Fleetwood Mac's next project in the recording studio.

RIGHT: *Stevie Nicks live onstage, the Alpine Valley Music Theater, Wisconsin, USA, July 1978*

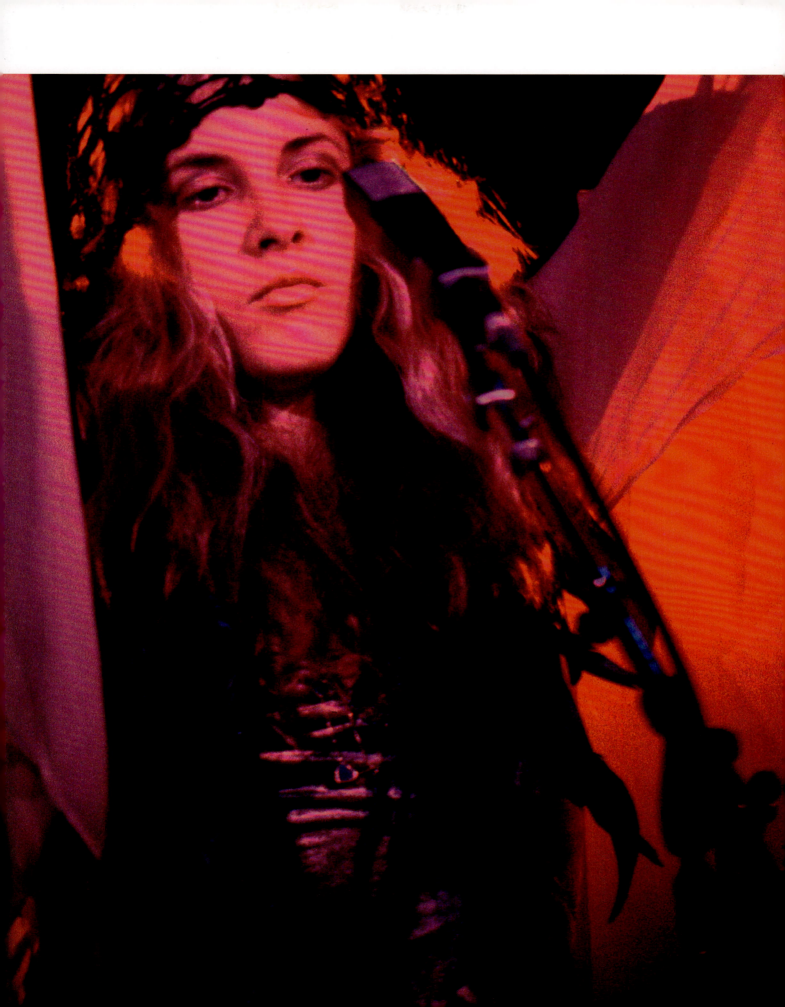

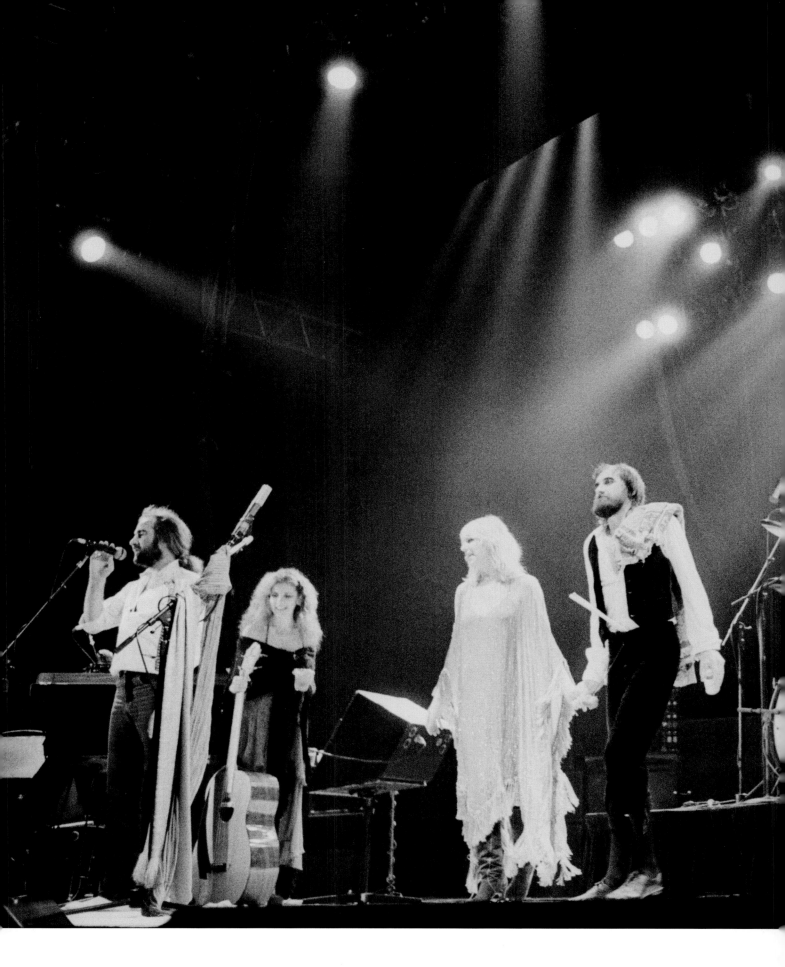

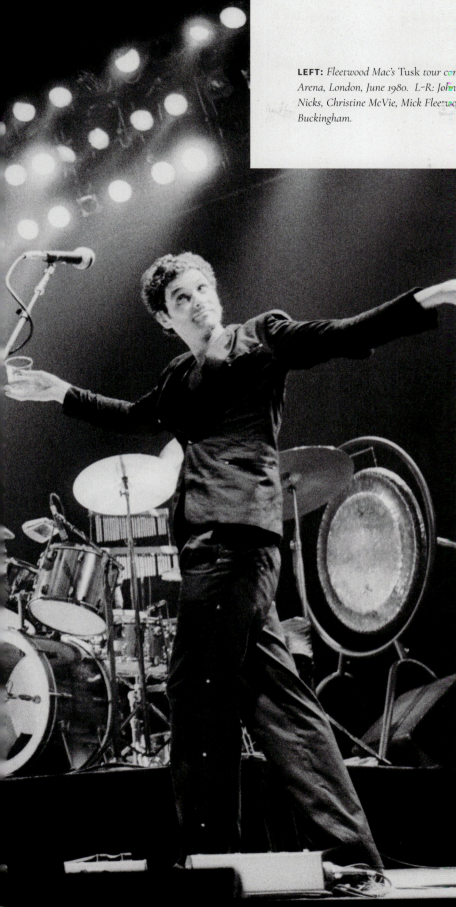

LEFT: *Fleetwood Mac's* Tusk *tour comes to Wembley Arena, London, June 1980. L-R: John McVie, Stevie Nicks, Christine McVie, Mick Fleetwood, and Lindsey Buckingham.*

Buckingham was the main musical brains and inspiration behind much of both *Fleetwood Mac* and *Rumours*, and while the record company wanted to repeat that success in terms of sales with a new album, the band certainly didn't want musical repetition. They were determined for a new release to be a conscious progression from *Rumours*, much as that album had been a step ahead from *Fleetwood Mac*. So for Lindsey, again at the creative helm in many ways, it was an opportunity to try out ideas he'd been taking note of from the punk musicians making waves throughout the music scene.

The first thing the band decided to establish about the new project—at the specific behest of Mick Fleetwood—was that the release would take the form of a double album. This was no easy proposal to get past the record company, Warner Brothers, who were famously reticent about spending large amounts of money. Mick proposed that they buy their own studio to avoid hourly rates, with money advanced by Warners. In the event, the company said no, so instead the band spent money they already had on a custom-built annex created at the Village Recorder complex in Los Angeles.

From the word go, Lindsey had his own ideas about how the recording should progress. Taking on the sparse, in-your-face dynamics of the punks, he announced that he wanted to record some of the material at home, coming into the studio later with prepared vocal and guitar parts. While this ran

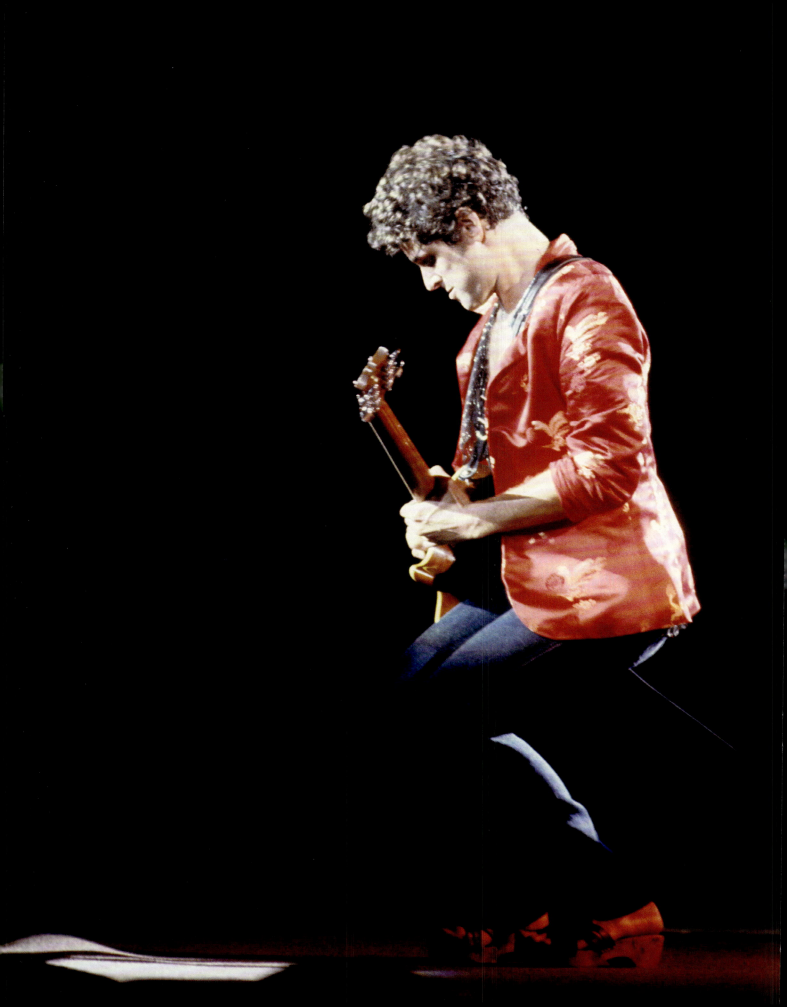

in the face of the basic punk ethos of recording as-live there and then in the studio, he hoped it would avoid the personality-driven friction that had previously dogged sessions and added to interminable delays in the production process. Mick Fleetwood was not happy with the idea, saying: "It was felt that this kind of segregation away from the cauldron of traditional Fleetwood Mac group creativity in the studio was . . . unhealthy," but let Lindsey get on with it regardless.

> "When a group reach Mac's status, their audience isn't sitting out there waiting to judge. They come to adore, to receive the blessings of a magic presence."
>
> RICHARD GRABEL, *NEW MUSICAL EXPRESS*

Lindsey was still very much part of the studio work, as a dynamic member of the production team. Along with much of the material he had been working on privately, Buckingham began creating radically experimental music which ended up in one form or another as part of the double album. And although Mick had already mooted the plan for a double format, Christine would later claim that it was the inclusion of Lindsey's more radical tracks that eventually resulted in the two-disc release.

Fleetwood Mac spent ten months studio time making *Tusk*, with a much-anticipated release on October 12, 1979. There was a sharp difference between the conventional, melodic songs courtesy of Christine and Stevie, and the decidedly *avant-garde* Lindsey Buckingham. John McVie wasn't the only person, on reflection, who thought it sounded like the work of three solo artists. And the critical reception was as mixed as the nature of the material, many reviews claiming that a single album of the more conventional material would have been more satisfactory. Indeed, Lindsey's original thoughts of a solo album might have worked better after all.

One bone of contention with both fans and the record company was the cost of the release. In recording and producing the album, the total expenditure came to over one and a half million dollars—at the time, the most expensive album ever made. With that in mind, Warner Brothers were concerned how fans might react to a double-disc price in the shops; the company even suggested two discs released individually, but the band were adamant it would go out as planned.

Eventually *Tusk* sold over four million copies worldwide, but was seen as a failure by Warner Brothers when compared to the sales figures for *Rumours*. And the company were quick to lay the blame with Lindsey Buckingham's uncommercial tracks. Buckingham would defend the album passionately, especially when the others seemed to be blaming him for the "disappointing" sales: "I got a lot of support from the band during the making of *Tusk*; everyone was really excited about it. Then, when it became apparent that it wasn't going to sell fifteen million albums, the attitude started to change—which was sad for me in a way, because it makes me wonder where everyone's priorities are.

OPPOSITE: *Lindsey performing live onstage, Wisconsin, USA, 1978*

They changed their attitude about the music after they realized it wasn't going to sell as many copies. That's not really the point of doing it. The point is to shake people's preconceptions about pop."

Mick Fleetwood, on the other hand, always insists he has great affection for the album. But he would admit that at the time he was apprehensive that the very separate stance of the three writers' material might encourage them to leave and do their own thing—very often a situation that led to bands splitting up. Music journalist Al Aronowitz made the same point in a *Washington Post* review, comparing the situation to the Beatles' "White" album, where the double album format allowed more room for the principal songwriters to express their separate musical personalities.

But despite all the reservations about its length and price, *Tusk* went on to make the No. 4 slot in the American chart, earning two Platinum discs in the process. Likewise it earned a Platinum award in the UK, where it topped the album chart and stayed in the Top 100 for six months.

Four singles from the album were released in the US, three of which were hits in the top twenty chart. The first was the title track "Tusk," released a month before the album. It made No. 8 in *Billboard*, and No. 6 in the UK, where it sold over a quarter of a million copies and was awarded a Silver disc.

SUPERSTARS

In the wake of the commercial triumph of *Rumours*, by the time they went into the studio to make *Tusk* every member of Fleetwood Mac was already a millionaire several times over. Mick Fleetwood would assess his wealth from *Rumours* alone topping the three million dollar mark, and as the main songwriters, Lindsey, Christine, and Stevie must have earned considerably more.

And privately, when they weren't on the road, the individual members certainly lived up to the image of millionaire rock stars. John McVie bought himself a Hollywood home in Beverly Hills and his first sailing boat. His estranged wife Christine also purchased a classic Los Angeles property, complete with personal staff, maids, and a custom-built studio to indulge in her art school passion of sculpture.

Mick Fleetwood, whose life with Jenny Boyd was becoming more and more fractured, indulged himself in a growing collection of classic vintage cars at his house in Malibu, while Lindsey Buckingham also found himself the owner of a grand LA pad. And Stevie Nicks purchased a big spread outside Phoenix, Arizona, the city of her birth where she spent much of her childhood.

But throughout 1978 and into 1979, while the band were working on *Tusk*, the personal affairs of the individual members—despite their opulent circumstances—were far from idyllic.

After living separately for some time, John and Christine had finally divorced, with John moving out of their house in Topanga to live on his forty-foot boat *Adelie* at Marina Del Ray. It was during that period of 1978 that he began a lightning affair with an employee at the band's office, Julie Ann Reubens, the pair getting married at an extravagant celebration—with Mick Fleetwood as best man—later in the year.

Christine's love life, meanwhile, was still full of surprises. Her ongoing relationship with the ex-Mac lighting man Curry Grant was grinding to a halt, and soon after her

OPPOSITE: *Mick Fleetwood and Stevie Nicks, 1980*

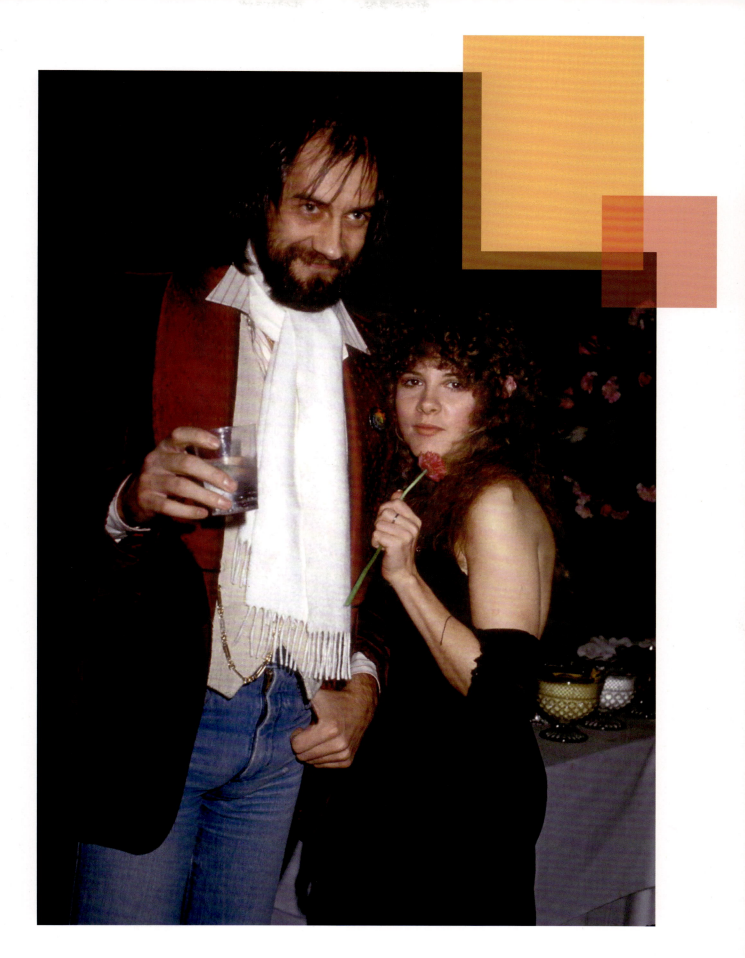

divorce from John McVie she hooked up with the volatile Beach Boys drummer Dennis Wilson. With Grant moving out of Christine's home and Wilson moving in, it was the start of a stormy three-year relationship during which they lived at the Beverly Hills house and Wilson's flashy boat at Marina Del Ray.

Mick Fleetwood's affairs were no less incendiary. He had reunited with Jenny and for most of 1978 seemed, to all intents and purposes, to have found an amicable life, but even on the surface things were far from perfect. For a start, they lived in separate homes, with Jenny and their two daughters in Malibu, and Mick in his luxurious Bel Air pile. He was also involved in a relationship with Stevie Nicks which had begun during the band's concerts in New Zealand closing the *Rumours* tour at the end of 1977. She was still seeing the Eagles' drummer Don Henley. According to Fleetwood's autobiography, the relationship had started in LA, but developed into something more serious during their time down under. They both played something of an on-and-off game as far as seeing each other was concerned, keeping their distance when necessary in the interest of band professionalism. When Fleetwood admitted to his affair, that was one transgression too far for Jenny. She finally brought an end to their marriage by moving back to England with the girls.

Things were further complicated when Fleetwood revealed to Stevie that he was now in love with her close friend Sara, then married to Jim Recor, who worked in the

BELOW: *At Mick Fleetwood and Sara Recor's wedding in 1988. The couple had been together since 1978.*

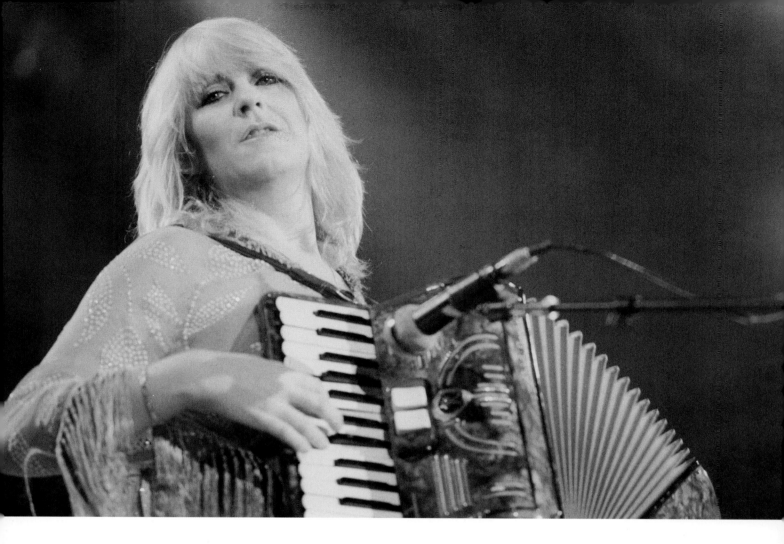

management of the rock act Loggins and Messina. When the duo toured with Fleetwood Mac, she became good friends with Stevie Nicks. When early in November 1978 the pair revealed their relationship, it shocked all those around them—although Jim Recor accepted the situation, even shaking hands with Mick to confirm they were still friends.

Stevie was distraught, as she recalled in a TV documentary years later: "I lost Mick and my friend Sara in one fell swoop." And Stevie would reference the affair in the *Tusk* track "Sara," which became the second single to be released from the album, in December 1979. It would be nearly ten years before the couple were actually married in 1988, at a spectacular wedding with guests including Bob Dylan, George Harrison, and best man John McVie. What would prove to be a stormy marriage came to an end when the pair divorced in the early 1990s.

After his traumatic break-up with Stevie Nicks, Lindsey Buckingham coasted along unattached for some time, mostly with informal girlfriends or in short-lived affairs, until 1978, when he started seeing Carol Ann Harris. She was a secretary with a record company and was a would-be model; their relationship would last a good six years.

Meantime, Stevie Nicks was still involved with Don Henley. The final days of Stevie's relationship with Henley would come when the band set off on their most ambitious schedule yet—the *Tusk* tour, lasting from October 1979 to September 1980.

The marathon trek would see the band playing in the United States, Canada, Australia, New Zealand, Japan, France, Belgium, Switzerland, Germany, the Netherlands,

ABOVE: *Christine plays accordion live onstage, Wembley Arena, London, June 1980*

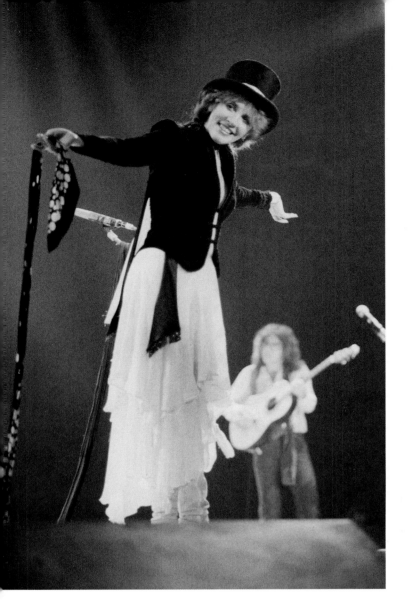

ABOVE AND OPPOSITE:
Fleetwood Mac live onstage, Wembley Arena, London. The band played six shows between June 20 and June 27, 1980.

and the United Kingdom—playing a total of 113 concerts in all. Determined to defy the critics who said that the material on *Tusk* was not as listener-friendly as on previous releases, the band played nine songs from the new album. To achieve the sound of the more extravagant arrangements on the record, which had involved much studio overdubbing, they hired three extra players to augment the onstage line-up—Ray Lindsey on guitar, Jeffrey Sova on keyboards, and Tony Todaro on percussion.

While the band were playing the Australasian leg of the tour, the third single from *Tusk* was released in March 1980. Christine's "Think About Me," with Lindsey's "Save Me a Place" as the B-side, made US No. 20, and boosted album sales. Likewise, the fourth spin-off single, Stevie's "Sisters of the Moon," helped sales while the band were playing Europe in June.

By the mid-seventies, a touring rock band with the kind of success that Fleetwood Mac were enjoying was truly living a life of luxury. Private planes were at their disposal, and they stayed in only the best hotels. No expense was spared, and riders in their contracts ensured that backstage every need was catered for, from extravagant food piled high to an unending supply of alcohol. Plus readily available drugs. John McVie would recall they were just like a bunch of kids let loose in a toy shop, and on a night-to-night basis their lifestyle was a fine balancing act in order to deliver their best performances.

They played the biggest venues possible, where the band were a miniscule sight for the majority of the crowd, but one they could hear perfectly. Reviewing their gig at New York's Madison Square Garden for *New Musical Express* in November 1979, Richard Grabel described how their fans came to worship uncritically: "So I wanted to know: how do these hit-makers face up to the crucial point when performer meets audience? Not that there is likely to be much of a confrontation here. When a group reach Mac's status, their audience isn't sitting out there waiting to judge. They come to adore, to receive the blessings of a magic presence." Another music writer compared the fan adoration that the band were generating to the hysterical scenes of Beatlemania in the 1960s, likening their appearance in San Francisco to "a teenage rock 'n' roll show."

After their European dates, which had finished with six sell-out shows at London's Wembley Arena, the band took a month off in July 1980, during which they completed

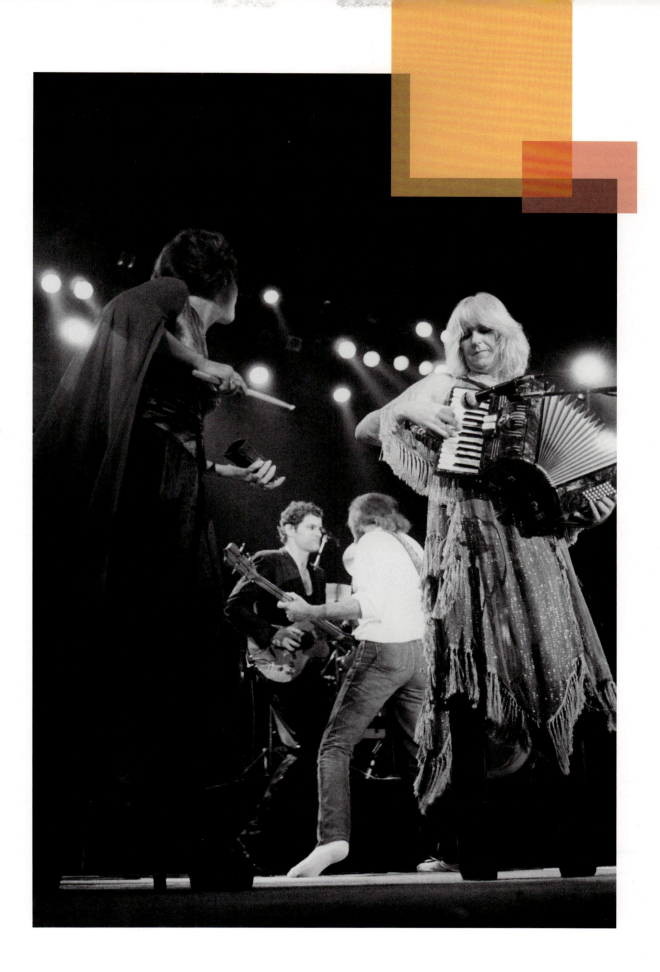

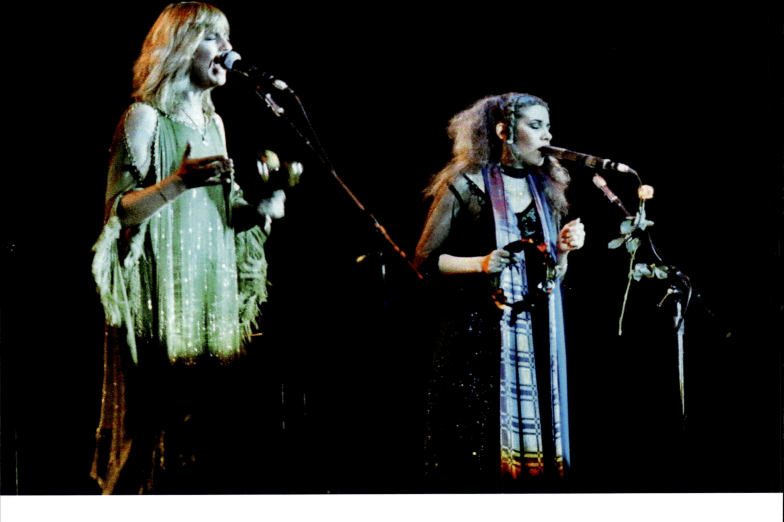

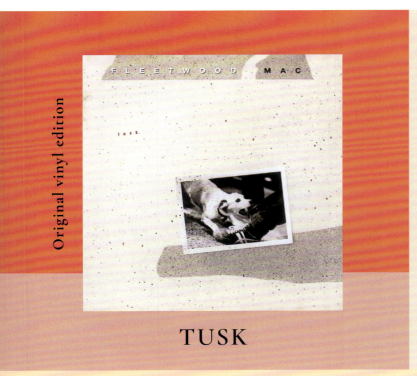

Original vinyl edition

TUSK

Side one
Over & Over [Christine McVie]
The Ledge [Lindsey Buckingham]
Think About Me [Christine McVie]
Save Me A Place [Lindsey Buckingham]
Sara [Stevie Nicks]

Side two
What Makes You Think You're The One [Lindsey Buckingham]
Storms [Stevie Nicks]
That's All For Everyone [Lindsey Buckingham]
Not That Funny [Lindsey Buckingham]
Sisters Of The Moon [Stevie Nicks]

mixing a live album, which had been a pet project for Mick Fleetwood since 1977. The others had never been that keen on the idea, but most of their live appearances since that date had been recorded, and now the feeling was that with over four hundred shows in the can for potential posterity, perhaps it was a good idea after all.

In the event, *Fleetwood Mac Live*, which featured concert recordings from 1977 to 1980, and one from 1975, did far better than the naysayers had feared when it was released in December 1980. It gained Gold disc status for sales in both the US and UK, making the US No. 14 spot.

Like *Tusk*, the live album broke new ground in that it was mixed digitally, a technical innovation in 1980. As co-producer Ken Caillat enthused, when interviewed about the process: "With analogue recording there's always some difference—in addition to the tape hiss there are little changes in the transient response. Digital will eliminate any harmonic distortion. It'll eliminate amplifier noise, it'll eliminate tape noise . . . Basically, what you'll get from the time you put a microphone in front of an instrument until the person at home listens to it should be identical."

A portent of the future. But in the short term, with no further Fleetwood Mac albums on the horizon and various solo projects being developed, there was increasing speculation that perhaps the band's future as an ongoing unit was in doubt.

LEFT: *Christine, Stevie, and Lindsey performing live onstage, Wembley Arena, London, June 1980*

Side three
Angel [Stevie Nicks]
That's Enough for Me [Lindsey Buckingham]
Brown Eyes [Christine McVie]
Never Make Me Cry [Christine McVie]
I Know I'm not Wrong [Lindsey Buckingham]

Side four
Honey Hi [Christine McVie]
Beautiful Child [Stevie Nicks]
Walk a Thin Line [Lindsey Buckingham]
Tusk [Lindsey Buckingham]
Never Forget [Christine McVie]

Recorded: 1978-1979, The Village Recorder, Los Angeles
Released: October 12, 1979
Label: Warner Bros. Records Inc.
Producers: Fleetwood Mac, Ken Caillat, Richard Dashut
Personnel: Stevie Nicks (vocals, keyboards), Lindsey Buckingham (guitar, piano, bass guitar, drums, harmonica, vocals), Christine McVie (vocals, keyboards), John McVie (bass guitar), Mick Fleetwood (drums, percussion)
Additional personnel: University of Southern California Trojan Marching Band, Peter Green (guitar) uncredited, George Harrison (guitar) uncredited
Chart position and awards: US No. 4, two Platinum discs, UK No. 1, Platinum disc

TRACK-BY-TRACK

OVER & OVER
A lush sounding but seductively laid-back track from Christine as an opener, vaguely reminiscent of the Fleetwood Mac period between Peter Green and Lindsey Buckingham. A firm candidate for the easy listening market, in stark contrast to some of the tracks to come.

THE LEDGE
A short but nevertheless arresting change of mood, with Lindsey Buckingham's first foray into the world of punk and new wave music. Overlays of his weird-sounding vocals, further distorted by electronic trickery, make for a manic, two-beat bassline excursion that never allows the listener to relax for a second.

THINK ABOUT ME
Released in March 1980 as the third track from the album to also appear as a single. With the following track "Save Me A Place" as the flipside, it just made the US Top Twenty best sellers at No. 20. Another candidate for mainstream rock radio, a melodic, feel-good, mid-tempo performance from Ms McVie.

SAVE ME A PLACE
Another track recorded solely by Lindsey, here referencing the influence of the Beach Boys with some tight harmonies on the jaunty singalong melody.

SARA
Much in the trademark Nicks style established by "Rhiannon," Stevie shines with an arresting melody, rich harmonies and generally atmospheric production. It was the second single to be pulled from *Tusk*, cut to four-and-a-half-minutes from the original album length of six-and-a-half. The Sara of the title was her good friend Sara Recor, who had been in a relationship with Mick Fleetwood since late 1978, when he was also still involved with Stevie.

WHAT MAKES YOU THINK YOU'RE THE ONE
Once again Buckingham affects some odd vocal textures in a bouncy, but ultimately vacuous-sounding, rocker. Oozing with a strident self-confidence that belies the ephemeral feeling of the whole song.

STORMS
Another atmospheric ballad from Stevie. A haunting melody backed by sensuous harmony vocals, and delicate acoustic guitars. Along with the aforementioned "Sara" and its predecessor "Rhiannon," pure pop drama of the highest order.

THAT'S ALL FOR EVERYONE
A dreamier Lindsey here with echo-laden reverb dominant in the mix, and again with the Beach Boys' inspiration very evident.

NOT THAT FUNNY
As in "The Ledge," another excursion into Lindsey's fervid imagination, with the sounds of new wave bands never far from the surface. With fuzz-box guitar to the fore, the caustic lyrics give a menacing edge to the song. Released as a single in the UK only.

LEFT: *Stevie Nicks, 1978*

SISTERS OF THE MOON
One of the rockier contributions from Stevie Nicks, with an echo-heavy guitar that melds perfectly with almost sinister lyrics. In retrospect, some critics have rated Nicks' parts in the album as her best recordings of her career. The fourth spin-off single from the album, it only made US No. 86.

ANGEL
Opening the second disc of the original vinyl release, a funkier Stevie than we've been used to elsewhere on the album. A rolling, bittersweet up-tempo ballad, handsomely supported by John McVie's ever reliable basslines and Mick's no-frills percussion.

THAT'S ENOUGH FOR ME
A countrified Lindsey here, it's short (at less than two minutes), fast-paced, and to the point. The third of three tracks on the album recorded completely solo, a rockabilly rampage that doesn't let up.

BROWN EYES
For Christine, an unexpected venture into the atmospheric world more associated with Stevie Nicks' songs. The dreamy delivery is enhanced by the backing vocals' evocative harmonies and doo-wop-inspired "sha la las." Plus some chilling guitar from an uncredited guest appearance by Peter Green.

NEVER MAKE ME CRY
Christine McVie breaking away from her usual keyboard/piano accompaniment, in a short, shimmering arrangement built around the sensual ebb and flow of waves of guitar.

> "Tusk sold nine million copies so it can't be too shabby can it? But a lot of people gave us flak about that album."
> — CHRISTINE MCVIE

I KNOW I'M NOT WRONG
Again, Lindsey manages to encapsulate a catchy melody line in an otherwise overtly leftfield production job. Jangling countrified guitars keep things on a more familiar keel, with a harmonica riff there in the mix. In many ways Buckingham's most satisfying track.

HONEY HI
Opening the final side of vinyl, Christine at her most relaxed with some intricate harmony vocals. It's possibly a song written on the road, in a lament for absent love, but with a bright, upbeat feel throughout.

BEAUTIFUL CHILD
A more straightforward ballad style than usual from Stevie. The stripped-down arrangement gives ample room for us to appreciate the raw beauty of both some exquisite harmony touches, and Nicks' heartrending, trademark vibrato.

WALK A THIN LINE
A more somnambulant Lindsey than usual. Again, the experimental sound of mid-sixties Beach Boys springs to mind, in a seemingly slight, laid-back number that can nevertheless become an earworm.

TUSK
Based on a drum riff that Mick played to Lindsey, which starts gradually then builds to a pounding stomp, driving a battalion of horns in its wake. The first single released, it introduced African-inspired percussion to the pop charts, as the song developed from a basic guitar and drum riff to a full-on, brass band celebration. Audaciously, Mick decided to record the horns live in situ, with a mobile unit from Wally Heider's studio locating to the LA Dodgers baseball ground, for an extravagant performance by the 112-strong University of Southern California Trojan Marching Band. It was used for an effective promo video.

NEVER FORGET
Christine's straight-down-the line closer, a brisk-sounding pop song that typifies the basic heart of the band at this stage in their career. A solid mid-tempo rocker that ties things up somewhat cozily, after the unexpected surprises and shifts from one style to another that characterizes much of the album.

"It took a year to make, but then in the meantime there was Lindsey, Mick, and Stevie's solo stuff, so in fact we had four albums in a year, which is pretty good if you look at it that way."

CHRISTINE MCVIE

MIRAGE

In the aftermath of *Tusk*, Fleetwood Mac as a unit did indeed seem to have reached a dead end. Not that the individual members were lacking in ideas or musical inspiration, but the sheer stress of being a continuous item was wearing heavily on each of them. Life on the road took its inevitable toll, as did the pressure of the constant expectation of a new album to follow the previous one.

Tusk had received a fair amount of criticism from both skeptical journalists and seasoned Mac followers, although as Christine would observe at the time of their next album a couple of years later, "*Tusk* sold nine million copies so it can't be too shabby can it? But a lot of people gave us flak about that album."

In the wake of the album, there began a period characterized by solo enterprises and after the *Tusk* tour concluded in the fall of 1980, it would be more than a year before the band got together again.

Meanwhile a meeting was convened to assess the financial outcome of the whole exercise. Mick Fleetwood had, of course, been acting as the band's manager for some years now—both in an individual capacity, and then as partner with John McVie in Seedy Management—attending to the day-to-day running of the group. The longer-term financial issues were overseen by their regular lawyer Mickey Shapiro. But at this latest financial summit, there were additional faces around the table; while the McVies and Fleetwood were represented by Shapiro as usual, Buckingham and Nicks both had their own accountants and lawyers. As they went through the books, the gathering of professionals was amazed that despite the huge performance fees and shares of the box office receipts, the tour had ended up not making a lot of money. Mick laboriously described item-by-item the expenses they would run up on the road, from the best hotels and private planes, to their various extravagances (at least the legal ones) backstage. But there were still large amounts of cash that were not accounted for, drawing a tacit implication among the lawyers that someone had been less than honest. From Mick's point of view, it was if the band (or individuals within the band) were being accused of the loss of money, money that they had, in fact, earned in the first place.

The immediate upshot was Mick having to relinquish his role as "manager," to be replaced by a committee of accountants, lawyers, managers, and all five members of Fleetwood Mac. A dominant voice in the reorganization was Irving Azoff, a tough music industry heavyweight who was also looking after Stevie Nicks' affairs, as well as managing the Eagles. He insisted there should be less of the lavish spending from here on in, and for a way be made possible for his client to follow her own ambition as well, which meant a solo album.

OPPOSITE: *Fleetwood Mac, 1982*

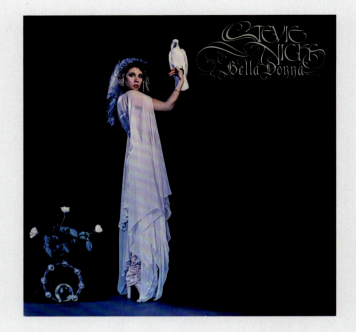

ABOVE: Bella Donna, *1981*. The debut solo album from Stevie Nicks.

Following the momentous meeting—with the rest of the band assuring their drummer that there was no sinister plot to oust him—Fleetwood Mac decided to lay off for nine months. Through the early months of 1981, solo albums by Mick, Stevie, and Lindsey were recorded and both their fans and the music press could be forgiven for surmising that the band might have, indeed, broken up. However, speculation concerning the band's demise proved to be unfounded. In November 1981 the group got together again to begin work on their next album.

Rather than choosing a studio in Los Angeles, or even London or New York, as would be expected, the band instead opted for a grand eighteenth-century French mansion near Paris, Le Château d'Hérouville. The opulent house had been converted into a high-end recording studio in the early 1970s, and boasted some of the biggest names in rock and pop music as its clients, including T Rex, Pink Floyd, David Bowie, and Iggy Pop. Among famous anthems recorded there was the Bee Gee's "Stayin' Alive" from *Saturday Night Fever*, and Elton John had referred to the studio in the title of his 1972 album *Honky Château*.

Two years had passed since the release of *Tusk*, so expectations were high on all sides. The record-breaking success of *Rumours* was nigh-on impossible to repeat, and the band—and record company—were anxious to avoid some of the more experimental excesses of *Tusk*.

One of the problems they had encountered as a group with the previous album was the disparate presence of various members at any given time. There had been a cut-and-paste attitude on *Tusk*, with contributions often recorded separately, along with edits, overdubs and so on. Now, for the first time in ages, the band were thrust together in the one working space for days on end. John couldn't record his bass parts and go off sailing, or Lindsey appear with half-finished tracks he had fashioned at home.

Likewise, paying for studio time was now recognized as a constraining factor, rather than the band entertaining the illusion that there was a limitless budget. This concentrated the collective mind, and enforced a discipline that had been absent in their most recent projects. As a result, the basic recording in France was made in a few weeks, followed by mixing, overdubbing and editing taking place in Los Angeles through into the spring of 1982.

The album *Mirage*, released on June 18, 1982, was distinguished as something of a return to the listener-friendly ambience of *Rumours*, but without the angst-heavy lyrics. As Christine would describe it, the "straightforward simple rock 'n' roll songs" were "an awful lot happier. *Rumours* was kind of the message of doom, the songs were up but the words were all about each other's jaded love lives."

ABOVE: *Stevie Nicks performs live onstage with Tom Petty, 1981*

GOING SOLO

During the nine-month break before the recording of *Mirage*, Stevie Nicks had been the first off the solo starting blocks. Indeed, solo albums had always been a distinct possibility alongside her career as a member of Fleetwood Mac. Not long after joining, in 1976 she had set up a record company, Modern Records, with two business partners, Paul Fishkin and Danny Goldberg. The long-term plan was for Stevie to establish a parallel solo career. As the only front-line vocalist who was not also an instrumentalist—as in the case of both Lindsey and Christine—she was literally a leading voice in the band, as she was well aware of: "Fleetwood Mac couldn't go onstage without me or Chris. We've fought hard to be anything but background singers. I think we would rather quit and do something else than be a background singer." And she would stress, time and time again, that Fleetwood Mac was always the first priority.

As a consequence, any solo projects were continually being postponed. Her fledgling company had secured a distribution deal with Atlantic Records, but it was four years before Modern could contemplate the first Stevie Nicks solo album. While still on the *Tusk* tour, Nicks had been writing new material and recording demos. But much of her

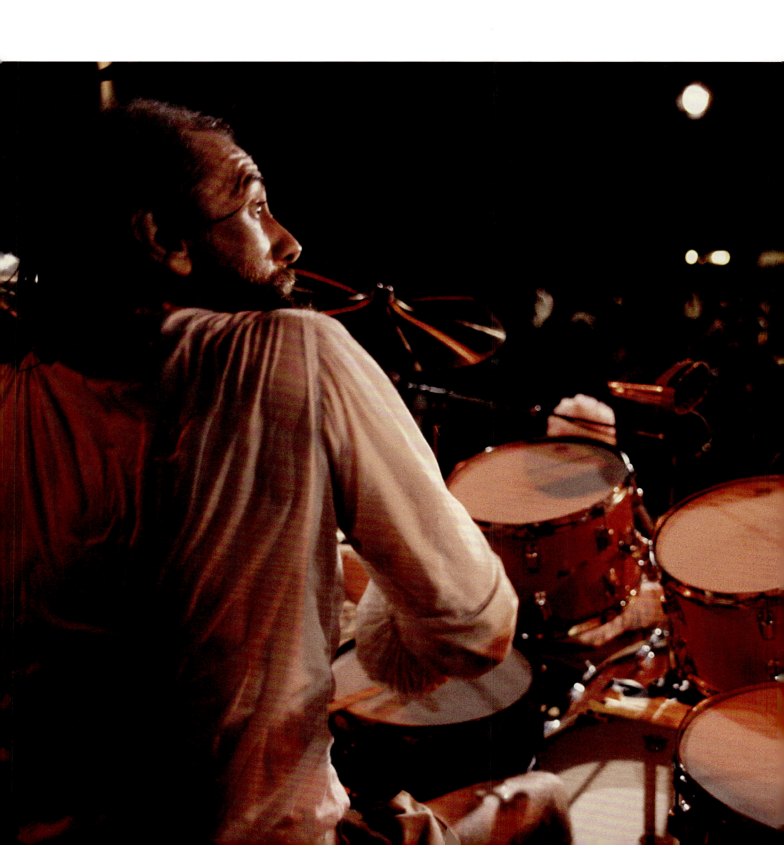

output, stretching back long before *Tusk*, would never be used by the band, as the repertoire had to be split between herself, Christine, and Lindsey. Contemplating the dozens of her songs that had accumulated, unused by the group, she decided that now was the chance to concentrate on some serious solo work in the recording studio.

During the tour, some of the demos Stevie made were with Tom Petty and the Heartbreakers, so it was a natural choice to have most of that band—along with her recent boyfriend Don Henley of the Eagles—as the core line-up. She was also able to engage the pick of other musicians for the sessions, given that she was now lead singer in arguably the biggest band in the world. Luminaries on various tracks included the legendary Memphis bass player Donald "Duck" Dunn, Bruce Springsteen's pianist Roy Bittan, and Elton John's guitar player Davey Johnstone. Plus there were backing vocals provided by two singers who would feature on all Stevie's solo albums thereafter, Sharon Celani, and Lori Perry.

The album would be called *Bella Donna*, and the numerous recording sessions stretched from the fall of 1980 through to the spring of 1981, mainly at Studio 55 in Los Angeles. Over twenty musicians took part in total, with ten tracks eventually chosen for

LEFT: *Mick Fleetwood giving a live performance in a club in Ghana, Africa, February 1981*

ABOVE: *Peter Green, circa 1980. Peter, credited as Peter Greenbaum, sings lead vocals and plays lead guitar on "Rattlesnake Shake" on Mick's debut solo album,* The Visitor.

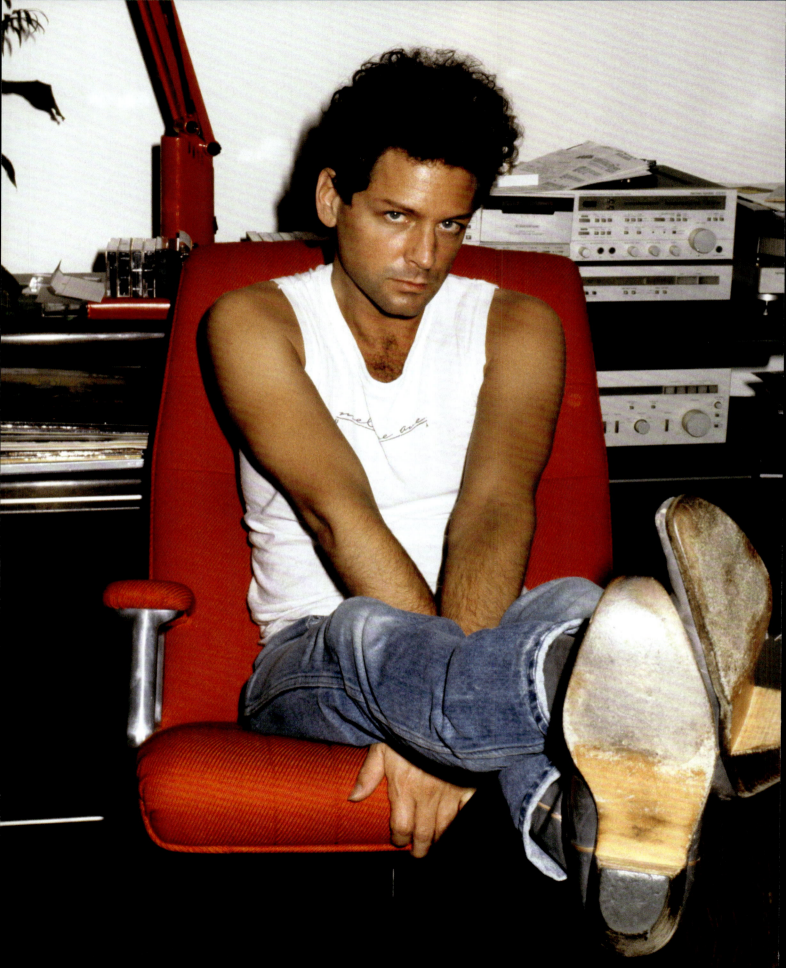

the release of July 27, 1981. It was a sure-fire hit from the start, attaining the No. 1 spot in the *Billboard* US chart in the September, and earning a Platinum disc in early October. It went on to sell over four million copies in the US alone. It was also a chart-topper in Australia, and peaked at UK No. 11. The album also spawned four US hit singles in 1981 and 1982: the duet with Tom Petty, "Stop Dragging My Heart Around," hit No. 3 six months before the album release, "Leather and Lace" with Don Henley made the No. 6 spot in July 1981, "The Edge of Seventeen" was at No. 11 in June 1982, and "After the Glitter Fades" (which Stevie had written in 1974) hit No. 32 in the Top Forty at the end of 1982.

> "Fleetwood Mac couldn't go onstage without me or Chris. We've fought hard to be anything but background singers. I think we would rather quit and do something else than be a background singer."
>
> STEVIE NICKS

Four months after the release of *Bella Donna*, Stevie—now a star name in her solo capacity—took off on a short promotional tour. It started on November 27, and consisted of just ten concerts—five of which were at one venue, the Wilshire Fox Theater in Los Angeles. Called the White Wing Dove Tour, the mini-trek ended up at the Fox on December 13, where the show was recorded for an HBO TV special, *White Wing Dove: Stevie Nicks In Concert*.

Fleetwood Mac's sabbatical also allowed Mick Fleetwood to indulge in a pet project that wouldn't have been possible under the band's normal schedules. The drummer had long been fascinated by the music of Ghana, on the west coast of Africa. It was from that area of the continent that the slave trade had flourished, transporting millions of Africans to the Americas, through the sixteenth to the nineteenth century. And with them came their drum-based music, which in the USA evolved in the twentieth century into blues, jazz, rock 'n' roll, and all its many variations. Mick decided the break was the chance to fulfill a long-held ambition, to record in Ghana using local musicians—particularly local drummers.

He assumed there would be ample funding for the project from Warner Brothers, considering the millions of dollars they had earned, and were still earning, from *Rumours* alone. He estimated he would need up to half a million dollars to get the project off the ground, what with transport of equipment, and setting up sessions around the country. But the record company—as ever, wary of spending money that they deemed an unnecessary risk—turned him down. Fleetwood took his idea around the other major record outfits, and found a benefactor in RCA.

Mick flew out to the Ghana capital, Accra, in December 1980. On this first research trip, he was accompanied by lawyer Mickey Shapiro, and their immediate impression was of a run-down city that had certainly seen better days. In their hotel the telephones

OPPOSITE: *Lindsey Buckingham at WEA Records in Soho, London, 1980*

were unreliable, the elevators didn't work, and there were no taxis or hire cars available. Fleetwood's original idea of recording on site at various locations, in the musicians' home environments, became less attractive, and seemed more of an impossible challenge.

Salvation, however, came in the person of Faisal Helwani, a big-time operator on the Ghana music scene. Helwani owned the only studio in Accra, a simple eight-track facility which at the time was being used by Brian Eno to record a local band. Mick used Faisal as a go-between to hire local musicians, and then to fit out a dilapidated soundstage at the Film Institute of Ghana as a recording studio where they would also put on film the entire proceedings.

BELOW: *Mick Fleetwood performs live onstage, Los Angeles, USA, 1982*

Recording commenced early in the new year, after Mick visited Jenny and the family for Christmas. A chartered plane flew into Accra piled with recording and film equipment, a five-man crew, plus co-producer Richard Dashut, bass player George Hawkins, and guitarist Todd Sharp from Bob Welch's band. Over the coming weeks a multitude of local musicians took part in the recordings, including the Superbrains vocal and percussion outfit led by Alfred Crentsil, the Ghana Folkloric Group, and drum wizard Lord Tiki with the Accra Roman Catholic Church Choir.

Seven numbers were specifically written for the planned album, as well as three interesting covers: the old Fleetwood Mac specialty "Rattlesnake Shake" (originally recorded for *Then Play On* in 1969), Buddy Holly's "Not Fade Away," and from Fleetwood Mac's last album *Tusk*, Lindsey Buckingham's "Walk a Thin Line." Most of the overdubbing and mixing was done when Mick returned to LA, after a short stop-over in England where he began working on the recordings in various locations including Jimmy Page's studio near Henley-on-Thames. A number of UK musicians took part on odd tracks, including Ian Bairnson from the Alan Parsons Project on "Not Fade Away," and "Cassiopeia Surrender," Mick's ex-brother-in-law George Harrison on "Walk a Thin Line," and—most significantly for Fleetwood—Peter Green on "Rattlesnake Shake," credited in his real name of Peter Greenbaum.

Titled *The Visitor*, the album was released in June 1981, but with a minimal amount of publicity, it made

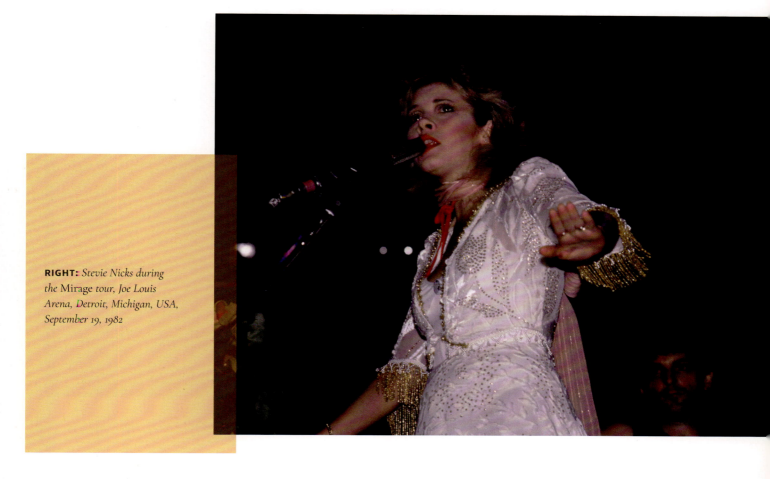

RIGHT: *Stevie Nicks during the* Mirage *tour, Joe Louis Arena, Detroit, Michigan, USA, September 19, 1982*

almost no impact on the charts. A single was subsequently taken from the collection, "You Weren't In Love" backed with "Amelle," but like the album failed to make any big impact sales-wise. Nevertheless, the whole project had been a cathartic experience for Mick Fleetwood, who confirmed so in the liner notes to the album, concluding "Being a visitor to Ghana will be a heartfelt memory with me for the rest of my life."

Meanwhile, Lindsey Buckingham had also been at work on his first solo project during Fleetwood Mac's self-imposed hiatus in 1981. Like Stevie, he had a rich backlog of untried songs ready to develop, far more than the band were likely to use in the foreseeable future.

He started preparing his solo debut, which would be titled *Law and Order*, while Mick Fleetwood was working on his own solo project in Ghana. As with his songs on *Tusk*, much of the preparatory work on *Law and Order* was a one-man exercise, Lindsey working alone in his home studio. Then when he did develop the songs in a full studio context—at the Larrabee Sound and Wally Heider studios in Los Angeles—the final album had Buckingham playing guitar, keyboards, bass, drums, and percussion, as well as taking all the lead vocals.

Some observers feared that this signaled the beginning of the end for Fleetwood Mac, but they needn't have worried. In fact, the only additional players on the album—on just one track each—were Mick Fleetwood and Christine McVie (providing backing vocals), bass player George Hawkins, who Mick had used on *The Visitor*, and Lindsey's girlfriend Carol Ann Harris on back-up vocals.

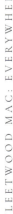

Law and Order was released on October 16, 1981, and though enjoying nowhere near the spectacular success of Stevie Nicks' solo debut, certainly clocked up better sales figures than Mick Fleetwood's intrepid venture into the musical world of West Africa. It made it to No. 32 in the US, with a spin-off single "Trouble" released the following month, which hit US No. 9, UK No. 31, and a chart-topping No. 1 in Australia.

In the wake of no less than three solo albums since the last Fleetwood Mac release as a band, when *Mirage* went on sale in June 1982 it soared to No. 1 in the American chart, earning two Platinum discs in the process, and hit the Top Ten in another half dozen countries around the world. Two of Christine's songs were released as singles, "Hold Me," which peaked at No. 4 in *Billboard*, and "Love In Store" which made No. 22. Stevie scored with "Gypsy" at No. 12 in the US, and Lindsey's "Oh Diane" was a big hit in the UK (at No. 9) and elsewhere in Europe.

Following the release came the tour, a shorter trek than their previous marathon expeditions. Two months took them through September and October, including a festival in California which paid them $800,000 dollars (a cool two million by today's count) for just one show. Mick Fleetwood for one felt that the short tour didn't give the album the exposure it deserved, claiming that it would have stayed at No. 1 for far more than five weeks, had they been on the road longer.

The other four members were not as keen as Mick to spend a longer time touring the album. Stevie in particular had other commitments, in the wake of her solo success with *Bella Donna* plus two hit singles. As a big name in her own right, she was having to strike a careful balance between her new-found personal fame, and her role as an integral part of Fleetwood Mac, one of the biggest rock bands on the planet.

ABOVE: *Lindsey Buckingham plays at the US (pronounced as the pronoun, us) Festival in Glen Helen Park, Devore, Southern California, September 5, 1982.*

OPPOSITE: *Fleetwood Mac, 1982*

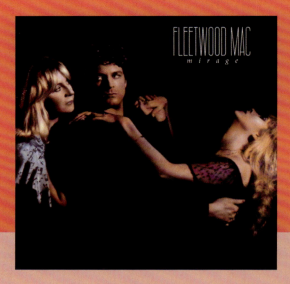

Original vinyl edition

MIRAGE

Side one
Love In Store [Christine McVie, Jim Recor]
Can't Go Back [Lindsey Buckingham]
That's Alright [Stevie Nicks]
Book Of Love [Lindsey Buckingham, Richard Dashut]
Gypsy [Stevie Nicks]
Only Over You [Christine McVie]

Side two
Empire State [Lindsey Buckingham, Richard Dashut]
Straight Back [Stevie Nicks]
Hold Me [Christine McVie, Robbie Patton]
Oh Diane [Lindsey Buckingham, Richard Dashut]
Eyes Of The World [Lindsey Buckingham]
Wish You Were Here [Christine McVie, Colin Allen]

Recorded: November 1981-March 1982, Le Château, Hérouville, France; Larrabee Sound, Los Angeles; Record Plant, Los Angeles
Released: June 18, 1982
Label: Warner Bros. Records Inc.
Producers: Fleetwood Mac, Richard Dashut, Ken Caillat
Personnel: Stevie Nicks (vocals), Lindsey Buckingham (guitar, keyboards, vocals), Christine McVie (keyboards, vocals), John McVie (bass guitar), Mick Fleetwood (drums, percussion)
Additional personnel: Ray Lindsey (guitar)
Chart positions and awards: US No. 1, two Platinum discs, UK No. 5, Platinum disc

TRACK-BY-TRACK

LOVE IN STORE
Written by Christine McVie in collaboration with Jim Recor, the ex-husband of Stevie's friend Sara Recor—who later married Mick Fleetwood. It's straightforward, cheerful pop of the quality we'd come to expect after the memorable up-tempo anthems on *Fleetwood Mac* and *Rumours*. Rich harmonies emphasize the sheer togetherness of the group sound, after the unconnected nature of the tracks on *Tusk*.

CAN'T GO BACK
A lively song from Lindsey, here with his pop singer's feet firmly on the ground. The enhanced integration between the members is confirmed, with the girls providing lush harmonies behind Buckingham's still contrived-sounding vocals.

THAT'S ALRIGHT
Stevie Nicks in a solid country groove, on a number she originally wrote for Buckingham Nicks back in 1974. Bass and drums keep it simple, Lindsey sounds like a regular session man fresh out of Nashville.

BOOK OF LOVE
Lindsey shows his vocal range on his most distinctive contribution to the album, with smooth crooning in the verses giving way to emotionally charged, plaintive bursts of energy on the chorus lines. The guitar fade at the end begs the question of whether there was more on the take than the three-and-a-half-minutes here—or, as often the case with fade-outs—there was nothing more of merit worthy of inclusion.

GYPSY
A typical piece from Stevie, promoted by an atmospheric video featuring Nicks in full flowing mood. Straight ahead percussion keeps everything nicely anchored by Mick Fleetwood, who would rate the track as "one of Fleetwood Mac's

> "[*Mirage's*] straightforward simple rock 'n' roll songs [were] an awful lot happier. *Rumours* was kind of the message of doom, the songs were up but the words were all about each other's jaded love lives."
>
> CHRISTINE MCVIE

greatest works of art." As a single, it made both the *Billboard* rock and pop charts, the differing categories an important factor at the time.

ONLY OVER YOU
A totally seductive smoothie from Christine, credited, "With thanks to Dennis Wilson for inspiration," referencing the ex-Beach Boy who she had recently broken up with, and who would die the next year by drowning. A heartfelt ballad with appropriately sumptuous (albeit synthesized) strings in the mix, along with some wistful backing vocals.

EMPIRE STATE
One of three collaborations between Lindsey Buckingham and co-producer Richard Dashut, and a bit of an oddity. A jerky, staccato-delivered paean to New York City, with some distinctively oddball guitar, plus the unusual sound of a harp somewhere in the mix.

STRAIGHT BACK
Another slice of what was by now an archetypal ballad style from Stevie Nicks, with an insistent beat, choral-like backing vocals, and Stevie's trademark vibrato echoing through the mellow arrangements. It was written in late 1981 in the context of Nicks' break-up with her lover, producer Jimmy Iovine; and, as she would later confirm, frustration at having to put her burgeoning solo career on hold for the Mac's return to business in 1982.

HOLD ME
An effervescent number from Christine—co-written with the English singer-songwriter Robbie Patton— full of catchy hooks and melodic twists, which sped up to No. 4 in the US charts, as the first single to be released from the album.

OH DIANE
A huge hit in the UK and mainland Europe, composition-wise it's Buckingham and Dashut in *Happy Days* nostalgia territory. From the opening chord, an evocation of the kind of corny pop that succeeded the mid-1950s rock 'n' roll explosion at the latter end of the decade.

EYES OF THE WORLD
Again, Buckingham's vocal style is impressive. A rock 'n' roll stylist of the highest order when he wants to be, with some ear-popping semi-acoustic and full-on electric guitar, for good measure.

WISH YOU WERE HERE
Christine teamed up with UK drummer Colin Allen to write "Wish You Were Here." From the opening piano chords, an elegant ballad that stands as possibly the finest moment on *Mirage*. The poignant lyrics end the album on a lump-in-the-throat high.

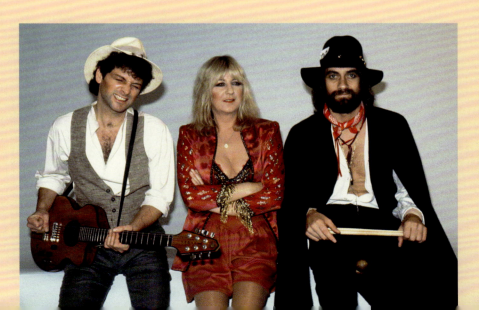

RIGHT: *Christine flanked by Lindsey and Mick at a photoshoot, 1982*

"By the time we did *Tango in the Night*, everybody was leading their lives in a way that they would not be too proud of today. It was difficult for everybody."

LINDSEY BUCKINGHAM, 2013

TANGO IN THE NIGHT

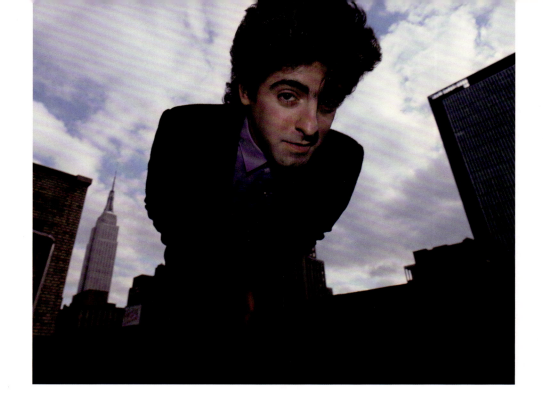

ABOVE: *Billy Burnette, circa 1983*

OPPOSITE: *Mick Fleetwood performing live onstage at a charity event—the UCLA 10k Rock N' Run—Los Angeles, California, April 1, 1983*

After the release of *Mirage*, and the comparatively brief tour that followed, there was a break of almost five years before another studio release. In the meantime, there would be five new solo albums in the record stores, one each from Mick, Christine, and Lindsey, and two from Stevie Nicks.

Mick Fleetwood found himself in a situation he could not have predicted—he was flat broke. In 1984 it became clear that he was spending money that he simply didn't have, and he had to file for bankruptcy. With the lack of activity, the band hadn't been generating cash flow, and his personal spending on projects like the *Visitor* album made in Ghana couldn't have helped. And that was followed by another solo venture *I'm Not Me*, which appeared in May 1983.

Early in 1983 Mick had got together with a bunch of friends at a portable studio, Hornet's Nest, near his house in Malibu. There was a core group of players—Fleetwood, bassist George Hawkins (who'd been a major voice on Mick's Ghana project *The Visitor* in 1981), guitarist Steve Ross, and Billy Burnette on guitar and vocals. The loose-knit group was known as The Zoo.

Mick's original plan for his new solo project was something along the lines of *The Visitor*, with he and George Hawkins basing their work on a foray into the music of South America. RCA records, who'd released the Ghana-based album, had a studio in Rio de Janeiro, Brazil. However, the post-*Mirage* Fleetwood Mac tour took precedence, and Mick decided the South American project was out of the question.

In the event, The Zoo sessions—in contrast to the studio finesse of a Fleetwood Mac release, or the world music explored in *The Visitor*—were exercises in pure, back to basics rock 'n' roll. And nobody was better qualified to inject an authentic feel of roots rock into the proceedings than Billy Burnette. Born in Memphis, Burnette came from authentic rock stock: his father and uncle, Dorsey and Johnny Burnette respectively, had fronted the legendary 1950s rockabilly act The Rock 'n' Roll Trio.

The central quartet of Burnette, Ross, Hawkins, and Fleetwood were augmented on various tracks by three saxophone players, guitarists Todd Sharp (who had also been involved in *The Visitor*) and Ron Thompson, plus Christine McVie, and Lindsey Buckingham. *I'm Not Me* featured a mix of classic oldies, covers of more recent material, and some original songs. The broad scope of the album's sources was typified by the inclusion of The Rock 'n' Roll Trio's 1957 hit "Tear It Up," The Beach Boys' "Angel Come Home," Lindsey Buckingham's "I Want You Back," and the title track, written by Billy Burnette. True to the unsophisticated pitch of the music, Mick took the band out on a low-key promotional tour of bars and small ballrooms, but the album made little impact in the charts. Nevertheless, the one single release from the album, Lindsey Buckingham's "I Want You Back," was a minor hit.

As well as the album, of course, there were the other indulgences which the press drew attention to, when the news of Fleetwood's financial plight broke. More than one excited tabloid journalist would claim that Mick had spent something like eight million dollars on drugs, although in reality the root of the crisis lay in some extraordinary expenditure on property. There were his two prime residences—the Blue Whale in Malibu and a house in Australia, Wersley Dale, which in total cost him forty thousand dollars a month in mortgage repayments. In addition, on the advice of his accountants, he had bought several other pieces of real estate as investments which didn't work out. "Basically, I bought too much real estate," he told *Rolling Stone* magazine in 1984: "Bank loans and payments go funny. There's no tax weirdness or anything like that. You just go too far into debt. There's not enough money coming in to keep the boat floating."

Over the next two years, Mick went through the agonizing process of selling off his prized possessions—recording equipment, flashy cars, and even the collection of Gold and Platinum discs he'd been awarded over the years. That was only nibbling at the edges of the problem, however; things couldn't really get back onto a positive financial basis until Fleetwood Mac started recording together again, a process which would finally get under way towards the end of 1985. And Christine McVie would be key to that reunion taking place.

At the end of January 1984, she had released her first solo album since *Christine Perfect*—which had appeared in 1970 after she had left Chicken Shack, but before she

OPPOSITE: *Stevie and Mick perform "Rhiannon" at the UCLA 10k Rock N' Run, Los Angeles, California, April 1, 1983*

ABOVE: *Christine McVie, 1983*

joined Fleetwood Mac. This time round she went for another eponymous title, *Christine McVie*, recorded in Montreux, Switzerland, and two studios in England—Lower Dean Manor in Gloucestershire, and the famous Olympic Sound Studios in London. The album line-up included Lindsey Buckingham, plus Mick Fleetwood and his compadres from the Zoo ensemble, bass player George Hawkins and guitarist Todd Sharp. Additional big-name players comprised Eric Clapton, Average White Band drummer Steve Ferrone, Steve Winwood, and percussion virtuoso Ray Cooper.

The album received muted praise, some commentators noting that the songs lacked variety, and as such might have worked better as part of a regular Fleetwood Mac collection. Nevertheless, it peaked at US No. 26, and produced two hit singles, "Got a Hold On Me," and "Love Will Show Us How," both co-written by Christine and Todd Sharp. And, crucially, while it was during the longest period that the members of Fleetwood Mac had ever been apart professionally—with no cast-iron guarantee that they would reassemble—it allowed Christine to prove that she was more than capable of going it alone if necessary.

While *Christine McVie* was hitting the shops in early 1984, Lindsey Buckingham was setting to work on his second solo album. It was recorded not long after his seven-year relationship with Carol Ann Harris had ended, and he would admit that much of the material was a reflection on that traumatic break-up. *Go Insane* was another virtually one-man project by Buckingham, on which he played all the instruments and effects,

BELOW: *Lindsey Buckingham (right) with Brian Wilson, 1986. Buckingham cites the Beach Boys as a major musical influence.*

LEFT: *Stevie Nicks remains busy while on hiatus from Fleetwood Mac with the release of solo albums* The Wild Heart, *1983 (far left) and* Rock a Little, *1985 (left)*

apart from the minor addition of co-producer Gordon Fordyce on keyboards and bassist Bryant Simpson, on two tracks each. On its release at the end of July 1984, the album didn't set the charts alight, reaching just No. 45 in *Billboard*. But it did receive praise from some reviewers who applauded its experimental daring, *Rolling Stone* calling it "possibly his least commercial work, but also his most daring and savory."

Buckingham's continuing inspiration from the work of The Beach Boys was flagged in one track in particular, "DW Suite," a tribute to the late Beach Boys' drummer Dennis Wilson (ex-lover of Christine McVie). And the title track, when released as a single in the same month as the album, managed to reach No. 23 in the charts in the August.

REUNION

In 1985 Christine was approached to record a version of the Elvis Presley classic "Can't Help Falling in Love," to be used on the soundtrack of a movie in production called *A Fine Mess*. The film company said she could choose who to work on the session, and her first thought—knowing they were huge Elvis fans—was to ask Lindsey Buckingham and producer Richard Dashut. It was a small step of logic to add John McVie and Mick Fleetwood to the line-up, and straight away there were four of the Fleetwood Mac five-piece—plus their regular producer—together in the studio again. The session for the Elvis song went predictably smoothly, and there was a good jamming atmosphere as they busked together on various numbers. Inevitably, the conversation got round to the possibility of them reuniting in the studio as a group.

Lindsey would spell out how the dynamics of Fleetwood Mac as an entity led to some initial restraint on getting an album together: "We hadn't worked together for four years and we weren't really used to seeing one another. When that happens there's pressure from Warners, of course, and the people on the periphery, the lawyers and the management, start to move in to initiate an album. There *was* a group need to record but all our individual managers and lawyers had to talk because there was no one else to put the thing together on a logistics level—the band as such doesn't have a manager since Mick stopped doing that. The meetings are a little chaotic. More people than I've ever seen. But . . . that's show business." Although Lindsey was the only one who hesitated

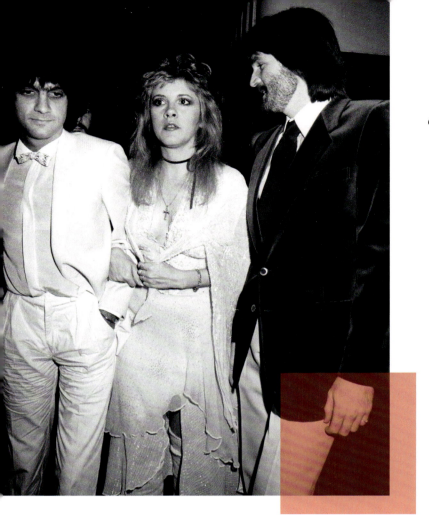

"I decided to go to Betty Ford. Nobody came and threw me in a van and took me. That was my decision. I booked the room. I paid for it. So I really think when it comes down to that stuff, it's really all up to you."

STEVIE NICKS

ABOVE: *Stevie Nicks with producer Jimmy Iovine (left) and husband Kim Anderson (right) at the 10th Annual American Music Awards, Los Angeles, California, January 17, 1983*

slightly—he was, as he pointed out, halfway through his third solo album—he was soon won round. The next step was to get Stevie involved.

Nicks' management company, Frontline, were approached to negotiate her participation in a new album by Fleetwood Mac. They agreed to Stevie taking part, but with the proviso it would be subject to her fitting in sessions around her tough touring schedule—mainly promoting her third solo album *Rock A Little*—already lined up—which totaled six months through the middle of 1986.

Stevie had started recording her second solo collection, *The Wild Heart*, towards the end of 1982, shortly after the tragic death of her close friend Robin Anderson, and many around her felt that the new project was a useful therapy in her huge personal loss.

Stevie and Robin had been close friends since their days at San Jose junior high school. Robin moved to LA soon after Stevie, and got embroiled in the record industry via her association with Nicks. She had a job as secretary to one of Stevie's partners in Modern Records, and was dating an employee at Warner Brothers, Kim Anderson. It was the day Stevie's album *Bella Donna* topped the billboard chart, in the summer of 1981, that Robin was diagnosed as having leukemia, a virulent blood cancer. Stevie was shattered by the news, a bombshell followed almost immediately with the announcement that Robin and Kim were getting married. Then in the spring of 1982, the couple surprised everyone again with the revelation that Robin was pregnant.

The couple's son Matthew was born in the fall; Stevie was delighted when she was asked to be the child's godmother, but just three days later after what had been a difficult

birth, Robin passed away. Over the weeks that followed, Stevie was drawn closer to Kim as she vowed to help nurture the baby, and just three months after Robin's death, Stevie and Kim announced their January 1983 marriage. Stevie stressed that their prime motive was the welfare of Matthew, who was now her stepchild. But the relationship turned out to be a disaster, and the couple were divorced just three months later.

The trauma of both Robin's death, and her subsequent brief marriage to Kim, left Stevie in an increasingly troubled mental state. As she edged closer to a genuine emotional crisis, with her solo career becoming more of a priority in the absence of Fleetwood Mac activity, she found herself more and more dependent on drugs just to keep going.

For *The Wild Heart*, Stevie had recruited many of the musicians from the *Bella Donna* sessions, including Tom Petty and his guitarist Michael Campbell, plus on this occasion Mick Fleetwood. The personnel fluctuated song by song, and the only names credited to every track were those of Sharon Celani and Lori Perry. And although he went uncredited, Prince played synthesizer on "Stand Back," the most successful single to be taken from the album, hitting No. 5 in the *Billboard* chart.

After its release on June 10, 1983, Stevie compared her album favorably with its predecessor: "It's like *Bella Donna*'s heart is wild all of a sudden . . . " she enthused to *Rock Magazine*. "I'm very pleased with the album because there are no holds barred on it. It's real strong and emotional." It sold a million copies by mid-September, hitting No. 5 in the album charts. Three hit singles were also released from *The Wild Heart*: "Stand Back," which preceded the album in May 1983, "If Anyone Falls", that appeared in the charts in September, and "Nightbird," released at the end of the year. "Stand Back" was also nominated as best rock vocal performance by a female artist at the twenty-sixth Grammy Awards.

Rock A Little was originally scheduled for release in late 1984, and she began recording with producer Jimmy Iovine, who had worked on both *Bella Donna* and *The Wild Heart*. Things didn't go smoothly, however, and Nicks decided to scrap all the material they had so far. Just as dissatisfied with the project was Iovine himself.

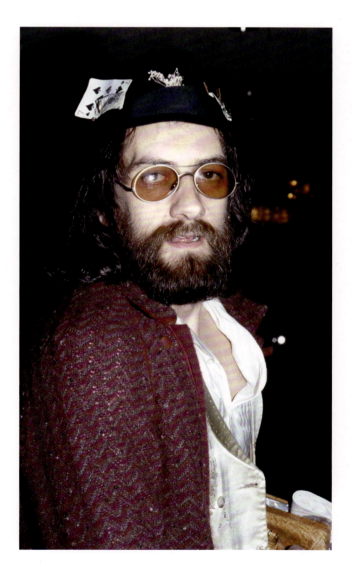

BELOW: *Mick Fleetwood, 1984*

He and Stevie had been in a relationship, which was now a thing of the past, and added to that was his concern—along with others close to Stevie—about the singer's increasing drug use. Iovine decided enough was enough, and dropped out of the project.

Stevie's response was to hire Keith Olsen, who'd worked with both Buckingham Nicks and Fleetwood Mac, and begin recording again from the start. *Rock A Little* was eventually released in November 1985, and was said to have cost over a million dollars to record. Despite some mixed reviews, it made it to No. 12 in the *Billboard* album list, with a Platinum disc. There were also two spin-off singles, "Talk To Me"—a No. 4 chart entry in November 1985—and "I Can't Wait," which hit the No. 16 spot in the summer of 1986.

In April 1986, Stevie set out on a six-month tour to promote the album, ending with eight dates in Australia—the first time she had toured outside of North America in a solo capacity. But cocaine use, plus some heavy drinking, was taking its toll. Her stage announcements were often incoherent, her singing voice was more husky, and when she indulged in her trademark twirling dance routine, she would be spinning round almost out of control—more than once in danger of falling off the edge of the stage.

As soon as the tour was finished, Stevie booked herself into the Betty Ford rehabilitation clinic. The strict regime involved getting up at 6 a.m. with study and therapy sessions all day. But it worked, and when she emerged from the treatment she was clean, and would remain so thereafter. Subsequently describing herself as "strictly an orange juice girl," Stevie would stress that the decision to go into rehab was hers, and hers alone: "I got through it, so I was lucky. I would never lecture anybody, because I don't think that's the way to get to people. It certainly wasn't the way to get to me. I decided to go to Betty Ford. Nobody came and threw me in a van and took me. That was my decision. I booked the room. I paid for it. So I really think when it comes down to that stuff, it's really all up to you."

John McVie had been the only member of Fleetwood Mac who hadn't got involved in any kind of solo project, and had spent much of the band's long sabbatical deliberately keeping the music business at arm's length. Instead, apart from the occasional gig with a reformed John Mayall's Bluesbreakers, he and his wife Julie enjoyed indulging his favorite pastime of sailing, going on long trips away from it all.

That didn't mean life was totally idyllic, of course. There were still the demons present in his long-standing problem with drinking. John had struggled with alcohol addiction of one kind or another since his late teenage years, and in 1987 would suffer an alcoholic seizure. That was the trigger that led to therapy, after

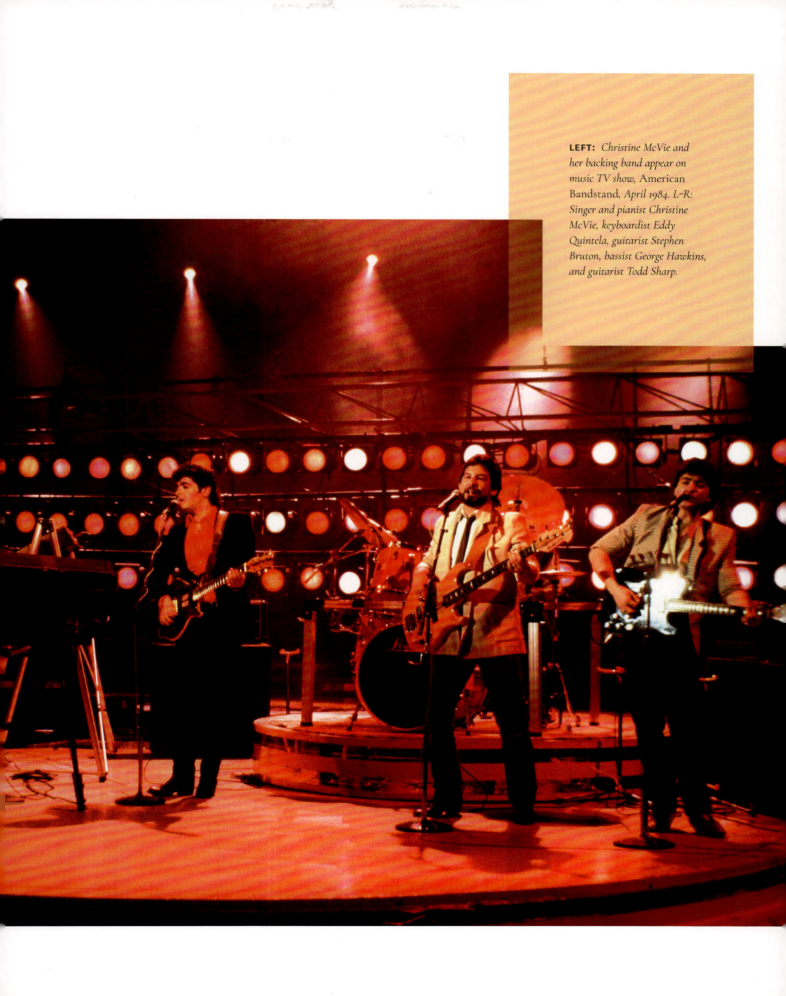

LEFT: *Christine McVie and her backing band appear on music TV show,* American Bandstand, *April 1984. L-R: Singer and pianist Christine McVie, keyboardist Eddy Quintela, guitarist Stephen Bruton, bassist George Hawkins, and guitarist Todd Sharp.*

which he managed to quit drinking altogether. "It was time to stop," he said, "plus it was destroying everything. There's nothing constructive comes out of being an alcoholic." In the meantime, therapy of a more instant kind, albeit transient in its effect, came when the band got together again to begin work on their next album.

Mick, Lindsey, John, and Christine assembled in the wake of Christine's "Can't Help Falling in Love" sessions and there was some initial stiffness in the studio environment, particularly for John McVie, who had generally distanced himself from the music scene since they were last playing as a band. The actual recording, at Rumbo Recorders in Los Angeles, and Lindsey's home studio The Slope, lasted sixteen months from the first get-together, eventually finishing in March 1987. Dashut would describe many of the sessions as being particularly tedious, even by Fleetwood Mac's slow-motion standards, with numerous re-takes and the reassembling of entire numbers being the general pattern of activity.

Although she only took part in the sessions for a matter of a few weeks, Stevie ended up fronting three songs on the album. For Nicks, the recording was something of a distraction as she was busy promoting *Rock A Little*. She would send in demos of her songs, recorded while on tour, for the others to work on. And when she did appear at the studio, Stevie felt far from positive about the experience: "I can remember going up there and not being happy to even be there," she would recall. "I didn't go very often."

And Lindsey Buckingham, as co-producer, felt frustrated during the making of the album—often just in terms of getting the band together both physically and musically. He later said, "That was in my estimation when everybody in the band was personally at their worst. If you take the whole subculture that existed in the 1970s, and what it led to—and how it degraded—by the time we did *Tango in the Night*, everybody was leading their lives in a way that they would not be too proud of today. It was difficult for everybody."

But in the event, all three principal songwriters in the band came up with the goods. Lindsey contributed four songs, all of which he had earlier allocated to his (now-delayed) next solo album. Christine provided the collection's best-seller as a single spin-off, "Little Lies," which was co-written with keyboard player Eddy Quintela. He had played on Christine's 1984 solo album *Christine McVie*, and the two subsequently became involved romantically. The couple got married in October 1986, while the *Tango in the Night* sessions were still in progress. Stevie didn't take part in the sessions until January 1987, her songs including the single "Seven Wonders."

Named after Lindsey's song, *Tango in the Night* was released on April 13, 1987. For Fleetwood Mac fans around the world the album marked a triumphant return, both for the band to be together again, and because—despite a somewhat bumpy recording process—they were certainly on top form. It hit US No. 7, where it went on to sell over three million copies. Four singles from the album—"Big Love," "Little Lies,", "Everywhere," and "Seven Wonders"—made the *Billboard* Top 20, while in the UK the album occupied the No. 1 spot on three separate occasions through 1987 and 1988. It became Fleetwood Mac's best-selling album after *Rumours*, which had appeared ten years earlier.

OPPOSITE: *Fleetwood Mac, circa 1987*

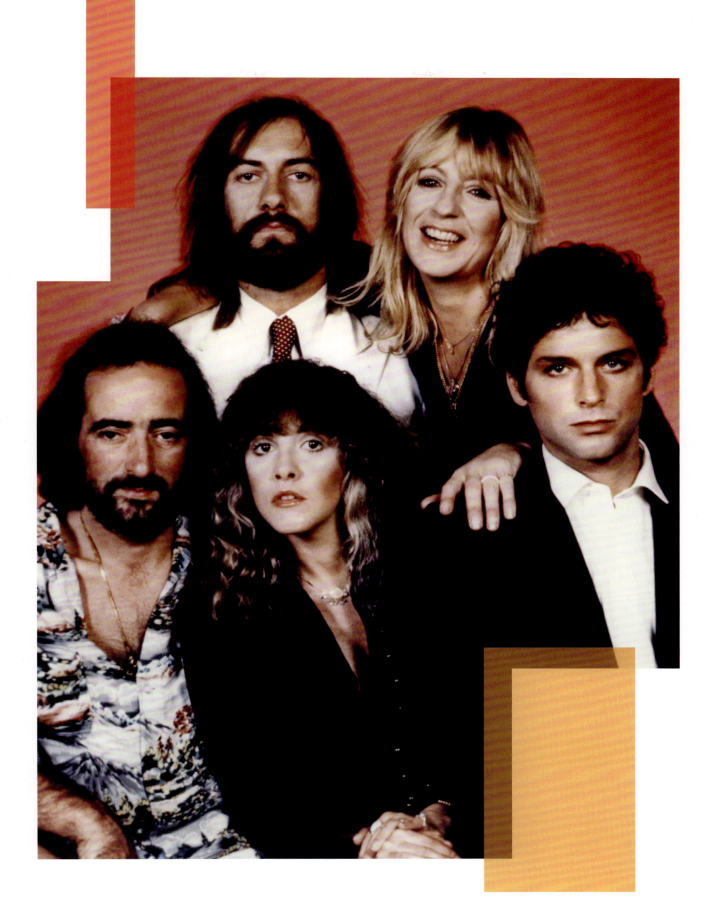

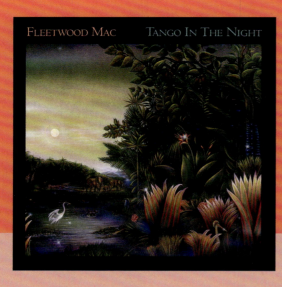

Original vinyl edition

TANGO IN THE NIGHT

Side one
Big Love [Lindsey Buckingham]
Seven Wonders [Sandy Stewart, Stevie Nicks]
Everywhere [Christine McVie]
Caroline [Lindsey Buckingham]
Tango In The Night [Lindsey Buckingham]
Mystified [Christine McVie, Lindsey Buckingham]

Side two
Little Lies [Christine McVie, Eddy Quintela]
Family Man [Lindsey Buckingham, Richard Dashut]
Welcome To The Room . . . Sara [Stevie Nicks]
Isn't It Midnight [Christine McVie, Eddy Quintela, Lindsey Buckingham]
When I See You Again [Stevie Nicks]
You and I, Part II [Lindsey Buckingham, Christine McVie]

Recorded: November 1985–March 1987, Rumbo Recorders and The Slope, Los Angeles, California
Released: April 13, 1987
Label: Warner Bros. Records Inc.
Producers: Lindsey Buckingham, Richard Dashut
Personnel: Stevie Nicks (vocals), Lindsey Buckingham (guitar, percussion, drum overdubs, vocals), Christine McVie (keyboards, synthesizer, vocals), John McVie (bass guitar), Mick Fleetwood (drums, percussion)
Chart positions and awards: US No. 7, three Platinum discs, UK No. 1, eight Platinum discs.

TRACK-BY-TRACK

BIG LOVE
One of Buckingham's more abstract songs, lyric-wise. But the nebulous verses of the opener are matched by some equally inconsequential guitar licks, adding up to an exercise in bland pop. But the majority of fans, arguably starved of Mac product for so long, were happy enough to promote the single release to US No. 5.

SEVEN WONDERS
A cool song from Stevie, which she co-wrote with her *Wild Heart* collaborator, Sandy Stewart. A neat synthesizer hook gives the track added character, while the McVie and Fleetwood rhythm section keep the track floating along nicely. Another chart entry—at No. 19 in *Billboard*—when it became the fourth single stripped from the album.

EVERYWHERE
A dreamy, warm track from Christine. The solid bass from her ex-husband is complemented by the synth and vocal backing that keep an almost weightless quality to a classic slice of Mac magic, a texture which one reviewer rightfully described as "incandescent." Third track on the album, and the third to hit the American singles listings, at No. 14.

CAROLINE
One of Lindsey Buckingham's best. His voice hovers over the light-touch backing, supported by totally sympathetic bass lines and repetitive, but never intrusive, synth riffs. Written about Carol Ann Harris, who was his regular girlfriend from the mid-seventies to early eighties, and appeared on back-up vocals on his 1981 solo album *Law And Order*.

TANGO IN THE NIGHT
What sounds like the strum of a harp, but uncredited so one can assume it's a synth effect, introduces declamatory, isolated vocals on the title track. Buckingham—

> "We hadn't worked together for four years and we weren't really used to seeing one another. All our individual managers and lawyers had to talk because there was no one else to put the thing together on a logistics level."
>
> LINDSEY BUCKINGHAM

who co-produced the album with Richard Dashut—holds court with spooky, staccato harmonies, a voice in a lonely, echo-drenched universe. An epic soundscape, punctuated by Lindsey's strident guitar figures.

MYSTIFIED
Sharing the composer credits with Lindsey, Christine closes the first side of the vinyl release with the nearest thing to a straightforward pop ballad on the album. But her blues-tinged delivery, set against rich harmony responses, elevates the track from the mere ordinary.

LITTLE LIES
Effectively promoted with a down-home video picturing the band in a rural farmstead setting, Christine and Stevie in faux cowgirl get-up, boots and all. Written with Christine's boyfriend, the Portuguese keyboard player and songwriter Eddy Quintela, it's an up-tempo track that belies the despondent message concerning the acceptance of deceit. One of Fleetwood Mac's all-time singalong favorites, it was the most successful single release from *Tango*

in the Night. It hit No. 4 in the US pop charts, and the Top Twenty in no less than thirteen countries worldwide.

FAMILY MAN
A strong contender in any Lindsey Buckingham late-night radio list, written with the album's co-producer Richard Dashut. With a smooth, insistent beat and straightforward lyrics, linked with some workmanlike, but appropriately economical, acoustic guitar.

WELCOME TO THE ROOM . . . SARA
Stevie Nicks used the pseudonym "Sara Anderson" when she checked into the Betty Ford clinic, prior to her rejoining the Mac in early 1987 for the *Tango* sessions. A surprisingly up-tempo song apparently referencing a depressing time in her life.

ISN'T IT MIDNIGHT
Christine once again shares the song writing, this time with both Lindsey Buckingham and Eddy Quintela. A hard-nosed, heavy rock-driven guitar matches a slightly sinister theme, a haunting call-and-response with a monotone Lindsey echoing through the synths and guitar and a colorless, disembodied reply.

WHEN I SEE YOU AGAIN
A disturbing reflection of Stevie Nicks' vocal condition at the time, with Buckingham reflecting years later that her voice—presumably addled by the effects of substance abuse—was the worst it had ever been. Although Lindsey achieved a weird collage taken from different takes of the song, the end product stands as a chilling reminder of how magnificent her delivery could be, even in the worst physical circumstances.

YOU AND I, PART II
Not included on the original issue of *Tango in the Night*, "You and I, Part I" appeared as the B-side to "Big Love," when it was released as a single prior to the album in March 1987. This sequel is a jaunty slice of effervescent pop courtesy of Lindsey and Christine, rounding off an often outstanding collection in an expertly delivered, but ultimately unmemorable, fashion.

"Being in the studio with two brand-new personalities made it a lot more like being in a new band of sorts again."

STEVIE NICKS

BEHIND THE MASK

As soon as it was released, *Tango in the Night* began selling well around the world, charting in Australia, Canada, Sweden, Switzerland, Norway, Germany, Austria, France, and Spain as well as the US and UK. As with previous albums, the next thought in mind for the band was to go on tour. Although that was something of a bold step after five years, the group—or at least, four of the group—were all for it. The odd man out was Lindsey, who had disliked touring for some time and wasn't keen to repeat the exercise—especially as it would interfere with his solo ambitions, which had been on hold during the making of the album.

With Buckingham sticking to his guns, the band convened at Stevie Nicks' house to persuade him otherwise. They even suggested that once the tour was finished, then he could feel free to leave Fleetwood Mac if he chose. It was an ultimatum hard to refuse, especially with his old partner and former love of his life Stevie putting on the pressure.

Lindsey agreed to think about it, and a few days later he gave his answer via a message to Mo Ostin, boss of Warner Brothers. He offered to go on tour with Fleetwood Mac for just ten weeks, and the rest of the band, excited at the prospect, began arranging rehearsals, fixing tour dates, and hiring a road crew. Then, at the eleventh hour, he changed his mind. Although furious at the guitarist's sudden about face, the others weren't totally surprised. During the recording of the album, it had become clear that Buckingham's solo career was now his priority, and going back on tour with Fleetwood Mac was probably the last thing he would want to do. Another meeting was scheduled, this time at Christine's house, on August 7, 1987. It would be what Mick Fleetwood called "a real showdown," and a moment of truth for the band.

The atmosphere was highly charged from the start, and soon Lindsey and Stevie were engaged in a full-on verbal confrontation. Buckingham stormed out to his car, followed by an hysterical Nicks begging him to stay with the band. As he got to the vehicle, Lindsey lost his temper, slapping Stevie and pushing her against the car; he was restrained by Stevie's manager and a roadie, before going back into the house, distraught and mortified at his own actions. Realizing Buckingham had gone beyond a point of no return, Mick simply said "Lindsey, why don't you just leave?"—although Fleetwood later insisted "What I meant was, 'Why don't you just leave *the room*!'"

Whatever Mick's intention was in the heat of the moment, it was clear that Buckingham had definitely left the band when he issued a press statement: "In 1985, I was working on my third solo album [*Out Of The Cradle*, eventually released in 1992] when the band came to me and asked me to produce the next Fleetwood Mac project. At that point, I put aside my solo work, which was half-finished, and committed myself for the next seventeen months to produce *Tango in the Night*. It was always our understanding that upon completion of the *Tango*... album I would return to my solo work. Of course, I wish them all the success in the world on the road."

LEFT: *Fleetwood Mac with new recruits Billy Burnette (back, left) and Rick Vito (front, right), circa 1987*

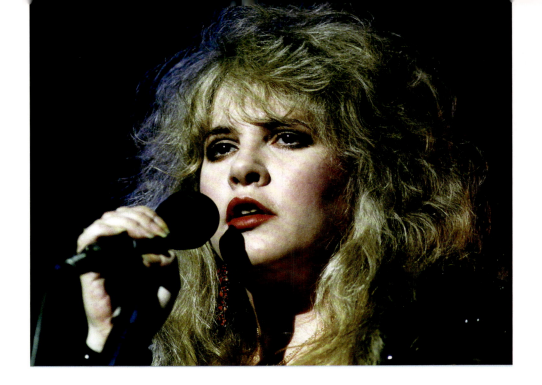

"It was amazing to watch. I don't know what it really was, except that we were just together so much, and we played so much, and everybody was intent on making these songs sound so good for the people who loved Fleetwood Mac."

STEVIE NICKS

BURNETTE AND VITO

Not for the first time in a checkered career, Fleetwood Mac found themselves searching for new faces in the line-up. And the highly regarded Memphis guitarist and vocalist Billy Burnette was an almost automatic consideration. He'd appeared on Mick's solo album *I'm Not Me* in 1983, and cut an unreleased track, "Are You Mine," during Stevie Nicks' *Rock A Little* sessions. It was a chance Burnette jumped at.

But in the void left by Buckingham, the band decided that another guitar voice was needed as well, and Billy suggested his friend Rick Vito. Born in 1949, Vito had been a Fleetwood Mac fan since his teenage years, having first seen them live in Philadelphia back in their blues band days in 1968. Particularly impressed by Peter Green at the time, he put together his own band in a similar mode. Since that time Vito had developed an impressive track record, playing with the likes of Bob Seger, Jackson Browne, Bonnie Raitt, and in the mid-seventies with John Mayall—a reunion tour which included John McVie on bass.

In order to take advantage of the continuing success of *Tango in the Night* and its spin-off singles, Fleetwood Mac were anxious to get on the road as soon as possible. The new Fleetwood Mac line-up—the eleventh so far—launched itself to the public, in what they dubbed the Shake The Cage tour. In Buckingham's absence, there had to be considerable adjustments to the on-stage repertoire; while much of the vocal emphasis was now on Christine and Stevie, the new players prompted a return to some of the band's back catalog. Rick Vito reintroduced Peter Green's "I Loved Another Woman" to fans, and Burnette delivered Green's "Oh Well," among several dips into the band's "oldies but goldies" musical history. There were also four additional back-up musicians on the tour: vocalists Lori Perry, Sharon Celani, and Eliscia Wright, all of whom had worked with Stevie on her solo albums; plus the percussionist Isaac Asanté, who Mick knew from his trip to Ghana in 1981.

With the album and singles still selling strongly, the tour was a great success, finalizing at the end of 1987 as the fourth single "Everywhere" was hitting the charts. Everyone in and around the band was ebullient about the success of the trek, and the way the new members fitted in seamlessly. Even Stevie, who had some doubts about replacement personnel after the loss of Lindsey, was enthusiastic about the way the

OPPOSITE: *Stevie Nicks live onstage at Flanders Expo, Ghent, Belgium, as part of Fleetwood Mac's Behind the Mask tour, August 1990*

BELOW: *L-R: Rick Vito, Christine McVie, Mick Fleetwood (back), Stevie Nicks, Billy Burnette, and John McVie*

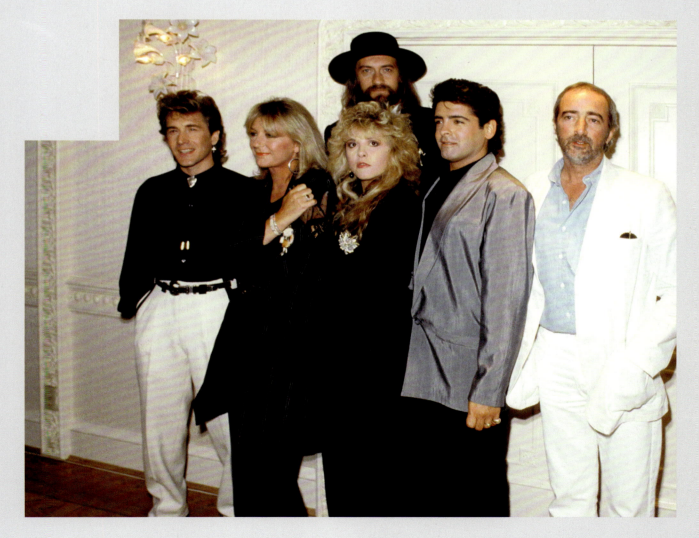

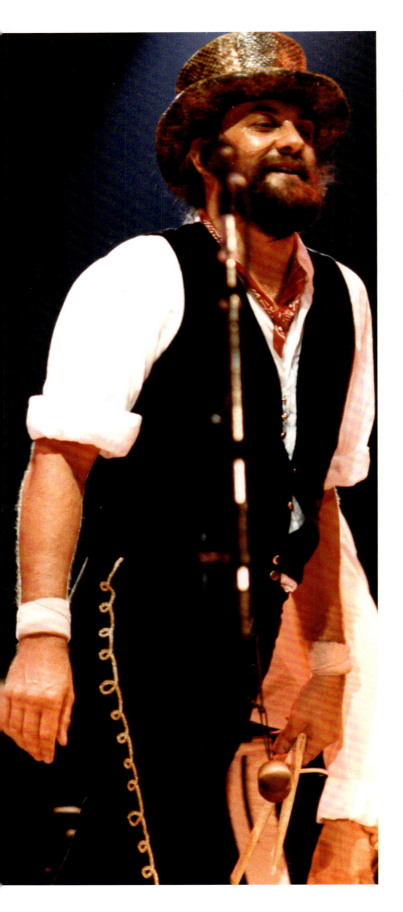

new line-up had jelled after just a week or so on the road. "It was amazing to watch," she told Mac biographer Bob Brunning, "I don't know what it really was, except that we were just together so much, and we played so much, and everybody was intent on making these songs sound so good for the people who loved Fleetwood Mac."

But although she had successfully conquered her addiction demons via rehab, Stevie was still experiencing issues with her throat. As a result, the second leg of the tour, which was due to begin in Australia in March 1988, had to be canceled. A European leg of the trek was rescheduled for early May, with concerts in Germany, Holland, and Sweden, followed by ten nights solid at London's Wembley Arena. It was the first time that Fleetwood Mac in any capacity had played in the UK for over eight years. With the line-up now half-American, they were anxious that they would be as well received as in days gone by.

Meanwhile Stevie, despite interruptions due to her throat condition, pursued her own solo career in tandem with Fleetwood Mac activities. While the new line-up was thinking about their next album, which would be the first full collection with Vito and Burnette, she had been preparing her next individual project. In May 1989 Nicks went on to release her fourth solo album, *The Other Side of the Mirror*. Based loosely on the children's classic *Alice's Adventures In Wonderland*, and recorded in Holland, England, and Los Angeles, the release—produced by Rupert Hine, with whom she would become romantically involved—was another triumph for Stevie. It made it to US No. 10 and No. 3 in the UK, while a single from the album, "Rooms on Fire," featured in the Top Twenty on both sides of the Atlantic.

After returning to the US at the beginning of July 1988, the band began considering their next album, and what direction that might take them in. Billy Burnette and Rick Vito had still to make their studio debut with Fleetwood Mac, so it was decided to ease them in for record buyers by way of a greatest hits package. The collection would cover the most successful singles since Buckingham and Nicks joined the line-up, plus two new tracks with Burnette and Vito, "As Long as You Follow," and "No Questions Asked."

The album—unambiguously titled *Greatest Hits*—was released on November 15, 1988, followed two weeks later in the UK by "As Long as You Follow" as a single. As

with most best-of packages, the album didn't hit the top of the charts, but fared well making No. 14 in the US list, and better in the UK, where it climbed to No. 3 on its release. In the long term it could only be viewed as a highly successful compilation, with eight Platinum discs awarded in America, and three in the UK.

For newcomers Burnette and Vito, recording just the two tracks added on to *Greatest Hits* was a perfect way for the pair to get used to working with Fleetwood Mac in the studio. It helped pave the way for their full-on involvement in the band's next album project, which began late in 1989 when recording sessions began for *Behind the Mask*.

With Lindsey Buckingham now out of the picture, there was a definite change in approach apparent almost as soon as they got to work on the new recordings. There was a new co-producer at the controls alongside the band, Greg Ladanyi, who had previously worked with Jackson Browne, Warren Zevon, and Stevie Nicks' ex-boyfriend Don Henley, among others. In a shift away from Buckingham's more mannered style, the resulting music moved even further into the mainstream territory of AOR (album-oriented rock).

Stevie, for one, thought the new approach paid off in terms of the ease with which they recorded, describing the sessions as a lot of fun: "Being in the studio with two brand-new personalities made it a lot more like being in a new band of sorts again . . . Going to the studio goes back to being a good time, as opposed to hard, difficult, and grueling work."

On the other hand, among fans and critics, opinion about the final result was divided. Some felt that Lindsey Buckingham's absence was a disadvantage (although he did make a guest appearance on acoustic guitar for the title track), while others appreciated the new zest that Vito and Burnette injected into the music. *Rolling Stone* magazine, for one, couldn't contain their enthusiasm, calling the new members of the band "the best thing to ever happen to Fleetwood Mac." And the *Los Angeles Times* was equally enthusiastic: "Without Buckingham's obsessively unique vision, the group has

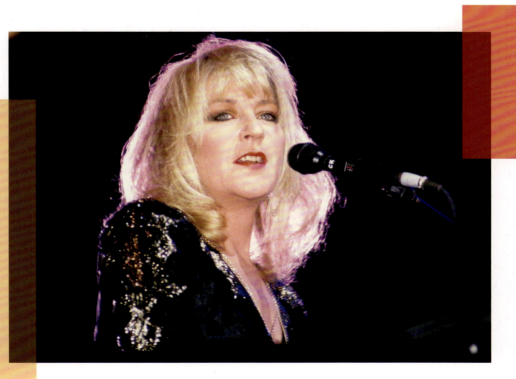

Mick (opposite) and Christine (right) perform live onstage at Wembley Arena, London, May 18, 1988.

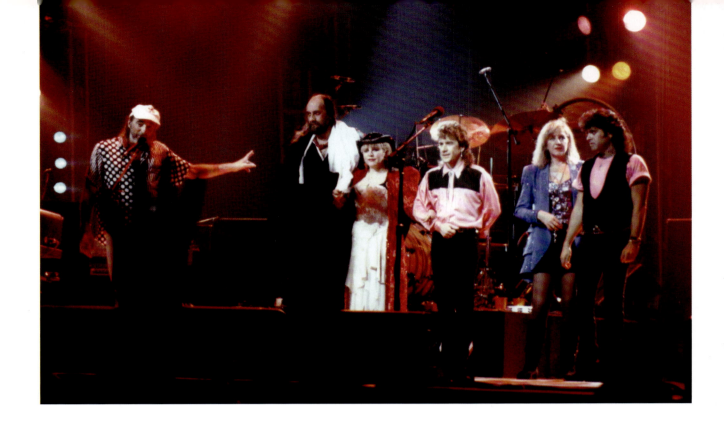

ABOVE: *Fleetwood Mac at the Met Center, Bloomington, Minnesota, USA, June 30, 1990. L-R: John McVie, Mick Fleetwood, Stevie Nicks, Rick Vito, Christine McVie, and Billy Burnette.*

OPPOSITE: *Stevie shakes her tambourine onstage, Maine Road Stadium, Manchester, England, UK, August 25, 1990*

embraced an all-for-one, one-for-all attitude for what sounds like the most truly group effort since *Rumours*, or perhaps even since 1972's *Bare Trees*."

Behind the Mask was released on April 9, 1990, and didn't do as well as the band (and the record company) might have hoped in the USA at least, where it only reached No. 18 on the *Billboard* chart. Elsewhere, it fared much better, hitting the No. 1 spot in the UK, and making the Top Ten in twelve other territories.

A promotional tour for *Behind the Mask* began after the album's release, with a series of dates in Australia and Japan, followed by a long North American trek that took them through Canada and the USA. Following the successful formula on the *Tango in the Night* tour, the presence of Rick Vito and Billy Burnette prompted the band to revive some Mac classics from the Peter Green days. As on the previous tour, "Oh Well" went down particularly well with audiences, as did "Stop Messin' Round," which they hadn't played live since 1968. Songs from the new album were kept to a minimum, with *Billboard* describing a performance in St Louis as "A lot like a graduation, class reunion, and prom all rolled into one," continuing, "With only two tracks featured from that new Warner Bros disc, the crowd was treated to a greatest-hits package, high on concert pomp and circumstance, the camaraderie of old friends, and familiar music from the past."

The marathon trek moved on to Europe at the end of August, before returning for more American appearances through October and November, with a final concert at the Great Western Forum in Inglewood, south of Los Angeles. At that closing date of the tour, the audience was stunned when who should get up with the band but Lindsey Buckingham, performing a duet with Stevie Nicks on "Limelight." He came on stage again for the closing number "Go Your Own Way," plus the first encore "Tear It Up," whereupon the crowd went crazy as he played spectacular guitar duels with Rick Vito and Billy Burnette. Inevitably, after that sensational closing date with the unexpected appearance of Buckingham, rumors of a reunion were rife.

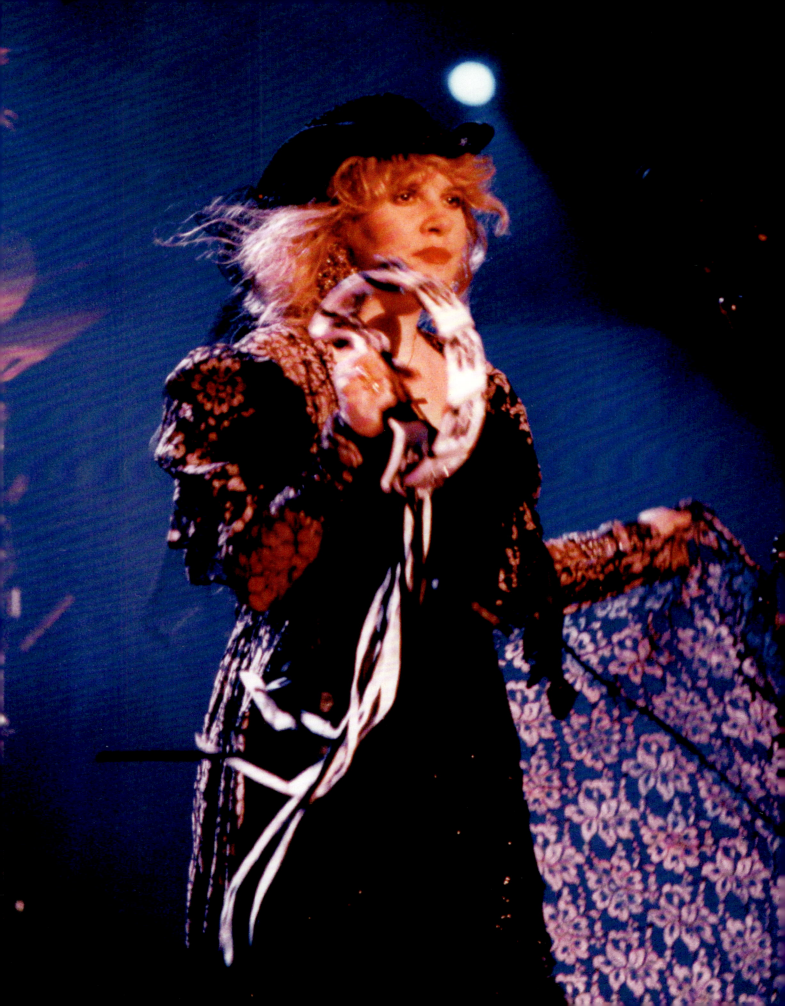

Original vinyl edition

BEHIND THE MASK

Side one
Skies The Limit [Christine McVie, Eddy Quintela]
Love Is Dangerous [Stevie Nicks, Rick Vito]
In The Back Of My Mind [Billy Burnette, David E. Malloy]
Do You Know [Christine McVie, Billy Burnette]
Save Me [Christine McVie, Eddy Quintela]
Affairs Of The Heart [Stevie Nicks]
When The Sun Goes Down [Billy Burnette, Rick Vito]

Side two
Behind The Mask [Christine McVie]
Stand On The Rock [Rick Vito]
Hard Feelings [Billy Burnette, Jeff Silbar]
Freedom [Stevie Nicks, Mike Campbell]
When It Comes To Love [Billy Burnette, Simon Climie, Dennis Morgan]
The Second Time [Stevie Nicks, Rick Vito]

Recorded: 1989-1990, The Complex, Los Angeles; Vintage Recorders, Phoenix
Released: April 9, 1990
Label: Warner Bros. Records Inc.
Producers: Greg Ladanyi, Fleetwood Mac
Personnel: Stevie Nicks (vocals), Billy Burnette (guitar, vocals), Rick Vito (guitar, vocals), Christine McVie (keyboards, synthesizer, vocals), John McVie (bass guitar), Mick Fleetwood (drums, percussion)
Additional personnel: Lindsey Buckingham (acoustic guitar), Isaac Asanté (percussion), Stephen Croes (synthesizer, keyboards), Dan Garfield (keyboards)
Chart positions and awards: US No. 18, Gold disc, UK No. 1, Platinum disc

TRACK-BY-TRACK

SKIES THE LIMIT
Christine opens for a co-write with Eddy Quintela. As usual, a confident pop rock delivery from McVie, with Burnette and Vito's guitar parts making themselves essential to the backing mix. As a spin-off single, it made No. 10 in the adult contemporary chart in *Billboard*; the category was certainly a sign of the times—both for the music scene generally, and Fleetwood Mac in particular.

LOVE IS DANGEROUS
Newbie to the band Rick Vito penned this with Stevie. A solid-sounding guitar intro sets the aural scene for a tougher-voiced Ms Nicks than we are used to. It's an energetic slice of funky rock that cuts through from the word go, although when released as a single, like the opener, it failed to make a big dent in the pop chart—but hit No. 7 in the mainstream rock section.

IN THE BACK OF MY MIND
After a lugubrious two-minute intro full of ambient noise and ghostly mumblings, Billy Burnette voices his own composition (written with country music songsmith David E. Malloy) in an equally lackluster fashion. After the promising energy of the first two tracks, a let-down in more ways than one.

DO YOU KNOW
Burnette teams up with Christine McVie for a delicate slice of evocative, country-tinged balladeering. A simply stated, melancholy lyric delivered via some incisive arrangements and rich harmonies from the pair. One of the strongest tracks on the album.

SAVE ME
A workaday song from Christine, once more in song-writing partnership with

> "Without Buckingham's obsessively unique vision, the group has embraced an all-for-one, one-for-all attitude for what sounds like the most truly group effort since *Rumours*, or perhaps even since 1972's *Bare Trees*."
>
> LOS ANGELES TIMES

Eddy Quintela. The instrumental accompaniment adds up to a seamless example of "sophisticated" mainstream rock beloved of their new generation of fans. But compared to her best, it all adds up to a fairly pedestrian piece of work from Ms McVie.

AFFAIRS OF THE HEART
Lyric-wise, Stevie's in a similarly confessional love mood to the preceding track. Richly layered harmonies give textural lift, and there's a lot going on instrumentally. One of four compositions or co-writes by Nicks—the most in one album for a decade—the song represents one of her best in a long time.

WHEN THE SUN GOES DOWN
New boys, Vito and Burnette, get together for a stirring slice of good ol' country rock. Right from the top, it's no-nonsense, western bar music. Taking it in turns on the vocals, the pair in many ways take the other Mac members closer to their blues roots than they have been in a long, long time.

BEHIND THE MASK
Hardly a barnstormer for a title track, Christine's opener to the second vinyl side is pleasant enough. Among the misty backing voices and bland rhythm track, the main factor worthy of mention is the acoustic guitar breaks, provided by the now-estranged Lindsey Buckingham.

STAND ON THE ROCK
A strident rock song from Rick Vito, who also composed the track. As with Billy Burnette's contributions, their straightforward song-writing style and fuss-free delivery contrasts sharply with some of the fancier production techniques in Fleetwood Mac's previous releases.

HARD FEELINGS
Written with Los Angeles songwriter Jeff Silbar, Billy Burnette emotes effectively enough, although the end product—with lots going on in the production department—adds up to a lesser experience than perhaps intended.

FREEDOM
Stevie Nicks, whose voice has certainly lost its "angelic" edge on this track and others, comes over as somewhat one-dimensional in her delivery. Nicks wrote this with Mike Campbell, guitarist with Tom Petty and the Heartbreakers, who would go on to be part of the Fleetwood Mac line-up in 2018.

WHEN IT COMES TO LOVE
A sleepy ballad co-written by Billy Burnette, UK songwriter and session player Simon Climie, and the Nashville-based composer Dennis Morgan. Climie and Morgan had previously collaborated several times, including on the Aretha Franklin/George Michael 1987 chart-topper "I Knew You Were Waiting (For Me)." The lead vocals are shared between Burnette and Christine, with the latter's voice delivered with a more masculine-sounding texture than usual.

THE SECOND TIME
Again, a harder-sounding Stevie Nicks than fans had previously been used to. A short, sad, but strangely powerful ballad from Nicks and Vito. With a sparse acoustic guitar providing most of the backing, it's a tearful reminiscence of a love long lost, and a melancholy end to a mixed-bag album.

"I never really know what's going to happen . . . I never burn bridges, but right now I don't think I'll work with them."

STEVIE NICKS

TIME

ABOVE: *Christine McVie with her father, Cyril (left) and Eddy Quintela (right)*

OPPOSITE: *John McVie and Mick Fleetwood, 1994*

In the wake of the *Behind the Mask* tour—and Lindsey Buckingham's surprise appearance at the final concert in particular—came much speculation of a full Fleetwood Mac reunion. But immediately following the tour, both Christine and Stevie made it clear that the mammoth trek would be their last live outing, with the proviso that they would still record as part of the band.

A major factor in Christine's announcement was the death of her father, which had occurred while the band was on the road; the bereavement had put things in a new perspective for her, as she realized she had considerations outside the priorities of the group. Recording schedules could be reasonably flexible, but tour dates, once contracted, were almost impossible to change.

EXIT STEVIE

Stevie's main job in hand was establishing a solo career. After the success of her fourth solo album, *The Other Side of the Mirror*, released in May 1989, she felt it was time for a best-of compilation. This would include a Fleetwood Mac archive rarity, "Silver Springs," from 1977. As it turned out, Mick Fleetwood was also planning a band retrospective that would include the same track, and he had final say of what could be used.

> "It was an experiment in true Fleetwood Mac tradition . . . We went out on the road, and we did OK. But without a hit album, and a reaffirmation with new members on radio, we didn't stand a chance. It was a good band, with the wrong damn name."
>
> MICK FLEETWOOD

When he refused to let her use "Silver Springs" for her solo release, Nicks was outraged. She had clashed earlier with Mick over the same track back in 1977, when the song had been recorded as part of the *Rumours* sessions, but didn't appear on the final album. It went on to feature as the B-side of the single release of "Go Your Own Way." The relationship between the two became so fractured over the issue that in the early summer of 1991 Stevie quit the band. When her compilation was released as *Timespace—The Best of Stevie Nicks* in September, it was without the track that had caused such disruption.

Inevitably, the confrontation between Mick and Stevie was hot news. Nevertheless, in various interviews Stevie was anxious to point out that, although she was out of the line-up for the moment, it was probably not for ever. Describing the band's soap opera history as "like a miniseries," she told the *Boston Globe*, "I never really know what's going to happen I never burn bridges, but right now I don't think I'll work with them." And the publicity surrounding Stevie's exit from Fleetwood Mac certainly didn't do any harm to her record sales worldwide when *Timespace* was released. Although the package only made No. 30 in the *Billboard* chart, it earned a Gold disc in the UK, and spent three weeks at the top of the charts in New Zealand.

The long-anticipated box set covering a quarter-century of Fleetwood Mac recordings finally appeared in November 1992. With seventy-two tracks spread over four CDs, *25 Years—The Chain* traced the band's career from its formation. As well as the vintage recordings,

including rarities never before released, it also featured a brand-new song by Stevie Nicks and Rick Vito, "Paper Doll," from the *Behind the Mask* sessions, two new Christine McVie numbers ("Heart of Stone" and "Love Shines") and a new track by Lindsey Buckingham, "Make Me a Mask." Among several tracks appearing on general release for the first time was an extended version of Stevie Nicks' "Gypsy," and the much-disputed "Silver Springs"—the catalyst for Stevie leaving the band the previous year. The collection sold relatively well, gaining a Gold disc in the UK and a total of four Platinum awards in Australia and New Zealand.

In the liner notes penned by Mick Fleetwood and John McVie, they mentioned the band's silver anniversary in tones that could be read as a final farewell. And at that moment in time—with Rick Vito also having left the band, to sign with Stevie's label Modern—it looked as if that may very well have been the case. But not for the first time, any mentions of the group's demise were to prove premature.

When President Bill Clinton was on the campaign trail leading up to the 1992 November election, his team chose Fleetwood Mac's 1977 hit "Don't Stop" as his unofficial theme tune. After the victory, came the celebration; for the grand president's inaugural gala, the Clinton office approached the band—now effectively disbanded—for a one-off appearance of the classic *Rumours* line-up. The group were more than keen to accept the invitation; it would be more than five years since they had played together as a unit—going back to before Lindsey Buckingham's departure.

The performance was held on January 19, 1993, at the Capital Centre in Landover, Maryland, a suburb of Washington DC. An all-star line-up included Elton John, Michael Jackson, Little Richard, Chuck Berry, and Aretha Franklin, but the highlight of the evening was when Bill and Hillary Clinton, and their daughter Chelsea, joined Fleetwood Mac on stage for a rousing finale rendition

ABOVE: *A specially reformed Fleetwood Mac perform at Bill Clinton's Presidential Inaugural Gala, January 19, 1993. L–R: Christine McVie, Chelsea Clinton, Hilary Clinton, Bill Clinton, John McVie (back), Stevie Nicks, Al Gore, Mick Fleetwood (back), Tipper Gore, and Lindsey Buckingham.*

Another line-up change. Bekka Bramlett (left) and Dave Mason (below) join Fleetwood Mac

of "Don't Stop." As Stevie Nicks would recall, "It was one of those experiences that you never forget." And although immediate speculation of a full reunion (again!) was proved wrong, the get-together and subsequent media attention did inspire John, Mick, and Christine to start thinking about recording another album.

BEKKA BRAMLETT, DAVE MASON

It was just a couple of months after the Bill Clinton concert that yet another departure put Mick, John, and Christine on the recruitment trail once again, when Billy Burnette announced he was leaving the band to develop his budding career as an actor.

The band turned to Bekka Bramlett, who had come to Mick Fleetwood's attention a year or so earlier, while he was finalizing the *Chain* box set. He had also found time to make a solo album with a new line-up of his ad hoc band, The Zoo. Bekka was the lead voice on the album, *Shakin' the Cage,* released in June 1992. The daughter of the rock/soul duo Delaney and Bonnie, Bramlett was best known as a studio backing vocalist, her first featured role being the Fleetwood solo album. And now, just twelve months later, she was being invited to join a new line-up of Fleetwood Mac itself—it was an offer she couldn't refuse.

Meanwhile, the UK guitarist Dave Mason had appeared in LA looking for work. A veteran of the British rock scene with the band Traffic, Mason was staying at Mick Fleetwood's house in Malibu, as Mick recalled in an interview for *Goldmine* magazine: "His own career is sort of like Fleetwood Mac. He's been here, there and everywhere, but he's always found a way of prevailing. There's a lot of things between Mason and myself. We've had some severe ups and downs, and had crazy times. He's a survivor. And I like to think, in the good sense of the word, that I am. Dave's kept his integrity as a person, and as a player."

Mick had been half-joking when he suggested to Mason he could fill the vacant place in Fleetwood Mac, but the guitarist immediately replied in the affirmative. So Mick began rehearsing with the latest recruits and in early 1994 they were joined by none other than Billy Burnette, whose acting ambitions had come to nothing. Burnette had asked if he could rejoin the band, and feeling they had nothing to lose, Mick agreed.

Between various live dates, the newly rehearsed line-up—minus Christine—carved out some studio time in preparation for the next Fleetwood Mac album. Recorded in Los Angeles, at two Hollywood studios—Ocean Way Recording, and Sunset Sound—the personnel for *Time* was completed with Christine McVie, plus some guest appearances, including Lindsey Buckingham providing backing vocals on one track, "Nothing Without You."

When it was released in October 1995, *Time* proved to be a disappointment for the band, and many fans and critics as well. The publicity effort on the part of Warner Brothers was decidedly muted, and sales were undoubtedly affected by half the line-up being unfamiliar to lots of fans. Amazingly, for a band whose previous record sales had been cause for celebration, the album didn't appear in the Top 200 list in *Billboard*, and only made it into the UK Top 50 at No. 47.

Mick Fleetwood, as ever, was sanguine about this latest chapter in the band's fluctuating history in the recording studio. "It was an experiment in true Fleetwood

Mac tradition, that me and John have always kept going. The reason Stevie and Lindsey were in Fleetwood Mac is because we kept going and didn't say, 'Oh, it's over now that Bob Welch has left the band. What'll we do? We haven't got a lead guitar player and a songwriter . . . ' It's what I've done for thirty years, so it was very normal behavior. And we made a really good album that didn't do diddley-shit. We went out on the road, and we did OK. But without a hit album, and a reaffirmation with new members on radio, we didn't stand a chance. It was a good band, with the wrong damn name."

Time was the only album by the band since *Heroes Are Hard to Find* in 1974 not to include any material by Stevie Nicks. And it was also the last Fleetwood Mac studio release to feature Christine McVie as an official member of the group—on the next studio album, *Say You Will*, she is credited as an additional musician. As Mick Fleetwood would confirm in his autobiography, Christine didn't originally plan to appear on *Time* until Warner Brothers insisted. Her five songs were recorded separately, with session player Michael Thompson contributing the guitar parts. She would describe her role in the recording as "something that I had not volunteered to do; it was contractual. I don't like to harp on it very much, but I thought the music was starting to get a little strange, the choices a little funny. I wasn't really enjoying that particular incarnation of the band, and I left."

Christine, of course, had already dropped out of the band as a touring outfit. When they took to the road with the newly recruited personnel in July 1994, and then again from April to September of 1995 (when they also recorded *Time*), her place at the keyboards was filled by session musician Steve Thoma. With the band yet having an album to promote, they appeared second on the bill for much of the long trek, and played a repertoire largely consisting of "golden oldies." And to the surprise of all and sundry, at their Tokyo performance in April 1995, they were joined on stage by Jeremy Spencer—who was still attached to the Children Of God cult—on guitar.

The poor performance of *Time* meant the latest rejuvenation of the band was deemed perhaps a waste of effort—especially following Christine's announcement that it would be her final album with Fleetwood Mac. Similarly disenchanted, Bekka Bramlett and Billy Burnette quit the group to form a country music duo, Bekka and Billy. Once again any future plans for Fleetwood Mac were in disarray, with just Mick Fleetwood, John McVie, and Dave Mason at the helm.

Mick went on to confirm, in an official announcement, that Fleetwood Mac had indeed disbanded.

OPPOSITE: *Mick Fleetwood, circa 1992*

TIME

Track listing
Talkin' To My Heart [Billy Burnette, Deborah Allen, Rafe Van Hoy]
Hollywood (Some Other Kind Of Town) [Christine McVie, Eddy Quintela]
Blow By Blow [Dave Mason, John Cesario, Mark Holden]
Winds Of Change [Kit Hain]
I Do [Christine McVie, Eddy Quintela]
Nothing Without You [Delaney Bramlett, Doug Gilmore, Bekka Bramlett]
Dreamin' The Dream [Bekka Bramlett, Billy Burnette]
Sooner Or Later [Christine McVie, Eddy Quintela]
I Wonder Why [Dave Mason, Franke Previte, Tom Fuller]
Nights In Estoril [Christine McVie, Eddy Quintela]
I Got It In for You [Billy Burnette, Deborah Allen]
All Over Again [Christine McVie, Eddy Quintela]
These Strange Times [Mick Fleetwood, Ray Kennedy]

Recorded: 1995, Ocean Way Recording, Hollywood; Sunset Sound, Hollywood
Released: October 10, 1995
Label: Warner Bros. Records Inc.
Producers: Fleetwood Mac, Richard Dashut, John Jones, Ray Kennedy
Personnel: Bekka Bramlett (vocals), Dave Mason (guitar, vocals), Billy Burnette (guitar, vocals), Christine McVie (keyboards, vocals), John McVie (bass guitar), Mick Fleetwood (drums, percussion, guitar, vocals)
Additional personnel: Michael Thompson (guitar), Steve Thoma (keyboards), Lindsey Buckingham (vocals), Fred Tackett (trumpet), John Jones (keyboards), Lucy Fleetwood (vocals)
Chart position: UK No. 47

TRACK-BY-TRACK

TALKIN' TO MY HEART
A slightly misleading and untypical opener as an introduction to the new line-up, with a dreamy duet between Billy Burnette and Bekka Bramlett that smacks solidly of mainstream country rock. The writing credits of Burnette, country singer Deborah Allen, and her then-husband country songwriter Rafe Van Hoy makes it clear where it's coming from.

HOLLYWOOD (SOME OTHER KIND OF TOWN)
A straightforward slice of pop song-writing from Christine and her husband at the time, Eddy Quintela. As with the other tracks on the album by Ms McVie, the guitarist is guest player Michael Thompson. Lush overlaid harmonies and a long fade-out ending add to the AOR feel of the track.

BLOW BY BLOW
Dave Mason shines with some powerful guitar fills on his vocal debut on the album, with the supporting chorus harmonies tight and effective. It was one of only two songs from the album—along with "Dreamin' the Dream"—featured on the pre-album tour by the band.

WINDS OF CHANGE
Written by Kit Hain, best known as the vocalist and bass player in the seventies UK pop duo Marshall Hain. Sung by Bekka Bramlett, it's a straightforward pop ballad given a country tinge by virtue of Bramlett's characteristic vocal style. Again an end-fade adds to the somewhat predictable, middle-of-the-road ambience of the entire track.

I DO
Christine brings back the effortless quality of the classic Mac sound on another collaboration with Eddy Quintela. The one single release from the album (which only charted in Canada, at No. 64), alongside additional guitarist Michael Thompson it

> "[*Time* was] something that I had not volunteered to do; it was contractual. I don't like to harp on it very much, but I thought the music was starting to get a little strange, the choices a little funny. I wasn't really enjoying that particular incarnation of the band, and I left."
>
> CHRISTINE MCVIE

features some fine playing from Billy Burnette. And the relaxed rhythm section of McVie and Fleetwood, a study in economical simplicity, reminds us that less is often best.

NOTHING WITHOUT YOU
Originally written by Bekka Bramlett's father Delaney for his 1975 album *Giving Birth To A Song*. This fresh co-write along with songwriter Doug Gilmore adds some Mac-inspired spice, for a piano-driven fusion of bar room country and seventies rock. A perfect vehicle for Bramlett's distinctive down-home delivery.

DREAMIN' THE DREAM
Bekka again, this time with a delicate lullaby of a song written with Billy Burnette. With acoustic guitar to the fore, the Tex Mex-flavored love ballad goes some way to fill the gap left by Stevie Nicks' departure.

SOONER OR LATER
A study in melancholy from Christine, with a backing chorus that takes the listener into an aural dreamland. With its own majesty—though not McVie's greatest work by any means—a standout track in a less than remarkable album.

I WONDER WHY
Dave Mason and Bekka Bramlett team up as the vocal duo on this purposeful rocker. Some solid guitar, presumably from Mason, and powerful choruses, add up to a smooth end product—co-written by Mason, singer/songwriter Franke Previte, and UK producer Tom Fuller—that would have been an uncomfortable fit on any previous Fleetwood Mac collection.

NIGHTS IN ESTORIL
Another memorable track courtesy of Christine McVie and Eddy Quintela, celebrating her time in Estoril, Portugal, with Quintela (himself Portuguese). With an all-encompassing drumbeat, sweeping synth sounds, and neat guitar licks from Mason and Burnette, it's a definite highlight of *Time*.

I GOT IT IN FOR YOU
Another composer link-up, between Billy Burnette and country singer Deborah Allen. A tough-sounding country rock song with a strident beat, incisive guitars, and on the ball dueling between Burnette and Bramlett that would foretell a subsequent vocal partnership.

ALL OVER AGAIN
A strong, soulful lamentation from Christine, which many felt was a heartfelt regret at the absence of Stevie Nicks in the line-up. Indeed, the song had its first live performance on the 2018 "An Evening With Fleetwood Mac" tour, as a duet between McVie and Nicks.

THESE STRANGE TIMES
An oddity; even more so as a conclusion to the album. It's a spoken-word poetry piece, voiced by Mick Fleetwood in his only vocal contribution an any Fleetwood Mac recording. With a sonorous drumbeat and synth-induced string effects, the gaunt-sounding recitation is a tribute to his old comrade in arms and Fleetwood Mac founder, Peter Green. In the latter half of the seven-minute epic, Mick's daughter Lucy chants "Faith! Have faith!" in the background. It's also a confessional detailing his own escape from dark places, as he told *Mojo* magazine in December 1995: "I nearly destroyed myself with drugs and alcohol and crazy behavior, and this is a positive thought mode that you can get out of the dark, into the light."

"I do have flashbacks occasionally. The beast might have had its nails clipped a bit... We're certainly not as dangerous for each other as we used to be. If anything, I'm hoping that we're now going to be good for each other. Wouldn't that be a nice way for things to turn out?"

CHRISTINE MCVIE

SAY YOU WILL

A year and a half after *Time*, in March 1997, Fleetwood Mac officially reformed for an MTV concert filmed on May 22 and 23 on a sound stage at Warner Brothers. The film was given a commercial release as a live video and an album that would put them back at the top of the US charts for the first time in fifteen years.

A week after the MTV concert was aired on US television, the live album, *The Dance*, was released on August 19. Some songs, Lindsey's "Bleed To Love Her," for instance, which was originally intended for a solo album, had not been released before, while others that were played at the gig—Stevie's "Gypsy"—never made it to the album. The CD closed with "Tusk," featuring the Trojan Marching Band from the University of Southern California from the original record release, followed by the now-anthemic "Don't Stop."

The seeds of the band's reformation had been sown back in 1995. Mick had begun doing some sessions with Lindsey Buckingham, with a view to making the latter's fourth solo album. Things didn't work out as planned for the album, but the sessions carried on longer than expected, with Mick calling in John McVie, and later Christine McVie, to participate on various tracks. Four out of the classic Mac five-piece were now playing together again, albeit in an informal studio environment.

Around the same time, Stevie Nicks was recording a song for the soundtrack of the movie *Twister*. She had brought in Lindsey to produce the number, and Mick Fleetwood was hired to play drums. The Fleetwood Mac ensemble were gradually being collected, if only by force of circumstance. The almost magnetic drawing power that seemed to be in action was evident again in May 1996, when a private party gig in Kentucky saw Stevie, Mick, John, and Christine together once more, with Steve Winwood deputizing for Lindsey.

RIGHT: *Fleetwood Mac perform at the Rock and Roll Hall of Fame induction ceremony, 1998*

ABOVE: *Christie McVie performs with Fleetwood Mac at the Meadowlands Arena, New Jersey, USA, September 1997.*

When it came to *The Dance*, twenty years after the release of *Rumours*, Fleetwood Mac were back in the spotlight in a big way. The album hit the top of the *Billboard* chart just a week after going on sale, and would go on to earn five Platinum awards in the US, for sales clearing the five million mark. And the video went to the top of the charts immediately.

And just a month after *The Dance* was released, confirming that the band were indeed reunited, the full Fleetwood Mac classic line-up (including Christine, despite her misgivings about going back on the road) began a major US tour. Guests from the live album came along, comprising Brett Tuggle on keyboards, guitar, and vocals, Neale Heywood on guitar and vocals, percussionist Lenny Castro, and backing vocalists Sharon Celani and Mindy Stein.

Christine participated in the tour with as much commitment as the others, while conscious of the volatile history of the band. "I do have flashbacks occasionally," she confessed to *Rolling Stone*. "The beast might have had its nails clipped a bit—I don't know. We're certainly not as dangerous for each other as we used to be. If anything, I'm hoping that we're now going to be good for each other. Wouldn't that be a nice way for things to turn out?"

However, not long after the end of the tour, following a spate of ceremonies which included live performances at the UK BRIT Awards and US Grammy Awards in early 1998,

Christine McVie once again announced her retirement from Fleetwood Mac, returning to England to spend her time with her family.

Meanwhile, Stevie Nicks, although still preoccupied with her solo career, saw the tour as a reaffirmation of the binding unity that existed between the five principal members, as she told *Mojo* magazine in September 1997: "You're never going to take away the fact that there's two ex-couples on that stage, you know. And you're never gonna take back the fact that a lot of those songs were written about each other. So no matter how cool anybody is, when you get up and *sing them* to each other . . . We can't *ever* look at each other as if we hadn't been totally involved."

Following the tour, Stevie started considering her own album, although that was postponed when Warner Brothers suggested a three-disc box set covering her entire career, from 1973's *Buckingham Nicks* onwards. The collection, called *Enchanted*, featured one track from the Buckingham Nicks archive, tracks from all of Stevie's solo albums since *Bella Donna*, various live recordings and alternative takes, and a new recording of "Rhiannon."

The set performed well sales-wise for such a big collection, making it to No. 85 in the American album chart. Stevie toured in support of the release, and with her name once more in the limelight, was then ready to concentrate on her new album. With some songs already written ready for the project, she brought in her friend, the country rock singer Sheryl Crow. Crow played on, and co-produced, several tracks, as well as contributing one of her own songs, "It's Only Love." When it was released in May 2001, the album *Trouble in Shangri-La* saw Stevie Nicks once again in the upper echelons of the US charts at No. 5 (for the first time since *The Wild Heart* in 1983) and earning a Gold disc in the process.

Before the release of . . . *Shangri-La*, on January 6, 2001, Stevie had joined Fleetwood Mac once again (now permanently without Christine) for a one-hour set at a surprise

BELOW: *Fleetwood Mac, including past member Peter Green (second right), are inducted into the Rock and Roll Hall of Fame, January 12, 1998*

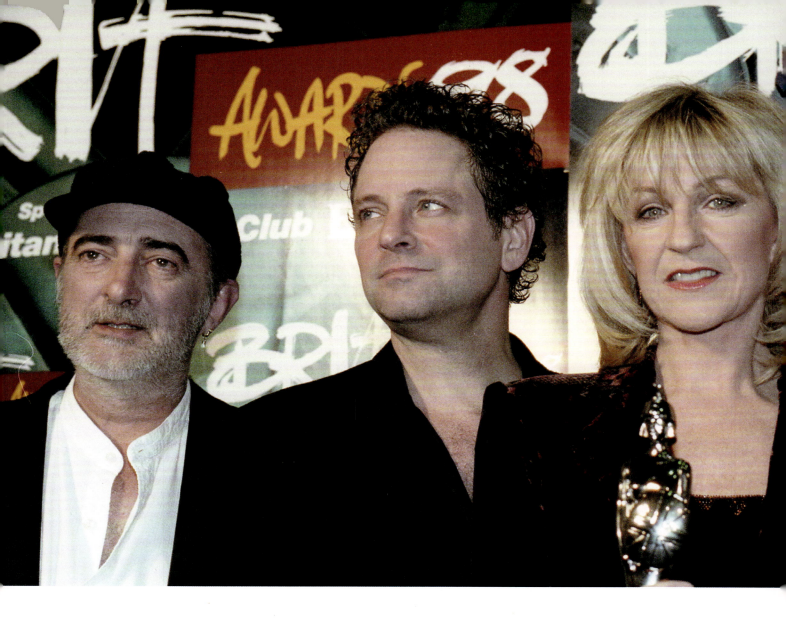

"You're never going to take away the fact that there's two ex-couples on that stage. And you're never gonna take back the fact that a lot of those songs were written about each other. So no matter how cool anybody is, when you get up and *sing them* to each other . . . We can't *ever* look at each other as if we hadn't been totally involved."

STEVIE NICKS

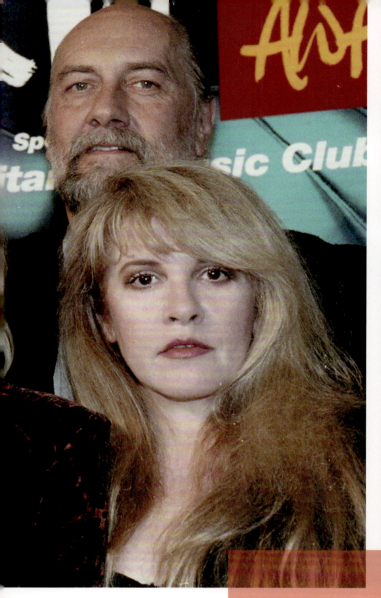

party for the outgoing US president Bill Clinton. And as soon as she had completed her support tour for her solo album, she hooked up with Mick, John, and Lindsey at the rented house in Bel Air, where the three had been concentrating on what would be the next Fleetwood Mac album.

The sessions at Bel Air would continue off and on through 2002. Meanwhile, another greatest hits collection, *The Very Best of Fleetwood Mac*, was released in the October. In the US it was released as a double-CD set that immediately climbed to No. 12, with thirty-six tracks dating from when Buckingham and Nicks first recorded with the group in 1975. And in the UK, a shorter collection hit the marketplace, with twenty-one tracks covering their entire career from the late 1960s. That too was a resounding success, making the No. 7 spot in the album chart.

With much anticipation on the part of long-term fans, Fleetwood Mac's seventeenth studio album *Say You Will* was released in April 2003. It was the first collection in over thirty years to feature no songs by Christine McVie, although she was featured on two

ABOVE, LEFT: *At the 18th BRIT Awards, London Arena, February 9, 1998*

ABOVE: *Lindsey and Stevie give a moving performance of "Landslide" at the Rock and Roll Hall of Fame induction ceremony*

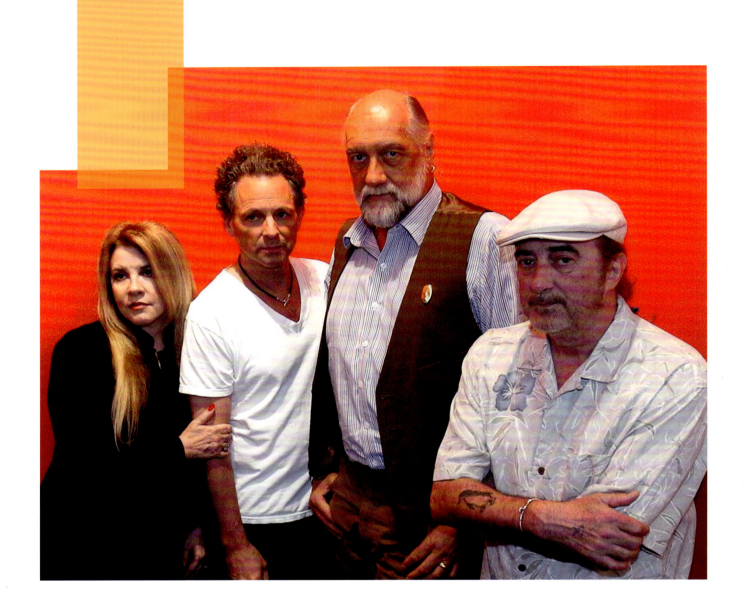

ABOVE: *Fleetwood Mac—a foursome once more, 2004*

tracks, "Steal Your Heart Away," and "Bleed to Love Her," It was a four-piece Fleetwood Mac that appeared on the album in its entirety. Among Stevie Nicks' contribution was "Smile At You," which dated back to the *Tusk* sessions in 1979, but hadn't been recorded by the entire group. Given that all of the album's eighteen tracks were composed or co-written by Buckingham or Nicks, it was fair comment in many reviews that it could have well been called "The Buckingham and Nicks Show," or words to that effect.

The release of *Say You Will*—which made the No. 3 and No. 6 spot in the US and UK respectively—was followed by a marathon, sixteen-month tour of America, Europe and Australia, stretching from May 2003 to September 2004. And in June 2004, a bonus from the tour came in the form of a double DVD and CD release, *Live In Boston*, from two of the dates in September 2003. The video topped the UK DVD chart as soon as it appeared.

The European leg of the tour included ten dates in the UK, with three sensational, sellout nights at the Earls Court arena in London. On the final night, December 10, 2003, Mick Fleetwood told the crowd that there was a very special person in the audience. It was Christine McVie, and although she had decided not to appear on stage, she was greeted by sustained, warm applause from the thousands of fans.

Track listing

What's The World Coming To? [Lindsey Buckingham, Julian Raymond]
Murrow Turning Over In His Grave [Lindsey Buckingham]
Illume (9-11) [Stevie Nicks]
Thrown Down [Stevie Nicks]
Miranda [Lindsey Buckingham]
Red Rover [Lindsey Buckingham]
Say You Will [Stevie Nicks]
Peacekeeper [Lindsey Buckingham]
Come [Lindsey Buckingham, Neale Heywood]
Smile At You [Stevie Nicks]
Running Through The Garden [Stevie Nicks, Ray Kennedy, Gary Nicholson]
Silver Girl [Stevie Nicks]
Steal Your Heart Away [Lindsey Buckingham]
Bleed To Love Her [Lindsey Buckingham]
Everybody Finds Out [Stevie Nicks, Rick Nowels]
Destiny Rules [Stevie Nicks]
Say Goodbye [Lindsey Buckingham]
Goodbye Baby [Stevie Nicks]

Recorded: 1995–1997, 2001-2002, the Bellagio House; Cornerstone Recording Studios; Ocean Way; Lindsey Buckingham's home, Los Angeles
Released: April 15, 2003 (US), April 29, 2003 (UK)
Label: Reprise
Producers: Lindsey Buckingham, Rob Cavallo, John Shanks

SAY YOU WILL

Personnel: Lindsey Buckingham (guitar, percussion, keyboards, vocals), Stevie Nicks (keyboards, vocals), John McVie (bass guitar), Mick Fleetwood (drums, percussion)
Additional personnel: Christine McVie (keyboards, vocals), Sheryl Crow (Hammond organ, vocals), Jamie Muhoberac (Hammond organ), John Pierce (bass guitar), John Shanks (keyboards), Dave Palmer (piano), Jessica James Nicks (vocals), Molly McVie (vocals), Madelyne Felsch (vocals)
Chart positions and awards: US No. 3, Gold disc, UK No. 6, Gold disc

Say You Will was the first collection in more than thirty years to feature no songs by Christine McVie.

TRACK-BY-TRACK

WHAT'S THE WORLD COMING TO
A jaunty rocker that Lindsey Buckingham takes in his stride without much effort. Co-written with the American songwriter Julian Raymond, it's nothing if not radio-friendly pop. Fleetwood's purposeful drumming glides us through comfortable layers of harmony vocals and predictable keyboard riffs, the latter contributed in part by songwriter/producer (better known as a guitarist) John Shanks.

MURROW TURNING OVER IN HIS GRAVE
Some neat bluegrass-flavored acoustic guitar introduces a social commentary of sorts, an anti-media lyric which references the legendary American journalist and broadcaster Edward R. Murrow in the chorus. Fevered, breathless vocals from Stevie and Lindsey add to a build-up of tension, aided by hot metal guitars, that continues into a frantic fade-out conclusion.

ILLUME (9-11)
Stevie Nicks' sonorous meditation on the tragic events of the terrorist attacks on the World Trade Center on September 11, 2001. Heavily strummed, repetitive guitar licks, and hypnotic percussion from Fleetwood and Buckingham, add a funereal intonation to a solemn and clearly heartfelt lyric.

THROWN DOWN
Another "serious" song from Stevie, a richly textured piece which relies solely on the devices of the four principals. With a simple love lyric, and given a suitably sparse treatment, it's one of Nicks' best.

MIRANDA
A folky lilt for a modern message from Lindsey, addressing the addiction of fame under the spotlight of contemporary celebrity. Instrumentally there are hints of the sitar-driven, Indian-influenced rock music of the late sixties, and the Beatles in particular.

RED ROVER
Despite the effects obscuring Buckingham's natural vocal texture—something not restricted to this track alone—the other-worldly aura works well here. And the guitarist plays without a plectrum, contributing a rawness to the neo-folk energy of the up-tempo ballad.

SAY YOU WILL
The title track conforms to the tried-and-tested Fleetwood Mac formula for creating accessible rock. Stevie's voice, as ever, is potently effective, supported by country rock star Sheryl Crow on Hammond organ and backing vocals. The children's chorus towards the end of the track included Stevie's niece Jessica (the daughter of her brother Christopher and her backing vocalist Lori Perry), and John McVie's thirteen-year-old daughter Molly.

PEACEKEEPER
John Shanks helps out again, this time with some additional guitar accompaniment. There's a lot going on backing-wise with this highly produced song from Buckingham, but the serious lyrics come over as shallower than intended, placed in the context of a smooth, easy-listening anthem.

COME
There's a prevailing dark atmosphere on this co-write between Lindsey and guitarist/composer Neale Heywood, who was a sidesman with Fleetwood Mac on the 1997 concert released as *The Dance*. The distorted vocals are archetypal Buckingham, as are the dynamic instrumental breaks, aided and abetted by top session keyboard man Jamie Muhoberac on Hammond organ.

SMILE AT YOU
A terrific track from Stevie, on which her husky voice is as potent as ever. It's a multi-layered love ballad that benefits from some thoughtful contrast in light and dark arrangements, as is Lindsey's acoustic guitar, backed by ghostly bass and drums on the fadeout.

RUNNING THROUGH THE GARDEN
Another great song from Stevie, comparable to her Fleetwood Mac classics of a previous era with the band. Strident and confident, her voice tears through the up-tempo ballad, which was co-composed with country singer Ray Kennedy, and Nashville singer-songwriter Gary Nicholson.

SILVER GIRL
Three in a row from Nicks are completed by the haunting "Silver Girl," in what is clearly an autobiographical piece. Once again, Sheryl Crow helps out on Hammond organ and backing vocals.

STEAL YOUR HEART AWAY
The first of just two tracks featuring Christine McVie on Hammond organ and keyboards. It's a straightforward, languid song from Lindsey Buckingham, with the band in a solid, but ultimately lackluster, groove.

ABOVE: *Stevie, Lindsey, Mick, and John outside the Rockefeller Center in New York City, 2003*

BLEED TO LOVE HER
The second Buckingham track with Christine, which was actually recorded in 1997 when she was still a regular part of the band. Her presence on vocals as well as keyboards only serves to emphasize the loss to the overall sound by her departure.

EVERYBODY FINDS OUT
Stevie on a song co-written with Rick Nowels, a prolific songwriter and record producer who has over ninety hit singles to his name. Stevie's voice is oddly knocked back at the beginning, then opens up into the rich tones we've come to expect. An energetic track that effortlessly carries the listener though a busy four-and-a-half minutes.

DESTINY RULES
Some bluegrass guitars from Lindsey support Stevie, typically throaty in her "witch" vocal mode. A solid melody, with appropriately reliable backing from the rhythm section of McVie and Fleetwood.

SAY GOODBYE
Once again Lindsey demonstrates his finger-picking skills on a fast run-through of a song, which is undoubtedly addressed to Stevie. There's a feel of the romantic pop balladeers of the mid-sixties about the whole delivery, in a sweet message to his ex that is reciprocated in the following, and final, track.

GOODBYE BABY
A gentle answer to Lindsey's previous message, Stevie says goodbye but don't forget over Buckingham's guitar picking, sumptuous string effects, and an overwhelming sense of loss. A refreshing slice of gentle melancholy that rounds off a worthy but inconsistent collection with a memorable finale.

"I enjoyed the storm… Even though I am quite a peaceful person, I did enjoy that storm. Although it's said that we fought a lot, we actually did spend a lot of our time laughing."

CHRISTINE MCVIE

EXTENDED PLAY

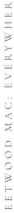

ABOVE: *The Mick Fleetwood Blues Band, featuring ex-Mac guitarist Rick Vito (left), performing live, Hamburg, Germany, October 12, 2008.*

OPPOSITE: *Lindsey Buckingham on the opening night of his solo tour in support of Gift of Screws, Saratoga, California, September 7, 2008.*

The early years of the twenty-first century saw little Fleetwood Mac activity, leaving the four remaining individuals free to pursue solo projects with little distraction from what was once the major commitment.

Despite having made very public her wish to retire from the music business altogether, in March 2004 Christine McVie announced that a new album was to be released in the coming months. With contributions from Billy Burnette, Robbie Patton (her co-writer on 1982's "Hold Me"), one-time Zoo bass player George Hawkins, and her ex-husband Eddy Quintela, *In The Meantime* was her first solo work to be released since 1984, and the first since she parted company with Fleetwood Mac. The songs were composed or co-written by McVie and her nephew Dan Perfect—who appeared on guitars and backing vocals on most of the twelve tracks. Hardly a successful return to the recording studio for Christine, the album failed to make the *Billboard* 200, and peaked at UK No. 133.

Also in September 2004, the month Christine's collection was released in America, the fifth Mick Fleetwood album, *Something Big*, appeared, credited to the Mick Fleetwood Band. Among the personnel, John McVie played bass guitar, while guest musicians included vocalist/songwriter Lauren Evans, singer Jackson Browne, and Fleetwood Mac original Jeremy Spencer. In 2008, Fleetwood assembled a quartet that included ex-Mac guitarist Rick Vito, which he dubbed the Mick Fleetwood Blues Band. Dedicated to his original Fleetwood Mac bandmates Peter Green, Jeremy Spencer, and John McVie, *Blue Again!* featured Peter Green involved in writing six of its twelve tracks. After the album's release in October 2008, the band played a number of dates in the US and Europe.

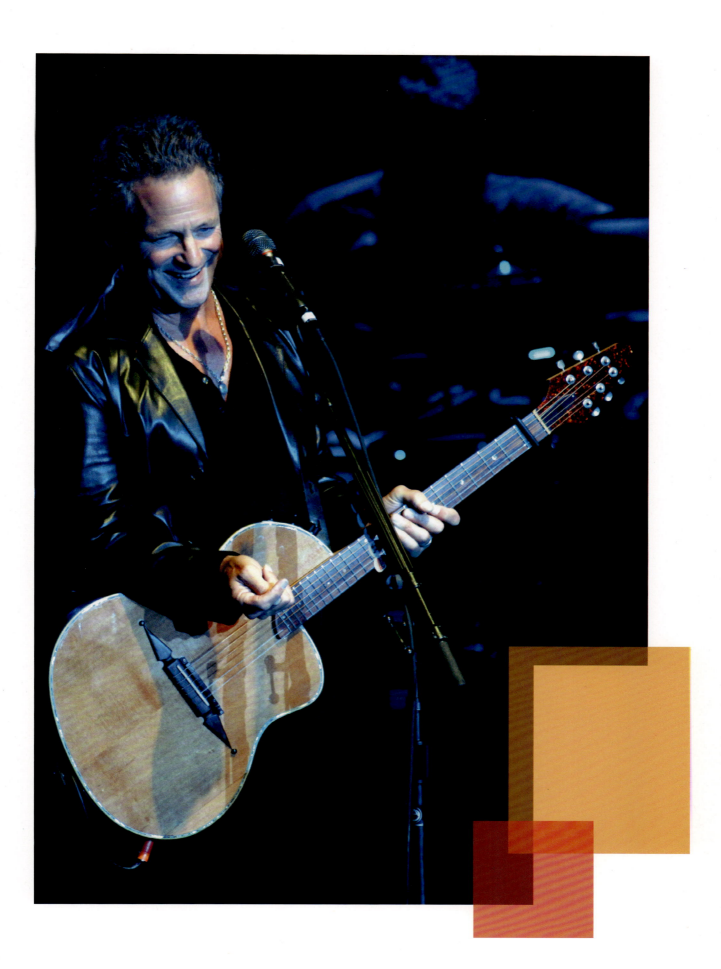

In the years following *Say You Will*, Lindsey Buckingham was similarly preoccupied with his own solo output. In 2006 he released *Under The Skin*; predominantly an acoustic set, only two tracks—"Down On Rodeo," and "Someone's Gotta Change Your Mind"—featured guest musicians, namely John McVie and Mick Fleetwood. Lindsey followed with his fifth solo album in 2008, *Gift Of Screws*, another collection heavily featuring tracks left over from previous projects from 1995 onwards.

Back in November 2006, while promoting *Under The Skin*, Lindsey had dropped various hints that a full-blown Fleetwood Mac tour might be likely in a couple of years' time. That prompted a flurry of, "Will they or won't they?" speculation for months on end. Stevie Nicks insisted she wouldn't be part of any reunited line-up unless Christine also joined; then a press item in March 2008 claimed that Nicks' former collaborator Sheryl Crow would replace Christine in the band; Stevie countered that prediction in the June, denying that Crow would be joining but confirming that Fleetwood Mac *were* starting to work on a new album. And in October 2008, Mick Fleetwood revealed in a BBC interview that the band were indeed working in the studio, and formulating a tour for 2009.

The following February, Fleetwood revealed that they would tour without an album for the first time. The tour, officially titled Unleashed, initially covered North America, lasting up until the end of June. In October, it restarted with dates across Europe which wound up at London's Wembley Arena. As at their previous London finale, Christine was in the audience; this time it was Stevie Nicks who paid a heartfelt tribute from the stage followed by a standing ovation from the capacity audience. When the tour finally came to a close in Australia and New Zealand in December 2009, it would be the last commercial date for Fleetwood Mac for quite some time. Commercially, the Unleashed tour was a resounding success, grossing nearly eighty-five million dollars.

In May 2011, Fox in America ran an episode of the hugely popular musical TV show about a singing club called *Glee* which included six tracks from 1977's *Rumours*. So successful was *Glee* that this revived interest in the classic album, and it re-entered the *Billboard* chart at No. 11. A sign of the times, music downloads now accounted for over ninety per cent of the sales figures. And it was the same week that Stevie Nicks' new solo album *In Your Dreams* hit the chart at No. 6. Later in the year, Lindsey Buckingham's sixth solo album, *Seeds We Sow*, also hit No. 6 in the *Billboard* Rock Album Chart.

The period between fall 2011 and summer 2012 was also marked by no less than three tragic deaths of former Fleetwood Mac members. On October 18, the original bass player with the band, Bob Brunning, died at the age of sixty-eight. Then in January 2012, former guitarist and vocalist Bob Weston was found dead at his London home, from a hemorrhage caused by cirrhosis of the liver; he was sixty-four. And in June 2013, the band's sixty-six-year-old ex-singer and guitarist Bob Welch died from a self-inflicted gunshot wound at his home in Nashville.

OPPOSITE: *Stevie Nicks and John McVie perform live at Madison Square Garden, New York City, March 19, 2009*

EXTENDED PLAY

Track listing
Sad Angel [Lindsey Buckingham]
Without You [Stevie Nicks]
It Takes Time [Lindsey Buckingham]
Miss Fantasy [Lindsey Buckingham]

Recorded: 2012-2013
Released: April 30, 2013
Label: LMJS Productions
Producers: Lindsey Buckingham, Mitchell Froom, Stevie Nicks
Personnel: Lindsey Buckingham (guitar, keyboards, piano, bass guitar, vocals), Stevie Nicks (vocals), John McVie (bass guitar), Mick Fleetwood (drums, percussion)
Chart positions: US No. 48, No. 13 Top Rock Albums chart, No. 14 Top Digital Albums chart, No. 9 Top Independent Album chart

OPPOSITE: *Stevie and Lindsey onstage at Stockholm Globe Arena, Sweden, October 23, 2013*

> "It's a work in progress but we're so enthused by what we've done that we thought we'd share some of it with our fans in the form of an EP now."
>
> LINDSEY BUCKINGHAM

TRACK-BY-TRACK

SAD ANGEL
A familiar-sounding quartet here, with dynamic vocal harmonies between Buckingham and Nicks. The up-tempo pop-rocker highlights Stevie's gritty texture contrasting with Lindsey's precise vocals, the nearest sound to classic Mac on the release. With state-of-the-art digital recording techniques in place, Lindsey's guitar tones shine while the rhythm section of McVie and Fleetwood keep things on the solid path we would expect.

WITHOUT YOU
An acoustic duet between Buckingham and Nicks, the rescued track from a bygone Stevie 'n' Lindsey era reworked for the EP. Stevie's only composition on the release, there are echoes of classic Everly Brothers in the balance of voices. The combination of Lindsey's high tenor and Stevie's rougher, nasal expressionism, make for a wondrous sound many fans thought they might never hear again.

IT TAKES TIME
Lindsey accompanies himself on contemplative piano. It's a stripped-down ballad with a minimal touch of orchestration, that addresses what we can assume is the break-up of his relationship with Stevie, and the gentle healing process that followed.

MISS FANTASY
Buckingham's trademark tone gives way to some falsetto edges, accompanied by strummed acoustic guitars and the always reliable, laid-back drumming from Fleetwood. Not for the first time in his career, Buckingham pays homage to the Beach Boys, with vocals enhanced by Stevie Nicks' stunning harmonies.

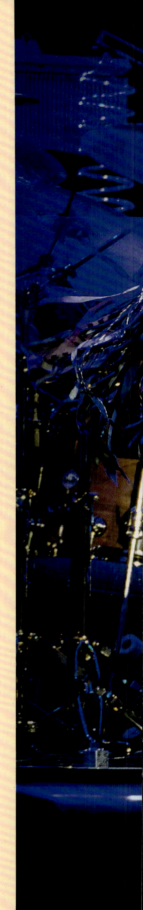

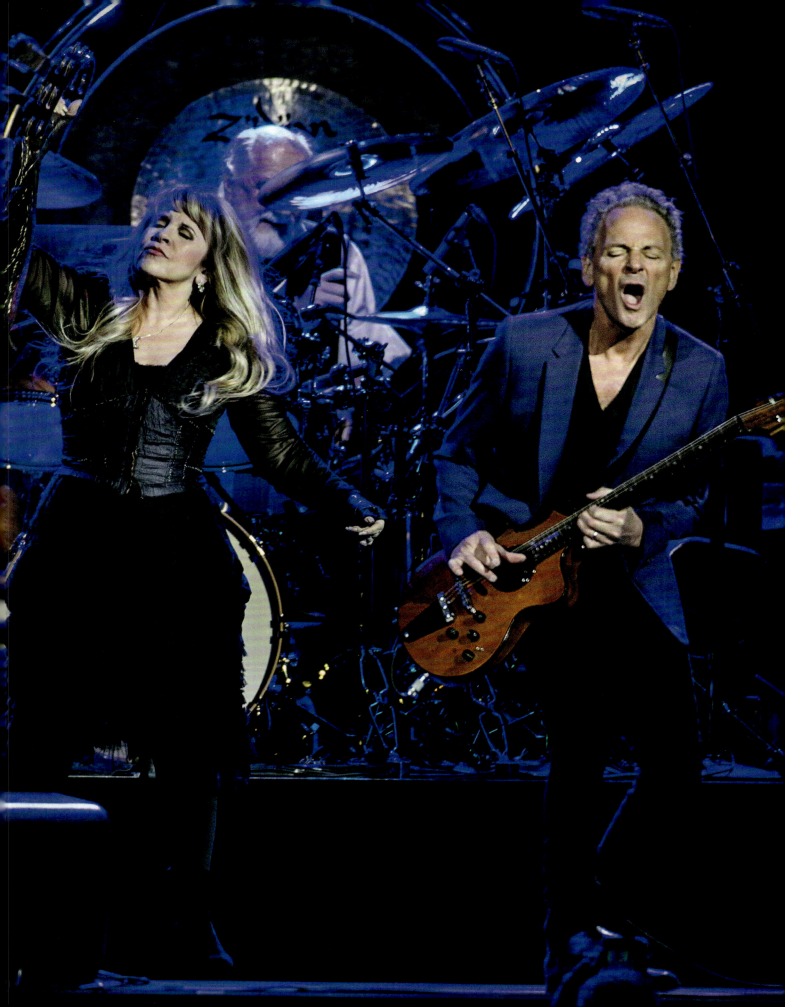

ABOVE: *Fleetwood Mac live at The O2, London, May 27, 2015*

OPPOSITE: *Christine McVie, 2018*

At the end of April 2013—just as they were kicking off their Fleetwood Mac Live tour—the band released their first new studio material since 2003's *Say You Will*, in the form of the digital download *Extended Play*. Only available via purchase from iTunes, the release featured three songs—"Sad Angel," "It Takes Time," and "Miss Fantasy"—written by Lindsey Buckingham, and "Without You" written by Stevie Nicks. The latter track was a lost item from the pre-Mac era of Buckingham Nicks, and the duo's eponymous album of 1973.

"We all felt that it would be great to go into the studio and record new material before embarking on this tour and the result has been remarkable—our best group of songs in a long time," Buckingham confirmed in a press release, "It's a work in progress but we're so enthused by what we've done that we thought we'd share some of it with our fans in the form of an EP now." Although there was no physical version ever released, *Extended Play* still made it to No. 48 in the *Billboard* album chart, selling nine thousand copies in the first week.

The 2013 Fleetwood Mac Live tour commenced in Columbus, Ohio, on April 4. Taking in thirty-four US cities, the band's repertoire included two new songs, "Sad Angel" and "Without You." During their London shows later in the year, on September 25 and 27, Christine McVie joined the band on stage at the O2 Arena for "Don't Stop," the first time she'd appeared on stage with the band in fifteen years. Many saw it as a sign of an expressed interest in rejoining the line-up. But the international trek came to a premature end on October 27, when the band's dates in Australia and New Zealand were canceled after John McVie was diagnosed with cancer to enable him to undergo treatment. The following month, Christine was happy to report that her ex-husband's prognosis was good, while also confirming that she might be returning to Fleetwood Mac.

In January 2014, Mick Fleetwood confirmed the news that Christine was rejoining and the group began working on a new album. The immediate priority was another world tour, called On With The Show, which opened for a thirty-three-city American trek in Minneapolis, on September 30. (Coincidentally, the release date of Stevie Nicks' eighth

> "I don't know. It's impossible to say. We might get back together, but I just couldn't say for sure."
>
> CHRISTINE MCVIE

solo album, *24 Karat Gold: Songs from the Vault*.) Signs of a new Fleetwood Mac album gradually diminished as their tour continued into 2015 with early summer dates in the UK and then Australia.

Lindsey Buckingham, meantime, suggested early in the year that the ongoing tour and the forthcoming album could be Fleetwood Mac's last, calling it "a beautiful way to wrap up this last act." But Mick Fleetwood had other ideas, saying that a new album could well take years to complete, with Stevie Nicks being undecided about committing herself to a new Mac studio project.

It would be another eighteen months before there was any more news on the record front. In September 2016 Mick revealed that, while Buckingham and Christine had amassed a huge backlog of material with the band, there was virtually nothing from Stevie Nicks, who had been concentrating on her solo career. In *Ultimate Classic Rock* Fleetwood said, "She [McVie] and Lindsey could probably have a mighty strong duet album if they want. In truth, I hope it will come to more than that. There really are dozens of songs. And they're really good. So we'll see."

It was a portent of things to come, when the following June *Lindsey Buckingham Christine McVie* was released; with the rhythm section of John McVie and Mick Fleetwood, it was effectively a new Fleetwood Mac album but without Stevie Nicks. The album (also known

EXTENDED PLAY

231

as *Buckingham McVie*) debuted in the *Billboard* chart at No. 17, and hit the UK charts at No. 5. The pair toured in support of the album, between June and November 2017, during which time Fleetwood Mac made just two appearances, at the Classic West and Classic East concerts in Los Angeles and New York City, on July 16 and 30 respectively.

The next time Fleetwood Mac got together on stage was when they received the Person Of The Year Award from the charity MusicCares, in April 2018. They played several songs at the gala concert honoring them, in a show which also included Harry Styles, Lorde, and Miley Cyrus. It would be the last time Lindsey Buckingham would play with the band.

Plans had been underway for some time for a new Fleetwood Mac tour, the band's profile buoyed once again, this time via streaming services catapulting *Rumours* back into the charts. But when the band began to decide on the set lists they would feature, some serious disagreement arose between Lindsey and the others. Buckingham wanted newer and less-familiar material to be included, the rest of the band preferring a "greatest hits" approach. Nobody would budge on the issue, least of all Lindsey, who refused to sign off on a tour they had been planning for eighteen months. In late April, he was summarily dismissed.

Buckingham went on to file a lawsuit against Fleetwood Mac and, while they eventually came to a settlement, the harm to their personal relationships was done. In preparation for the tour, due to begin in a few weeks, the band (not for the first time) had to find suitable replacements to complete the line-up. An Evening With Fleetwood Mac was launched at the iHeartRadio Music Festival on September 21, 2018, at the T-Mobile Arena, Las Vegas. Augmenting the band were guitarists Neil Finn and Mike Campbell. Singer-songwriter Finn was well known from the late seventies as part of the New Zealand outfit Split Enz, and the Australian group Crowded House. Campbell had been a prominent name with Tom Petty and the Heartbreakers and had appeared on *Behind the Mask*. As a companion to the tour—which would last until November 2019—the band released *50 Years—Don't Stop*, a three-CD box set covering Fleetwood Mac's recording history from 1967 to 2013.

While the tour was being put together, the band had received the sad news of the death of their former guitarist Danny Kirwan. He had lived for many years on social benefits, and royalty payments from his time with Fleetwood Mac, but died in his sleep on June 8, 2018, aged sixty-eight, after contracting pneumonia. In a tribute article devoted to Kirwan in *Mojo* magazine, Christine McVie said, "Danny Kirwan was *the* white English blues guy. Nobody else could play like him. He was a one-off . . ."

And another loss of a key figure in the Fleetwood Mac narrative would occur on July 25, 2020, when the band's founder member Peter Green passed away at the age of seventy-three. Green's distinctive guitar style marked him out as a virtuoso during the late sixties UK blues movement, and his compositions like "Albatross," "Black Magic

OPPOSITE: *Christine, Mick, and Lindsey perform live onstage at the 2018 MusiCares Person of the Year honoring Fleetwood Mac, Radio City Music Hall, New York City, January 26, 2018*

Woman," and "Man Of The World" helped establish Fleetwood Mac as a major name on the UK rock scene. For some time Green had lived the life of a recluse, but in recent years had toured the UK, Europe, and Australia, fronting Peter Green and Friends. Among fulsome tributes from the music fraternity, former Oasis songwriter and guitarist Noel Gallagher described Peter as "without question the best British blues guitarist ever", while one of Green's heroes, guitarist B.B. King, had once said he was "the only one who gave me the cold sweats."

While fans continued to speculate as to whether Fleetwood Mac would make yet another reappearance on the music scene, whether on stage or in the recording studio, the key members were living a more settled life into the third decade of the twenty-first century.

Stevie Nicks was certainly the most active over the past few years. In September 2020 she released a live album and film of her 24 Karat Gold tour that had run through 2016-17. In May 2021 she was a headliner at the Shaky Knees Festival in Atlanta, Georgia, but had to cancel further solo dates that year because of the Covid-19 pandemic. And in August 2022, the virtual group Gorillaz included a collaboration with Nicks on the second track—"Oil"—from *Cracker Island*. A month later, she released a single of her cover of a Stephen Stills/Buffalo Springfield song from 1966, "For What It's Worth."

Despite undergoing open-heart surgery in 2019, Lindsey Buckingham didn't let the grass grow after leaving Fleetwood Mac. In September 2021 he released his seventh studio album, simply titled *Lindsey Buckingham*. And in August 2022 he joined his friends The Killers—with whom he'd collaborated on their *Imploding The Mirage* in 2020—on stage in Los Angeles, to play a cover of the Mac's "Go Your Own Way."

However, in October 2022 Lindsey had to cancel UK and European dates for a second time in the year. The concerts had already been postponed due to members of his band and road crew testing positive for Covid, and now Buckingham himself was forced to cancel due to what were described as "ongoing health issues."

John McVie was declared clear of colon cancer in 2017. He remains married to Julie Ann, with whom he shares daughter Molly, now in her early thirties. As it has been for many years his biggest passion outside music and family is sailing, but he would always stress he was ready for the call, should it come from Mick Fleetwood, for the band to get together one more time.

And Mick himself is the only one of the various line-ups to have been a constant member of the band since its formation in 1967. Alongside an infrequent secondary career as a film and TV actor, he seemed to have a "never say never" attitude to the prospect of Fleetwood Mac reappearing as a unit somewhere, sometime.

Meanwhile, while determined to lead a domesticated life out of the music biz spotlight, Christine McVie was still happy to adopt her music persona from time to time.

In 2019 she featured in a ninety-minute BBC documentary *Fleetwood Mac's Songbird—Christine McVie*, and in June 2022 released a collection of her solo work (including two previously unreleased tracks), *Songbird (A Solo Collection)*. Quizzed by *Rolling Stone* at the time, as to whether the core Fleetwood Mac would ever come together again, she replied noncommittally, "I don't know. It's impossible to say. We might get back together, but I just couldn't say for sure."

But it was not to be. On the last day of November 2022, the remaining members of Fleetwood Mac—and fans around the world—were shaken by the news that Christine McVie had died after what her family announced as "a short illness." In a statement online, the group described her as "the best musician anyone could have in their band, and the best friend anyone could have in their life." And Mick Fleetwood tweeted, "This is a day where my dear sweet friend Christine McVie has taken to flight . . . and left us earthbound folks to listen with bated breath to the sounds of that songbird."

Christine's passing has almost certainly closed the book on speculation as to yet another Fleetwood Mac reunion. But the heartfelt tributes accorded to her memory are testament to the continuing appeal of Fleetwood Mac to generations of fans, young and old alike. Early in 2023 the launch of the TV series *Daisy Jones & The Six*—based on a novel inspired by Fleetwood Mac's sometimes turbulent past—confirmed the enduring fascination with the band's story. It's a story intertwined with their recorded output, as chronicled in these pages, which stands as a permanent monument to their enduring place in pop and rock music history.

ABOVE: *Yet more line-up changes. New recruits Neil Finn (left) and Mike Campbell (right) at the 2018 iHeartRadio Music Festival at T-Mobile Arena, Las Vegas, September 21, 2018*

OVERLEAF: *Stevie Nicks, John McVie, Christine McVie, Lindsey Buckingham, and Mick Fleetwood take a bow onstage during the 2018 MusiCares Person of the Year honoring Fleetwood Mac*

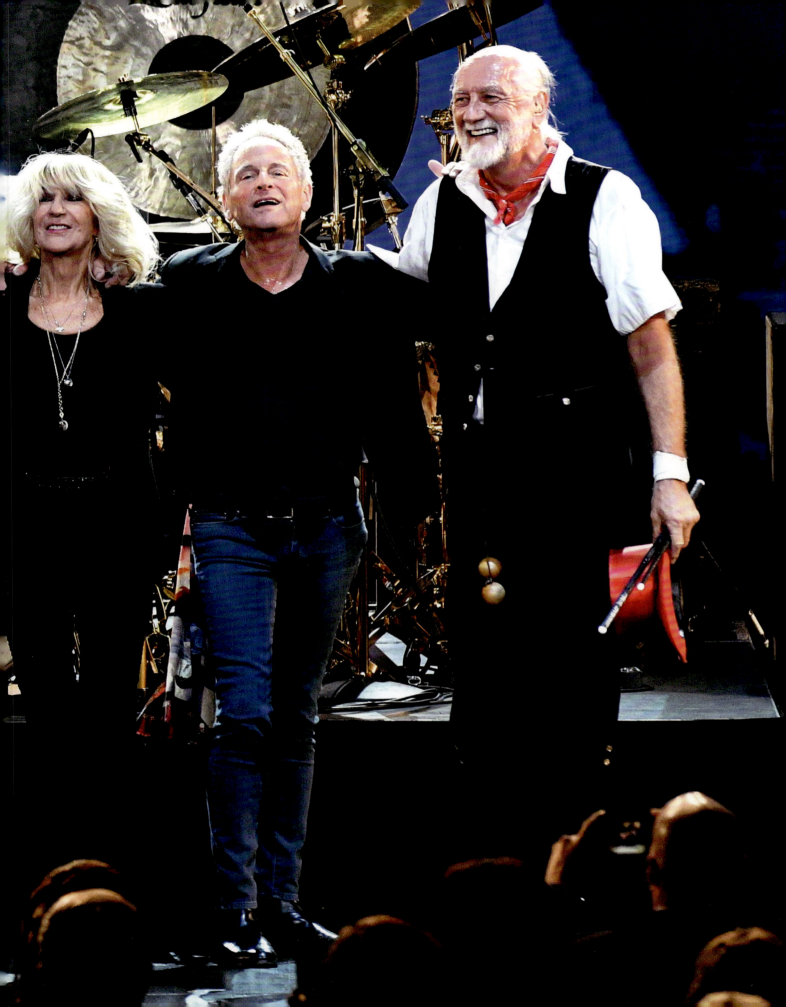

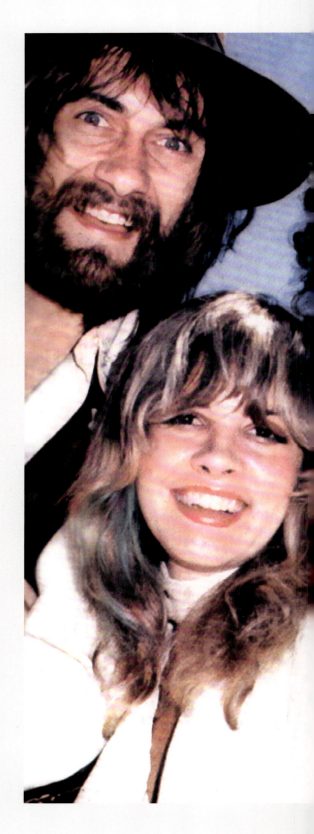

"This is a day where my dear sweet friend Christine McVie has taken to flight . . . and left us earthbound folks to listen with bated breath to the sounds of that songbird."

MICK FLEETWOOD

CHRISTINE MCVIE: 1943-2022

PICTURE CREDITS

T: Top **B:** Bottom **L:** Left **R:** Right

ALAMY 6-7, 18 Tony Gale Pictorial Press Ltd 12 Lebrecht Music & Arts 21 M&N 24-25, 26-27, 37, 41, 60, 183, 188-189, Pictorial Press Ltd 39, 70, 158, 177R Vinyls 55 Universal Images Group North America LLC 61 f8 archive 111, 177L Sjvinyl 113 Trinity Mirror/Mirrorpix 124 Prestor Pictures LLC 145 Phil Roach/Globe Photos/ZUMAPRESS.com 169 Mario Ruiz/ZUMAPRESS.com 202-203 Mark Reinstein 229 Frank Micelotta/PictureGroup 230-231 Claudio Bresciani/TT **BRIDGEMAN** 34 © Odile Noël **GETTY Cover,** 35, 36, 64-65, 75, 78-79, 80-81, 102-103, 128, 180-181 Michael Ochs Archives 4, 129 Ed Perlstein/Redferns 9 Silver Screen Collection 14 George Wilkes/Hulton Archive 24 Dick Barnatt/Redferns 29 Jan Persson/Redferns 38 Ivan Keeman/Redferns 44, 45 David Redfern/Redferns 52 ullstein bild 63, 159 Larry Hulst/Michael Ochs Archives 67 Ron Howard/Popperfoto 71, 72, 73, 83, 110, 112, 114, 115, 116, 118, 119, 121 Fin Costello/Redferns 82, 85, 90, 91, 92L, 99, 107, 140-141, 147, 148, 149 Michael Putland 84, 93 Ian Dickson/Redferns 92R, 98 Evening Standard/Hulton Archive 100 Central Press 104-105 Michael Montfort/Michael Ochs Archives 125 Richard Creamer/Michael Ochs Archives 126, 132, 142, 152, 160-161, 164, 173, 174, 191 Richard E. Aaron/Redferns 130, 131 Richard McCaffrey/ Michael Ochs Archive 138-139 Paul Natkin 146 L. Cohen/WireImage 150, 192, 195 Pete Still/Redferns 156 Ebet Roberts 161 Brian Rasic 162 Erica Echenberg/Redferns 165 Ross Marino 166 Bettmann 167 David Montgomery 172 Lynn Goldsmith/Corbis/VCG 176 Aaron Rapoport/Corbis 178, 179 Ron Galella Collection 194 Jim Steinfeldt/Michael Ochs Archives 201 David Keeler 204 Donna Santisi/Redferns 205, 225 Tim Mosenfelder 214 Ken Murray/NY Daily News Archive 216-217 JMEnternational 217 TIMOTHY A. CLARY/AFP 224 Jazz Archiv Hamburg/ullstein bild 226 Joe Kohen/WireImage 232-233 Samir Hussein 233, 235 Kevin Mazur 234 Dia Dipasupil 239 GAB Archive/Redferns **MIRRORPIX** 13 Surrey Herald 16-17 George Greenwell/Daily Mirror 28 Tom King/Daily Mirror 50-51 Bela Zola/Daily Mirror 57 Reading Post 190 Chris Grieve **SHUTTERSTOCK** 133 Fotos International 175 Eugene Adebari 193 Clive Dix 200 Richard Young 206 Shutterstock 212-213, 215 Sipa 218 Mick Tsikas/EPA 221 Richard Drew/AP **UMASS**

© Jeff Albertson Photograph Collection, Robert S. Cox Special Collections and University Archives Research Center, UMass Amherst Libraries

ALBUMS *Fleetwood Mac (1968)* Blue Horizon *Mr. Wonderful* Terence Ibbott: design and photography *Then Play On* Maxwell Armfield: painting, John Jesse Collection; Terence Ibbott: photography *Blues Jam at Chess* Jeff Lowenthal: photography; Terence Ibbott: design and sleeve photography *Kiln House*: Christine McVie: cover artwork *Future Games* John Pasche: design; Sally Jesse: cover photography; Edmund Shea: band photography *Bare Trees* John McVie: cover photography; *Penguin* Modula: design; inside photography: Barry Wentzell *Mystery to Me* Clive Arrowsmith: photography; Thomas Eccles: cover design *Heroes Are Hard to Find* Desmond Strobel: design; Herbert W. Worthington III: photography *Fleetwood Mac (1975)* Desmond Strobel: design; Herbert W. Worthington III: photography *Rumours*: Desmond Strobel, design; Larry Vigon: calligraphy; Herbert W. Worthington III: photography *Tusk* Peter Beard, Jayme Odgers, Norman Seeff: photography; Vigon Nahas Vigon: art direction, design *Mirage* Larry Vigon: art direction, design, and concept, inner sleeve illustration; Lindsey Buckingham: artwork (inner sleeve); MacJames: artwork (painting on cover photography); George Hurrell: photography *Tango in the Night* Brett-Livingstone Strong: cover painting; Greg Gorman: cover photography; Jeri Heiden: art direction *Behind the Mask* Dave Gorton: cover photography; Jeri Heiden: art direction *Time* Mick Fleetwood: cover concept; Gabrielle Raumberger: art direction; Frank Chi: design; Lance Staedler: band photography; Dale McRaven, Bonnie Nelson: cover photography *Say You Will* Stephen Walker: art direction; Keith Carter: "Hands 1991" photography; Karen Johnston, Neal Preston, Herbert W. Worthington III: photography

BIBLIOGRAPHY

Betts, Graham *Complete UK Hit Albums, 1956-2005* [Collins, 2005]
Betts, Graham *Complete UK Hit Singles, 1952-2004* [Collins, 2004]
Boyd, Joe *White Bicycles: Making Music in the 1960s* [Serpent's Tail, 2006]
Brackett, Donald *Fleetwood Mac: 40 Years of Creative Chaos* [Praeger, 2007]
Brunning, Bob *Fleetwood Mac: Behind the Masks,* [New English Library, 1990]
Celmins, Martin *Peter Green Founder of Fleetwood Mac: The Authorised Biography* [Sanctuary, 1998]
Chess, Marshall, Robert Schaffner, Mike Vernon *Fleetwood Mac in Chicago: The Legendary Chess Blues Session, January 4, 1968* [Schiffer, 2023]
Clarke, Donald (ed) *Penguin Encyclopedia of Popular Music,* [Viking, 1989]
Evans, Mike *The Blues: A Visual History* [Unicorn Press, 2014]
Fleetwood, Mick *Fleetwood: My Life and Adventures with Fleetwood Mac* [Sidgwick & Jackson, 1990]
Frame, Pete *The Complete Rock Family Trees* [Omnibus Press, 1993]
Hardy, Phil *The Faber Companion to 20th-Century Popular Music* [Faber & Faber, 1995]
Hewison, Robert *Too Much: Art and Society in the Sixties, 1960-75* [Methuen, 1986]
Kahn, Ashley, Holly George-Warren, Shawn Dahl (eds) *Rolling Stone; The Seventies* [Rolling Stone/ Little, Brown, 1998]
Logoz, Dinu *John Mayall: The Blues Crusader* [Edition Olms, 2015]
Ward, Ed, Geoffrey Stokes, Ken Tucker *Rock of Ages: The Rolling Stone History of Rock & Roll* [Rolling Stone/ Summit, 1986]
Wells, David (liner notes) *Crawling Up a Hill: A Journey Through the British Blues Boom 1966-71* [Grapefruit Records, 2020]
Whitburn, Joel *Billboard Book of Top 40 Albums* [Omnibus, 1991]
Whitburn, Joel *Billboard Book of USA Top 40 Hits* [Omnibus, 1989]
Wyman, Bill *Bill Wyman's Blues Odyssey* [Dorling Kindersley, 2001]

SOURCES

Periodicals: BAM, BBC, Billboard, Boston Globe, Circus, Creem, Daily Mirror, Disc & Music Echo, Goldmine, The Guardian, Hartford Courant, The Independent, Los Angeles Times, Melody Maker, Miami Herald, Mojo, Music Connection, The Music Paper, New Musical Express, Q, The Record, Record Mirror, Rock Magazine, Rolling Stone, Sounds, Taranaki Daily News, The Times, Trouser Press, Ultimate Classic Rock
Websites: blueprintblues.co.uk, classicrockreview.com, discogs.com, fleetwoodmac.net, fleetwoodmac-uk.com, fmlegacy.com, 991.com, pleasekillme.com, rateyourmusic.com, rocksbackages.com, setlist.fm, somethingelsereviews.com